Third Views
SECOND SIGHTS

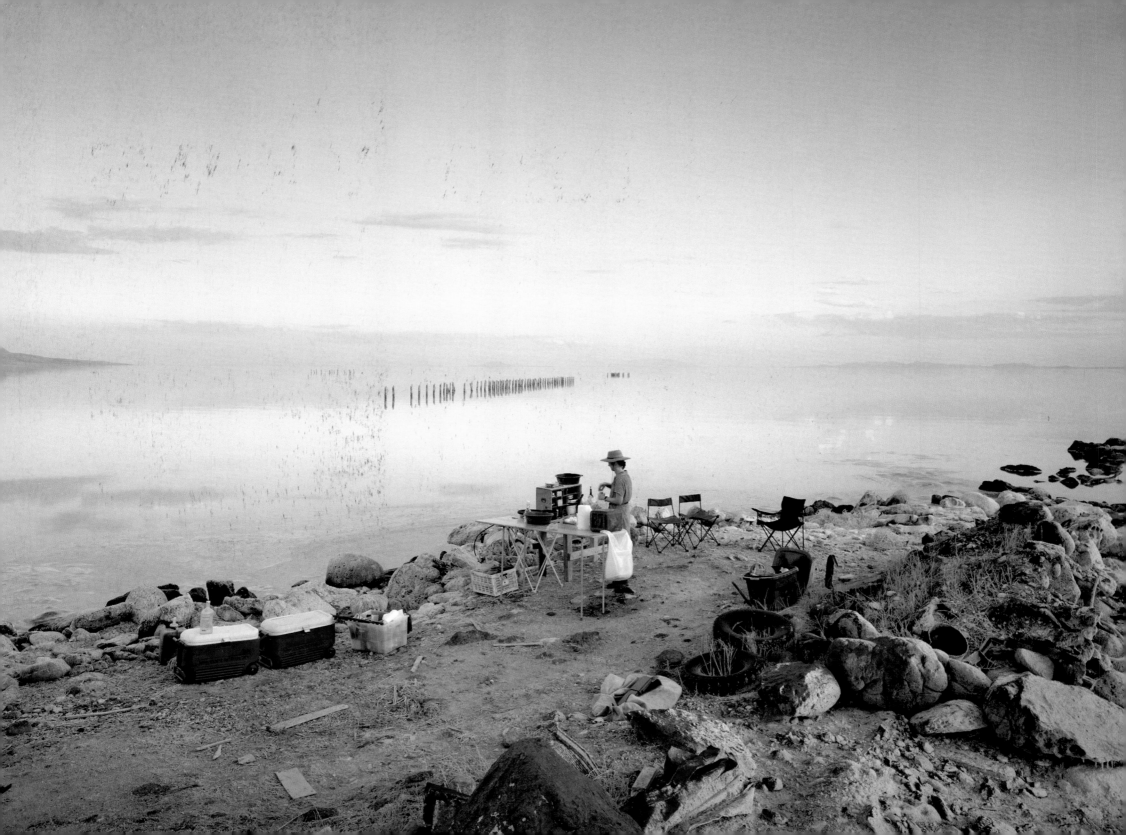

Third Views
SECOND SIGHTS
A REPHOTOGRAPHIC SURVEY OF THE AMERICAN WEST

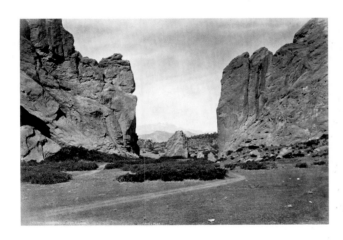 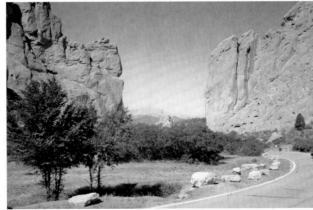 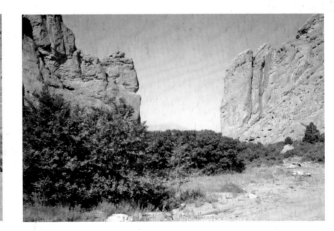

MARK KLETT, PROJECT DIRECTOR

Kyle Bajakian, William L. Fox, Michael Marshall, Toshi Ueshina, Byron Wolfe

MUSEUM OF NEW MEXICO PRESS · SANTA FE

IN ASSOCIATION WITH THE CENTER FOR AMERICAN PLACES

The Third View project was sponsored by Anderson Ranch Arts Center.

This book was developed by the Center for American Places (P. O. Box 23225, Santa Fe, NM 87502 www.americanplaces.org), in collaboration with the Museum of New Mexico Press.

Project editor: Mary Wachs
Design and production: David Skolkin
Manufactured in Singapore
10 9 8 7 6 5 4 3 2 1

Photograph page ii: Rebecca making coq au vin near the site of Robert Smithson's *Spiral Jetty,* the Great Salt Lake, UT. Mark Klett, 2000

Library of Congress Cataloging-in-Publication Data
Third views, second sights: a rephotographic survey of the American West / Mark Klett . . . [et al.].—1st ed.
 p. cm.
 ISBN 0-89013-432-4 (cloth)
 1. Landscape photography—West (U.S.) 2. West (U.S.)—Geography—Pictorial works. 3. Photography in geography. I.
Klett, Mark, 1952-
 TR660.5.T475 2004
 779'.9972—dc22

2004005133

Museum of New Mexico Press
Post Office Box 2087
Santa Fe, New Mexico 87504

Contents

Foreword

IN THE SUMMER OF 1999, Mark Klett and his Third View team arrived at Anderson Ranch Arts Center, a visual arts learning community near Aspen, to organize the data they had recently collected in the field. As they sat in front of our computers uploading their latest adventures onto hard drives, Mark and his colleagues began editing the video, audio, and still images. In the process, they were reinterpreting what they had just experienced, bringing meaning to the places they had just explored.

Speaking as one who worked both as a member of the Third View field team and later as the director of the Ranch's Photography program, I can say there was a certain excitement and synchronicity of purpose that linked Third View with the Ranch's interests. There was a commitment to exploration and discovery, to the creative process, and to that connection between artists and their evolving communities.

Author Wendell Berry once said, "If you don't know where you are, you don't know *who* you are." By embracing the visual legacy of the West, Third View helps establish who we are by telling us a great deal about where we are and where we have been—about our history, our geography, and our civilization. Like many communities in the West, Anderson Ranch has itself undergone a striking metamorphosis over the years, transformed from a turn-of-the-century sheep ranch into a contemporary art center committed to innovative and interdisciplinary approaches to art making. Third View created a methodology—a *mirror*—with which we all can reflect upon our changes over time.

The Board of Anderson Ranch Arts Center is proud to have been a major sponsor and values Third View's unique and powerful contribution to the field of contemporary landscape photography and to our understanding of the region in which we live.

—KYLE BAJAKIAN,
*Program Director for Photography and
Digital Imaging, Anderson Ranch Arts Center*

Acknowledgments

A PROJECT LIKE THIS requires collaboration by necessity since such work unfolds and develops only with the help of numerous individuals and organizations. We acknowledge those who not only made our work possible but also enjoyable and rewarding.

Third View began without a sponsor and with field trips funded by the sales of print sets produced by the Rephotographic Survey Project and sold to public collections. Both Ellen Manchester and JoAnn Verburg, original partners of the Rephotographic Survey Project, lent their support for the new project and approval to raise funds with photographs of the old.

Once the project was underway, a grant from the Arizona Commission for the Arts provided much-needed help with travel expenses and materials for our first field season. The second year a grant from the Institute for Studies in the Arts at Arizona State University paid for the creation of the project's first web site, and we further expanded our utilization of technology by uploading results directly from the field while traversing central Nevada. Later, support for Byron Wolfe's work on the project's electronic products came from the Departments of Communication Design and Sponsored Programs at California State University, Chico.

In the field, we were indebted to dozens of people who agreed to let us interview and videotape them, informed us of local history, and shared their personal stories. Those who enabled us to enter otherwise restricted or private properties included the National Park Service at Yellowstone National Park, Joe and Gwen Barron of Colorado Springs,

Colorado, Frank Cattelan of Echo, Utah, and Dennis Bowyer of the Parks and Recreation Department of Twin Falls, Idaho.

Others helped the project with invaluable labor after fieldwork ended. As the project printer, Mike Lundgren juggled hundreds of negatives and digital scans with exceptional craftsmanship. Aaron Rothman also did an excellent job editing hours of project videotape, work begun by field team members Toshi Ueshina and Mike Marshall. Richard Stuart , our first webmaster, accompanied us on the 1998 Nevada trip. Later, Johnny Poon, at California State University, Chico, redesigned the expanded web site into a form that was both functional and elegant. And Gary Baugh assisted Byron Wolfe with CD-ROM design and production.

Professional feedback helped refine our work, which was improved by the ideas, helpful criticisms, and friendly suggestions of our colleagues. John Rohrbach of the Amon Carter Museum, Fort Worth, Texas, and Tom Southall of the High Museum, Atlanta, both thoughtfully reviewed our CD-ROM presentations. Jennifer Watts of the Huntington Library, San Marino, California, first publicly showed the project's interactive disk. Writer Rebecca Solnit joined us in the field to engage the legacy of nineteenth-century photographers as well as contribute her expertise as a camp cook. Beth Hadas of the University of New Mexico Press encouraged Bill Fox to contact me, and shortly thereafter he officially joined the project field team.

Major support for Third View came from the Anderson Ranch Arts Center. Elsewhere in this volume Kyle Bajakian describes the Ranch's interest in the project, but it is important to state here that without the support of the Anderson Ranch, its Director James Baker, and its Board of Directors, the completion of the project and book would have been financially impossible. In particular Betsy Chaffin took our cause to her colleagues and spread enthusiasm for the project. The Ranch's Board of Directors understood the issues of our work, and their willingness to support projects like ours indicates why the Anderson Ranch is so important among American arts programs.

Finally, fieldwork, the core of the Third View project, would not have been possible without the sacrifice of our families, who put up with long absences (more than thirteen weeks in the field over four years) and untold hours of darkroom and computer work back at home. Their unfailing support was an invaluable gift.

ARIZONA

1. GRAND CANYON
(SEE PAGE 193)

2. MARBLE CANYON

CALIFORNIA

3. OROVILLE, CA (SEE PAGE 187)

4. DONNER PASS

COLORADO

5. ARKANSAS VALLEY

6. BOULDER (SEE PAGE 76)

7. CARIBOU

8. GATES OF LODORE, DINOSAUR
NATIONAL MONUMENT
(SEE PAGE 169)

9. COLORADO SPRINGS
(SEE PAGE 32)

10. GEORGETOWN
(SEE PAGE 72)

11. MOUNTAIN OF THE HOLY
CROSS, ROCKY MOUNTAINS
(SEE PAGE 174)

12. SILVERTON
(SEE PAGES 17 & 24)

13. TWIN LAKES (SEE PAGE 36)

IDAHO

14. CITY OF ROCKS
(SEE PAGE 120)

15. TWIN FALLS
(SEE PAGES 125, 128 & 133)

NEW MEXICO

16. EL MORRO NATIONAL
MONUMENT (SEE PAGE182)

NEVADA

17. AUSTIN (SEE PAGE 84)

18. DIXIE VALLEY

19. FALLON (SEE PAGE 88)

20. LOGAN (SEE PAGE 81)

21. PYRAMID LAKE
(SEE PAGE 178)

22. STEAMBOAT SPRINGS
 (SEE PAGES 104 & 108)

23. TRINITY RANGE
(SEE PAGE 92)

24. VIRGINIA CITY
(SEE PAGES 96 & 101)

UTAH

25. BIG AND LITTLE
COTTONWOOD CANYONS
(SEE PAGES 112 & 116)

26. ECHO CANYON
(SEE PAGES 52 & 56)

27. FLAMING GORGE
(SEE PAGES 136 & 141)

28. PROVO, UT

29. PROMONTORY POINT
(SEE PAGE 145)

30. SALT LAKE CITY
(SEE PAGE 40)

31. WEBER VALLEY
(SEE PAGES 44 & 48)

WYOMING

32. YELLOWSTONE NATIONAL
PARK (SEE PAGES 148, 152,
156, 160 &164)

33. GREEN RIVER
(SEE PAGES 60, 64 & 68)

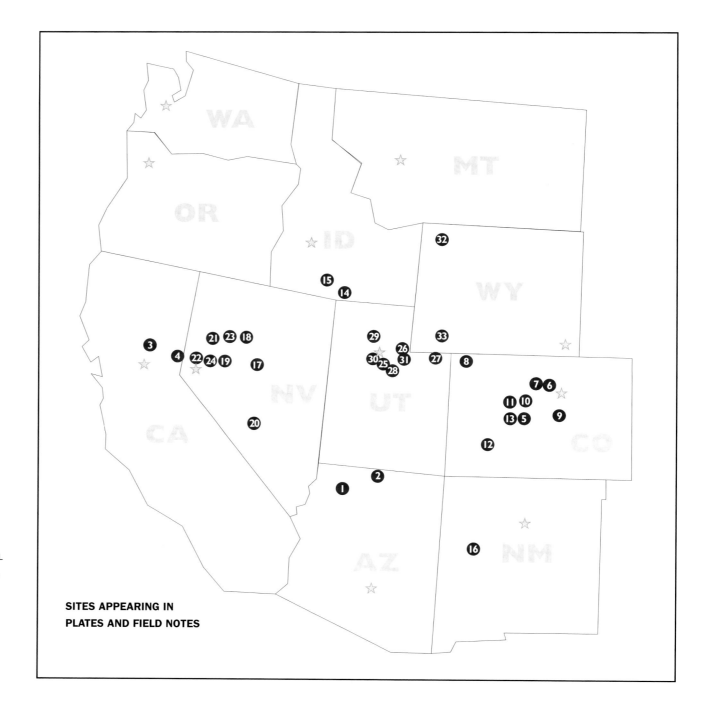

**SITES APPEARING IN
PLATES AND FIELD NOTES**

Introduction

by Mark Klett

WHY A THIRD VIEW? In late September of 1979, I finished the last in a series of visits to historic landscapes. For three summers my colleagues and I traveled eight states looking for and repeating the American West's first photographs: views made for the government-sponsored surveys of the 1860s and 1870s, work that would be published in 1984 as *Second View: The Rephotographic Survey Project*. Working on what was called the Rephotographic Survey Project (RSP), we had painstakingly made new views from the earlier vantage points and saw firsthand the changes over a century. The project studied how early photographs were made and compared contemporary perspectives to pictures of what were once newly explored territories. We were taking a fresh look at historic places by making a new view from the old, and it was interesting work. It was also tedious, demanding, and time-consuming, so after visiting more than 120 sites, we'd had enough. I remember thinking: Someone may do this work again someday, but thankfully it won't be me. So it was with no small dose of personal irony that twenty years later I proposed to visit once again the same sites I had gladly walked away from. Why a third view? The idea of repeating the repetition of a photograph seems a little unnecessary. Why would anyone want to cover the same ground (literally) that had been covered twice before?

Third View is the outcome of curiosity about time and change, photography, and a desire to reexperience dynamic western landscapes. Most people assume that landscape photographs are about rocks or trees or space, but I believe their real meaning concerns our essential connection to place, to each other, and, most important, to time. *Third View* is

the product of new minds working to reexperience known landscapes in new ways, with emphasis on how people and places have interacted. The work in this book combines two projects, two decades apart, and is based on the photographic legacy of the first era of western exploration. The three episodes are entirely separate, the work done for different reasons in each one. Still, each is linked by common points in space and contributes to an evolving dialogue about change, culture, and technology. In the twenty years since the second views, much has transpired in how photographs are both made and interpreted. *Third View* reflects a desire to explore not just known places but what has, in effect, become new territory with new ways of seeing it.

A TALE OF TWO PROJECTS In the beginning, there were four nineteenth-century government-sponsored surveys led by Clarence King, George Wheeler, Ferdinand V. Hayden, and John Wesley Powell. The surveys were typically large parties of men on horseback mapping lands and natural resources as they investigated the mountains and deserts bypassed in the rush across the continent. The interior West was considered big and exotic territory, and each survey employed a photographer to record landscapes. Photographs by William Henry Jackson, Timothy O'Sullivan, William Bell, John K. Hillers, and others now form an important visual baseline, the first photographs of the West.

The photographers never intended the sites they photographed to be revisited in such detail. Their pictures were used for various purposes, including scientific documentation and political lobbying. But by now the pictures have become historical icons of a significant era and have gained value as art objects, just as the photographers themselves have been studied and are considered early practitioners of the landscape photographer's art.

A fascination with these early photos and with the West of our imagination led to the formation of the Rephotographic Survey Project in 1977. Ellen Manchester, JoAnn Verburg, and I agreed to combine backgrounds in photographic history, earth science, and conceptual art to begin a "pilot project" for making what we called "rephotographs." The RSP was determined to make precisely repeated images at the early survey sites and to discover what could be learned by visiting the actual places where the images had been made. The idea of rephotography, as we defined it, was to adhere to a strict technical methodology. The new images would be made from the same vantage points as the originals (to within inches, if possible) and at the same time of day and year.

The RSP began with questions, and many were directed toward the logistics of repeating photographs. For example, we wondered at first if it were even possible to find the sites of early survey photographs. The answer soon proved to be a definite yes. In fact, we found over 120 sites, but altogether those represented only a small portion of the total places photographed by the original surveys.

We asked about the changes we would find in the intervening one hundred–plus years. There proved to be a wide variety. In some cases the changes were massive, such as huge water projects, and in other cases the land had barely changed at all. The results showed just how much the land has been shaped by the human presence and how slow a century is in geologic time.

Other questions took aim at the visual effects of pairing images, of combining two similar but different photos that were taken at two distinct times. We found that the two images together form a new whole. They create a new context in which neither photo exists in its time alone. One looks at one picture to define the other. Details are compared, and the immutability of time as a constant in our lives becomes suspect. The images sometimes defy expectations as to which image came first, and the changes evident do not always conform to one's expectations.

The process of making rephotographs can tell us much about the original photographers and how they worked. For example, we found they often worked by the side of an early road. They often made clear-cut choices about where to stand and how to frame their works. The photographers sometimes made monuments out of what are today considered ordinary western features by carefully selecting vantage points. The use of figures in their pictures had deliberate emphasis. Their work took place under difficult conditions and took great technical skill. The limitations of the process used affected the results: The exposures were long by

necessity, there was a limited time of day during which exposures could be made, and the sensitivity of the emulsions negated the inclusion of clouds. Nevertheless, their choices of where to position themselves and how to frame their images, when to expose their plates and what to include and exclude were every bit as sophisticated as the decisions made by contemporary photographers.

The limitations of our work also were revealing. Rephotographs can show change, but they can't explain history. Further, rephotographs can't show what is excluded by the view on either side of the picture's frame. The photographs alone cannot explain the context behind the taking of the images or the details hidden from the camera. They can express our wonder at change and imply the passage of time but not the causes or even existence of external forces.

There were three observations about landscape photographs that arose from the RSP's fieldwork. First, landscape photographs result from an interaction of personal experience and cultural influences. They reflect the external forces that shape the vision of their makers, and in a similar way, the forces that shape viewers influence their interpretation of photographs. Second, photographers are always participants in the making of a landscape, not simply impartial witnesses, and their photographs are never neutral. Third, landscape photographs are timely even when they seem timeless, and the moment of each image is unique and can never be exactly repeated.

Time and change are constant subjects of the rephotographic process. Photographs may represent a specific time, but change is the true measure of time passing. The scale of change often depends on the perspective of the viewer, on what is known about a subject, and on the way change is measured. Time on a natural scale, such as the movement of mountains, differs from the measure of human experience on the order of many magnitudes. Change and time must be measured on different scales. What appears to be no change is, on another scale, a dynamic transformation. The unsynchronized and unpredictable rhythm between the evaluation of time and real change is a topic of rephotography and one both the RSP and Third View teams explore. Outside the clock of conventional units, time in the conventional sense ceases tobe a reliable measurement.

Artifacts and signs of human passage are everywhere in the West and are among the most used indicators of change. These changes are both physical and perceived. Photographs themselves are artifacts in this equation, and photographers are the makers of artifacts as well as the storytellers of their time; their images are both commentary and opinion.

BASIS FOR A NEW PROJECT The Third View project was the reincarnation of rephotography as it was defined by the RSP, and it picked over questions raised by the making of second views that had been only partially answered. The new project began in 1997 on the twentieth anniversary of the RSP, and it purposefully chose to create a portrait of the West by reworking, extending, and updating the previous photographs. Third View was designed to address issues of representation, popular western mythologies, and the ever-changing relationship between nature and culture. The methods used by the project team explored technological advances that have made it possible to collect new data in the field, and new methods integrated various forms of electronic media into one presentation. The project was influenced by parallel work in other disciplines such as literature and history and the new views of the West being created in those areas.

FIELDWORK AND METHODS In four years, between 1997 and 2000, the Third View field team revisited more than 110 sites, twelve of which were not originally included in the RSP's work of the 1970s. When two views were available, we decided to target the second view in each series for rephotography, the view made by the RSP, rather than the original survey photograph. Our greatest interest was in the time period since the landscape sites were last photographed, and by using the second view as a standard, we resolved the choice between locations where there were slight differences between the first two vantage points.

Our methodology for making rephotographs was basically the same as that used by the RSP team.

Copy prints of both the first and second views were carried to the site. Site locations were then marked by GPS (Global Position Satellite) coordinates. Exposure data and camera information also were recorded for each exposure. A 4" × 5" view camera was used for the photography, and test shots were made onto Polaroid film. Measurements were taken between copy prints and the Polaroid instant print, then compared to calculate the most accurate placement of the camera (for a complete description, see the tutorial on the DVD included with this volume).

Exposures were made onto conventional black-and-white and color films at each site. However, unlike the earlier project where individual photographers often worked alone at sites, the Third View photographers worked as a team and after rephotographing the scene (or before) went on to collect more materials. These typically included videos of both the site and related areas; video and audio interviews with people associated with sites; other sound files that convey a sense of the places visited, such as ambient sound or found sounds (radio clips, discarded tapes); detailed field notes; artifacts and objects at or associated with sites and related areas; personal photographs made by members of the project team; and site-related imagery such as Quick Time Virtual Reality panoramas. The reason for collecting so many materials was to increase the probability that something interesting would be discovered from casting a wide net. We were interested in small parts that could be used to stand for the larger whole: the select object, image, or sound that could form the nucleus of a narrative or portrait of place. We also wanted to expose the conditions and contexts in which the team participated while collecting materials. From the beginning, the project explored techniques specifically designed for interactive programming on computers. We understood that these techniques could position the personal experiences of the team in either dominant or understated ways and allow the viewer to choose which materials were presented.

The photographic work took place between 1997 and 2000. The field team consisted of six people, five of whom were new to the idea of the survey (I was the only member who had been part of the RSP). The group traveled and worked together in a collaborative environment, and each brought to the project different backgrounds and expertise.

THE NEW TEAM Three of the four original members of the team began as graduate students in the photography program at Arizona State University. They had a thorough understanding of the history of landscape photography and an interest in reworking images they had known only in books. Byron Wolfe had a degree in environmental science, a desire to communicate personal experience through landscape photographs, and an expert ability to design and program interactive multimedia works for the computer. Kyle Bajakian had been a professional photojournalist

with outdoor skills and a knack for interviewing people and discovering their personal stories. Toshi Ueshina brought his Japanese vision to the West as fresh territory and a poetic sensibility toward making documents in both photography and video.

The Third View project team later expanded to include author Bill Fox and photographer Mike Marshall. Fox, a writer with a focus on "the intersection of landscape, art, and culture," joined the project in 1998; his book *View Finder: Mark Klett, Photography, and the Reinvention of Landscape* (University of New Mexico Press, 2001) provides another look at Third View fieldwork and historical issues relevant to the genre of landscape photography. Marshall, also a graduate student at ASU, had undergraduate training in physics and was interested in the relationship of science, art, and faith.

As a new generation of photographers, each team member had been busy working on defining his own relationship to the genre of landscape, but they began where many of my generation had concluded. They believed that photographs were mediated by cultural values but also were guided in their own work by the power of personal experience. They questioned documentary tradition and the faithfulness of photography to fact. They explored their interdisciplinary backgrounds and did not see the art of landscape photography as distant from the concerns of science, literature, or history. The team was interested in rethinking the mid- to late-twentieth-century approaches to making the land-

scape photographs that preceded them. The roots of the work they considered began not only with the survey photographers of the nineteenth century but, half a century later, with the modernist giant Ansel Adams.

THE CHANGES IN LANDSCAPE PHOTOGRAPHY The Adams model of photography, as we called it, was based upon a belief in the redemptive power of nature. The natural world was seen as the antidote to unending growth, and photographs were important contributions in the fight to preserve dwindling natural spaces. The photographs were celebrations of wild places and helped to define values many came to embrace in wilderness. In a view of the natural world that came to be defined by political policy in the United States Wilderness Act of 1964, wilderness was a place where man was an intruder, "a visitor who does not remain." The photographs made later, during the wilderness movement of the 1960s, often reflect this sentiment. Few "pure" wilderness photographs of that era and even those of the present day contain evidence of human beings. The message became clear through practice and policy that nature and culture are separate.

This older model of landscape photography was very effective at building an audience that celebrated nature's beauty. In its most public form, used in publications issued by organizations such as the Sierra Club to promote environmental causes, the

photography of wilderness landscapes became an important tool. The power of nature was something that many people could understand through personal experience. The photographs were both affirmation and invitation, and they popularized the wilderness movement. The approach to making the photographs became itself the canon of concerned landscape photographers.

Ironically, the popularization of the wilderness also threatened the very values that photographers sought to protect. As more and more people flocked to take advantage of nature's redemptive power, the nature writer Colin Fletcher once observed, "The woods are overrun, and sons-of-bitches like me are half the problem." The work contained a paradox: We should love the land but don't love it to death.

The Rephotographic Survey Project began at the time a new movement started to focus on what had been left out of previous nature photographs: the man-altered landscape. The idea that both nature and culture were fitting subjects for photography was a somewhat radical idea in the mid-1970s. The exhibition "New Topographics," developed by curator William Jenkins at the George Eastman House in 1975 was perhaps the first to recognize a growing interest in the subject by contemporary photographers such as Robert Adams, Lewis Baltz, Joe Deal, and others. The RSP was in many ways a response to this exhibition. The idea for us was to form a new landscape survey, one that took the word *topographical* at face value.

The term *New Topographics* later became loosely associated with work that positioned itself in opposition to the nature-only wilderness photographs of previous decades. And many photographers of the 1980s and early 1990s formed their imagery to make pointed commentaries on human intervention. While photographers no longer ignored the impact of culture on nature, the result was often a critical view of the interface. From a visual standpoint the result was strikingly different from that of previous decades. Instead of beautiful wild places, the photographs often showed their destruction. Growing urban centers, the results of toxic dumping, military abuses, devastation, and other examples of taking the land for granted were fair subjects. The more aggressive work targeted any remnants of belief in "Manifest Destiny," the nineteenth-century idea that the land was given to us by divine power to reach our national destiny. Instead, that destiny was irony, divinity was gone, and the land was the victim of human abuse.

In the early 1990s political activism became a focus for many photographers. Though it was never stated directly, the motivation for photographers was never very distant from that of older generations. The photographers' methods were different, the older group relying on the enduring power of nature to press its message of preservation, the newer group acknowledging a common sense of loss over the land's demise. Still, the photographers were all passionate in their feelings for a land undergoing radical change. Many of the new photographers even used

beauty to convey messages, much like their predecessors, but they often chose to make stunning photographs of scenes they found horrific rather than redemptive. Beauty became a means to an end, a tool to entice viewers to look and be moved, perhaps to mix revulsion with desire. Yet in the end, the underlying sentiments could be linked to the same concern as decades before: We must care for the land.

The older model of landscape photography and the work of a newer generation have as much in common as they are different. They both reflect the Western cultural tradition in which modern man is like the original sinner in Eden who was cast from the Garden, and while the motives are based on environmental concerns mixed with different methods, in neither case do nature and culture exist comfortably. Both approaches continue to describe the separation between culture and the land. In both cases, nature is not better off for our presence.

When Third View began in the late 1990s, the need to find new ground between the old and new models of landscape photography was (and still is) becoming acute. A newer generation of landscape photographers was beginning to ask the not-so-simple question: Do people belong in nature, and if so, how? The Third View group was interested in reexamining the western landscape in a way that didn't condemn human connections to the land. Instead, the project wanted to accept human existence as part of nature and to confirm the complexity of that relationship. It was a nonreductive approach to a deeply layered issue.

The group that started Third View operated with respect for the wide range of twentieth-century landscape practices but chose a different model for its operation. By design the project was an homage to the nineteenth-century western geographical surveys that combined multiple viewpoints and expertise. The group was drawn to the idea of working together on different tasks rather than to the more typical photographic practice of individuals working alone with singular visions. We sometimes referred to the historic practice of solitary photographers looking for great photographs as the "bagging trophies" approach, and instead we wanted to use the survey idea to develop a collaborative model for landscape photography. It is an underused approach in a genre where heroic exploits by individuals are legendary.

SOME QUESTIONS THAT STARTED THE THIRD VIEW AND A FEW OF THE ANSWERS Like the RSP, Third View began with questions. And also like the earlier project, not all of our questions had been answered by the end of it. Sorting through the results of fieldwork usually takes years, but some of the questions that fueled our work, and some of our conclusions, follow.

What has happened to the land in the last twenty years? Has there been more change in this short time span than in the first hundred years? Is there a trend to this change?

In most places there was less physical change in the last two decades than in the first century of

western settlement. Many striking land transformations have already occurred, such as the water impounds of Utah's Flaming Gorge (some of the largest visible changes in the land have had to do with water storage and transportation). As seen in Third View's work, many large-scale movements of earth such as mining continue, but not all conform to the expectation that such activities are accelerating (for example, the open-pit mine at Virginia City, Nevada, has been closed). Striking vegetation changes were encountered in some places (Witches Rocks, Utah). But perhaps the most prevalent changes relate to land management, and while they are visually subtle, these changes have profound consequences on how people can engage place. Some reflect changing concerns for ecosystems (for example, road closures and campground creation in the City of Rocks, Idaho) while others reflect management of people and access to public and private lands (see Cottonwood Canyon, Utah). There is evidence that human abuses to certain landscapes (Teapot Rock, Wyoming) are still on the rise, but so, too, are efforts to return some lands to more natural settings (for example, the Garden of the Gods, Colorado).

Changes caused by human interaction are ultimately the result of the once sparsely populated region becoming home for millions more Westerners. Growing population, the popular use of four-wheel-drive and off-road vehicles, cellphones, GPS receivers, and other technologies all close what once seemed like larger distances. Growing battles over control of the land by many interests—business, environmental, military, state, and federal agencies—have redefined the cultural map of the region. Increased tourism, a shift away from older extractive industries, and increasing demand for limited water supplies, combined with growing environmental concerns, form the groundwork for many of the visible changes.

While this is not the place for an explanation of complex western issues, our work addresses some of them by necessity. The photographs and interactive material make visible the results of what are otherwise abstract concepts. Others in fields such as history, literature, and environmental sciences are already engaged in a new look at the American West, and we see our work as contributing to a larger dialogue. We also believe that the West is a microexample of land and environmental issues that affect many parts of the nation as well as other places around the world.

Other questions that engaged us concerned the people we met through fieldwork. Many now live among the photographic icons left by the first surveys, and we found that every site has human stories. Sites once monumentalized by nineteenth-century photographs are often in someone's backyard (Castle Rock, Green River, Wyoming). The intimate knowledge of a region by its residents has changed the once common view that the West is empty geography, and in many places the land photographed has changed from frontier icon to a location under siege by urban development.

We asked how the stories we encountered confirmed or contradicted our expectations and how we could make use of them in our work. On a broader level, this was a question about how narratives describe a region, a time period, or a mythology, but it was also a practical question about how to integrate narratives with photographs.

In the 1970s, we had been interested in the stories of people we met during the RSP's fieldwork but had lacked the resources to integrate that information with images. By the time Third View began, we were able to include video and sound with photographs in one presentational form, and we could consider adding new materials to the archive of each site.

Our interests in discovering human stories at places we visited had to do ultimately with an idea about affecting the way a place is viewed. Can telling new stories about a place change the way we see it? Can new stories change human behavior?

These turned out to be bigger questions than we could answer. It will take more time to know if our thinking was on track, but our hypothesis remains the same: that changes in both human stories and behavior are happening in the West with great influence on each other. Photographers cannot escape the culturally significant role of storytellers, and one of the greatest challenges for contemporary landscape photographers is not to discover new landscapes but new stories.

THE ROLE OF NEW MEDIA

Third View may be distinguished from other rephotography projects by the materials it collected at sites. This was made possible by using media that were not easily accessible until the late 1990s. Some of our most intriguing questions concerned how to use technologies that have been commonly used singly in other documentary fields but have not been combined for use with this kind of focus. We asked how computer and electronic technologies are changing the way we see the West. What kinds of materials should we collect? What can they communicate about a place? Can we overcome the newness of the electronic medium and it's splashy façade to address real ideas and content? How can we present our fieldwork in a way that preserves the feeling of discovery we had in the field?

We found that computers and software allowed us to collect materials that could emphasize things photographs could not. This in turn made us look for different things than if we were just making photographs. For example, we collected artifacts at sites such as Teapot Rock in Wyoming only after we realized we could use them in interactive presentations of the work. At this site, the artifacts collected included real objects such as a teaspoon and a teacup handle as well as photographs and sounds. The mix of materials became a matrix around which we could understand the disparate threads of our own experiences while we were still in the field. The immediate feedback from such media as video and

sound was similar to that of the Polaroid positives we used both on this project and the RSP. The ability to see what we were doing and reflect on the results enabled us to act with greater spontaneity. The effects ranged from looking for oral histories to choosing new sites we had not previously planned to visit (for example, the Promontory, Utah, site and field notes).

We lugged computers around with us in 1998 and established a website to which materials were posted during the journey. Later, laptop computers were along on every field trip. It was possible for us to add locations we hadn't planned on visiting before the trip began. For example, in Twin Falls, Idaho, we were able to download images from the National Archives while visiting Shoshone Falls. From the city library and from our motel room, we added to our site list and actually used the image on our laptop's screen to find and line up O'Sullivan's vantage point above the falls.

We tried to use the media and the materials they allowed us to collect to provide new, even unusual contexts for the rephotographs. In many cases the history of a place and the changes it may have experienced are clarified through an interview, a text, or a video clip. For example, we were able to wrap the interconnected histories of Promontory Point, the Morton Thiokol Corporation, and artist Robert Smithson's earthwork, *Spiral Jetty*, through photos, video, and text. The rephotography alone is limited to the one site near Promontory

(Andrew J. Russell's photograph, *Big Trestle and the 119*).

Each item collected, whether photograph, sound, artifact, or video clip, could be used as one small part that stands for a larger whole, and the presentation of a site could become as poetic as it was representational. We were excited to discover how meaning could be created through combinations of seemingly disparate materials and various presentations. The problem we faced in editing and organizing this work was that there were few precedents to use as guides other than computer games and a few interactive presentations. Other drawbacks included the fast-changing pace of technology that renders programs obsolete after only a few years. We have no idea whether our electronic efforts will be readable even in the next decade.

But in spite of its drawbacks, new media allow materials to be presented in ways that are more participatory than static. The use of overlapping images in time, as seen through the "time reveal" window, was a major breakthrough in how change could be visualized. In the design of an interactive piece, a viewer can make choices about what materials to see and in what order. Enabling viewers to "discover" a site was one of the most important reasons for choosing the electronic medium as one venue for our work. We felt a viewer engaged in the experience of discovery would be more likely to explore the content and participate in its interpretation. Perhaps the best example of this is the site at Logan Springs,

Nevada (O'Sullivan made the photograph in 1871, and the site was not revisited before Third View). The materials collected at the location and presented on the project's DVD lead viewers through the same experience of discovery as the field team. We felt the site raised important issues about time, change, and our place within the West.

THE FUTURE: A FOURTH VIEW? The disappearance of the small but growing town of Logan contradicts the contemporary expectation of western urban growth and expansion. Who were the anonymous people standing in the photograph, and what happened to the seemingly solid structures of their new settlement? We found the buildings stripped to their foundations and the stones given new life in a contemporary house seen in the right-hand edge of the rephotograph. Yet like those before it, this house also was abandoned, forming a modern-day ghost town of one dwelling. Evidence indicated that a family had lived in the house until recently. Like the earlier scene, the reasons why people lived in, then left, this remote place remain a mystery. In a video made inside the house, the eerie screech of a rusty door and the evidence of a hasty retreat question the assumption that the past is safely behind us.

While neither the rephotographs nor the other materials collected at the site (see the electronic version) can explain the legacy of loss at Logan Springs, we felt they offered a lesson about histori-cal cycles. We cannot look at Logan without seeing our own era placed firmly in the course of a continuous process, in this case one showing that abandonment is also a contemporary experience. Are these simply isolated moments in time, or do they share connected histories? And if abandonment can happen in our lifetime as well as in that of a distant past, what does that imply for the security of our own expectations? It becomes easier to ask the questions: What will happen to that which now seems so permanent, what will be our future, and what will become of our dreams?

The real connections between the Logan photographs and their implications may be debated, but linking one separate moment to another is not only irresistible, it is a skill necessary for survival. We no longer have the comfort of knowing the land is the one constant that can be counted on to stay the same. What we do know about the land is that it has been changed forever, and it is only human to want to know how what has been changed will in turn change us.

The connections made between photographs and collateral materials are narratives that require participation to construct. The process enables us to envision a past or a future, and it is a powerful tool to gain a perspective, which is otherwise very difficult to achieve, about where we are now, where we have been, and where we are in relation to what is possible. The process is also a means to recognize change, the truest measure of time, and that raises questions about our values and connections to the

land. On a personal note, perhaps the ultimate lesson in revisiting these sites has been in making me more aware of the present.

The rephotographs and the questions they raise confirm the simple idea that it is not possible to see any place the same way twice or even three times. The photographs can never be the same, and that is the point. Each time and place is unique, and a new view is a call to face the responsibilities of the moment.

Third Views
SECOND SIGHTS

Plates

Silverton sits in a bowl-like depression high in the San Juan Mountains. W. H. Jackson's views show the young mining town of Silverton located nearly in the center of a volcanic caldera. The newer versions of the panorama split a recently reroofed house in the foreground. In 1997 the owner of the house, Bob Ward, was a retired hard-rock miner who had worked for years in the local mines extracting gold, silver, lead, zinc, copper, and antimony. He suffered from silicosis, also known as miners' consumption or "miners' con" for short, and was connected to an oxygen tank when the field team asked for permission to make the photograph. In the years since that visit he has passed away.

Although the permanent population of five hundred residents is small compared to the Silverton of Jackson's original photograph, the town has grown since the second view and more houses now dot the background streets.

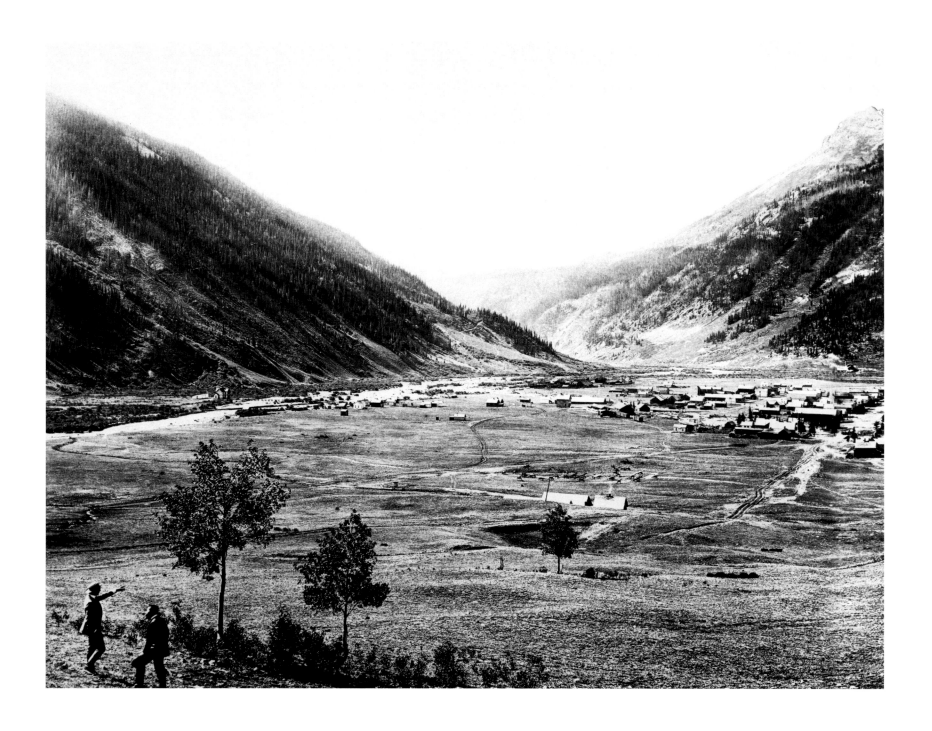

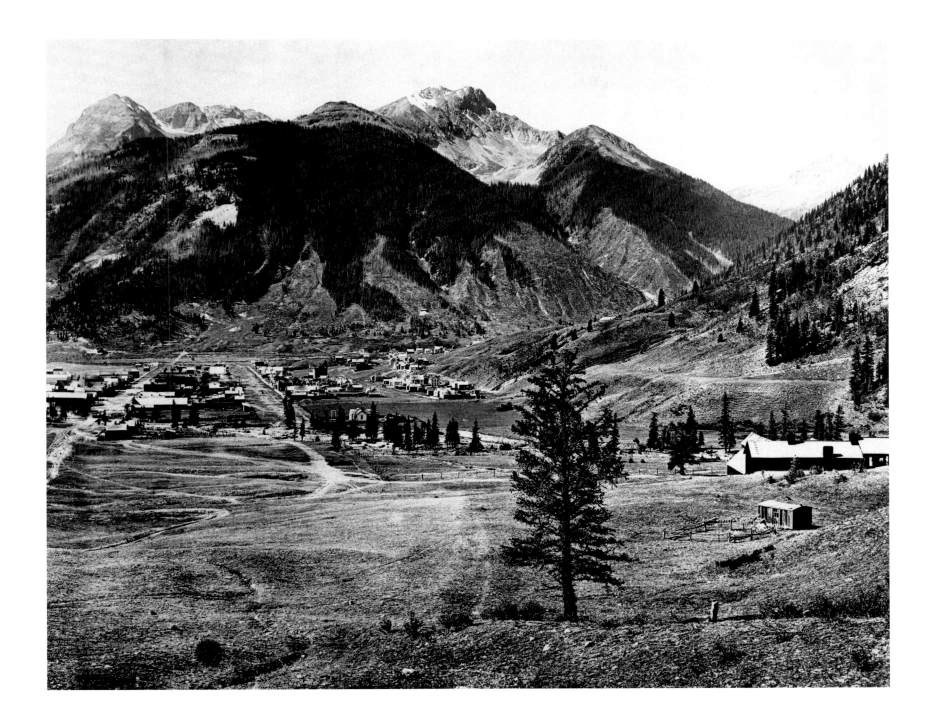

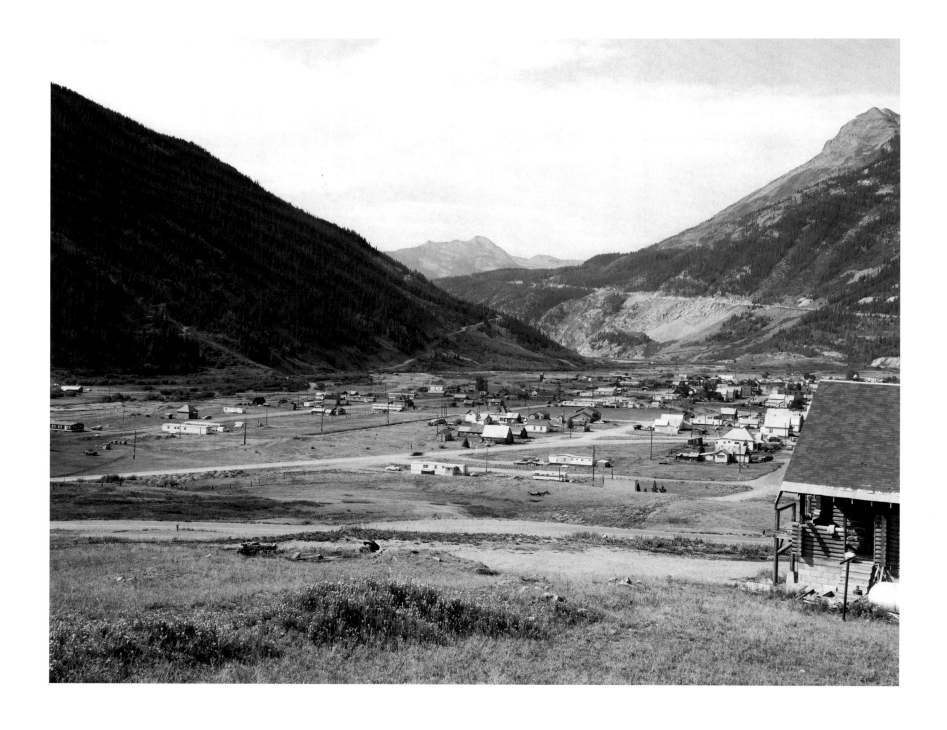

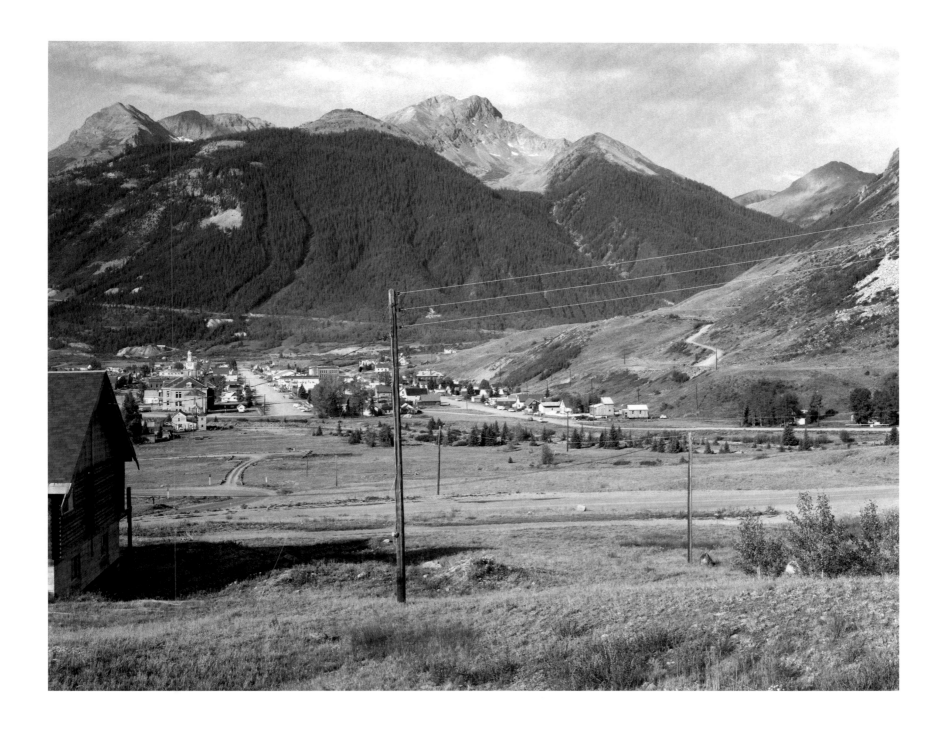

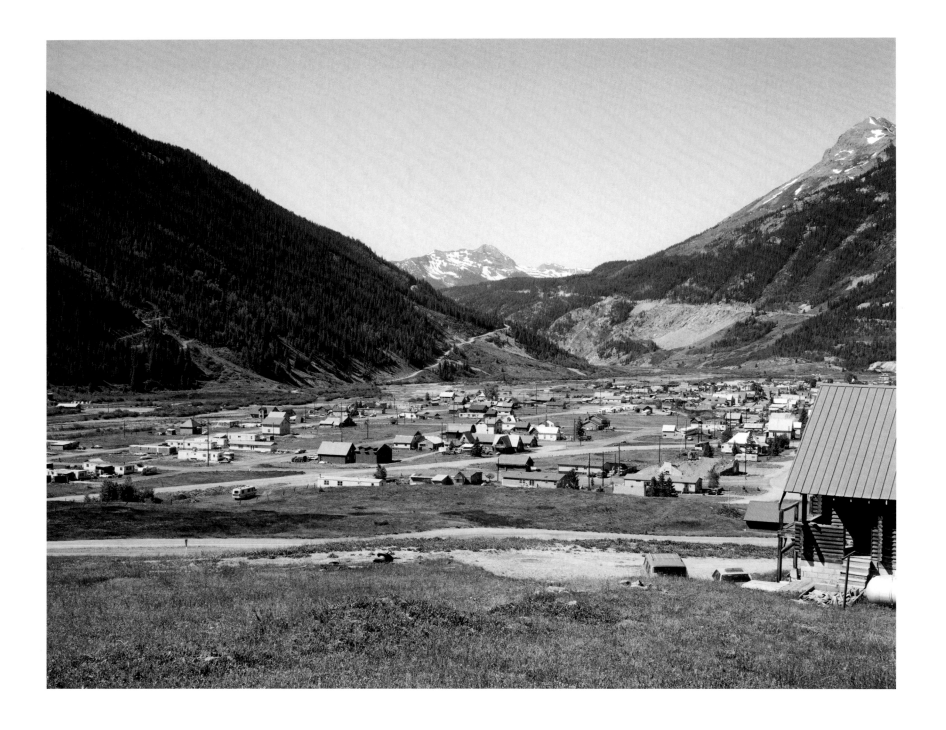

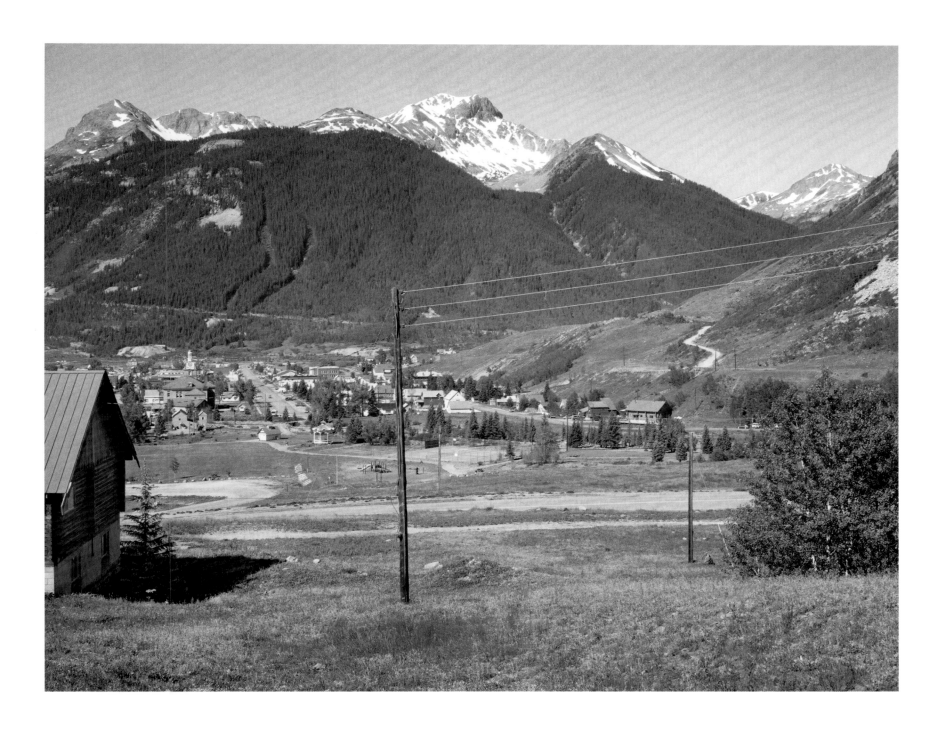

SULTAN MOUNTAIN, COLORADO

Sultan Mountain rises more than thirteen thousand feet behind the town of Silverton. The basin in which Silverton sits originally was named Baker's Park after Captain Charles Baker, who was chased away by the Ute people for invading their native hunting grounds.

Rephotographic Survey Project photographer Gordon Bushaw made the second view in 1978, and it shows evidence of significant mining activities throughout the middle ground, much of which occurred before 1991. The third view indicates a substantial decline in mining as the same terrain is reclaimed by vegetation. Tourism is now the primary economic activity for the town.

The bottom right foreground of the second view indicates blowing dust and sand—also a problem during the making of the third view, as strong winds violently shook the camera during the exposures. Third View team members Kyle Bajakian and Byron Wolfe found themselves ill prepared for the quickly changing weather and suffered from dehydration, windburn, and sunburn, a testament to the often dangerous and unpredictable conditions at higher elevations in the Rockies.

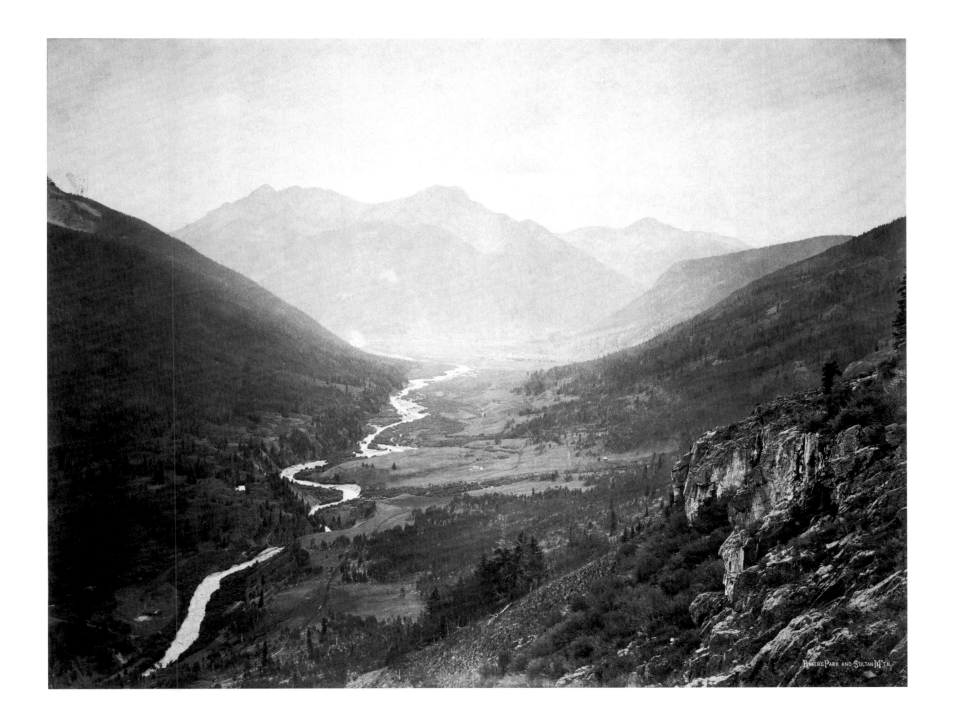

BAKER'S PARK AND SULTAN M'T'N.

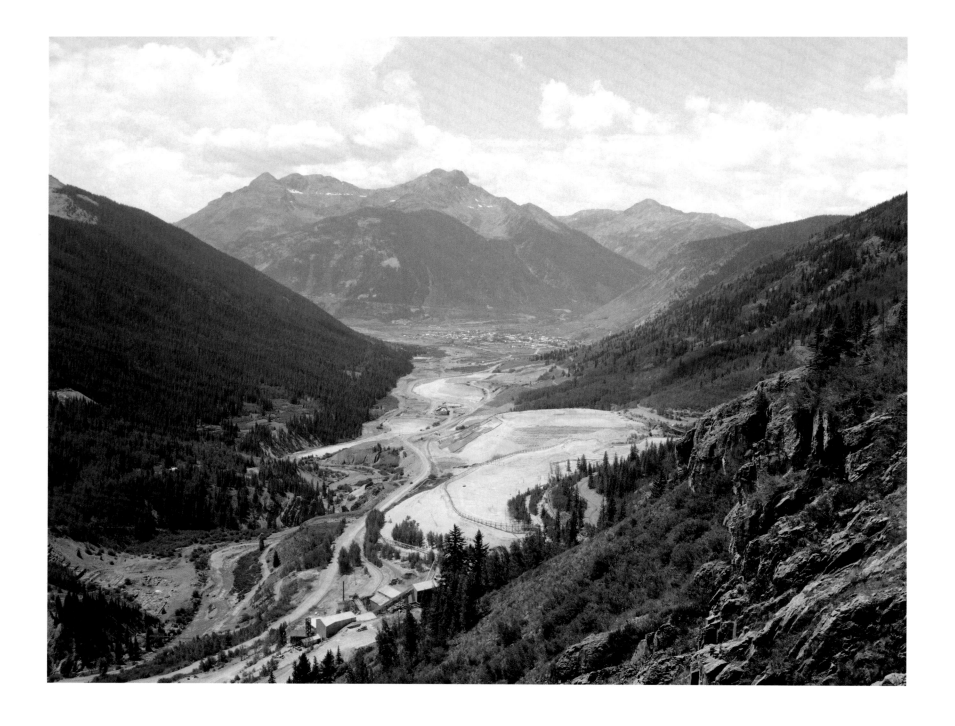

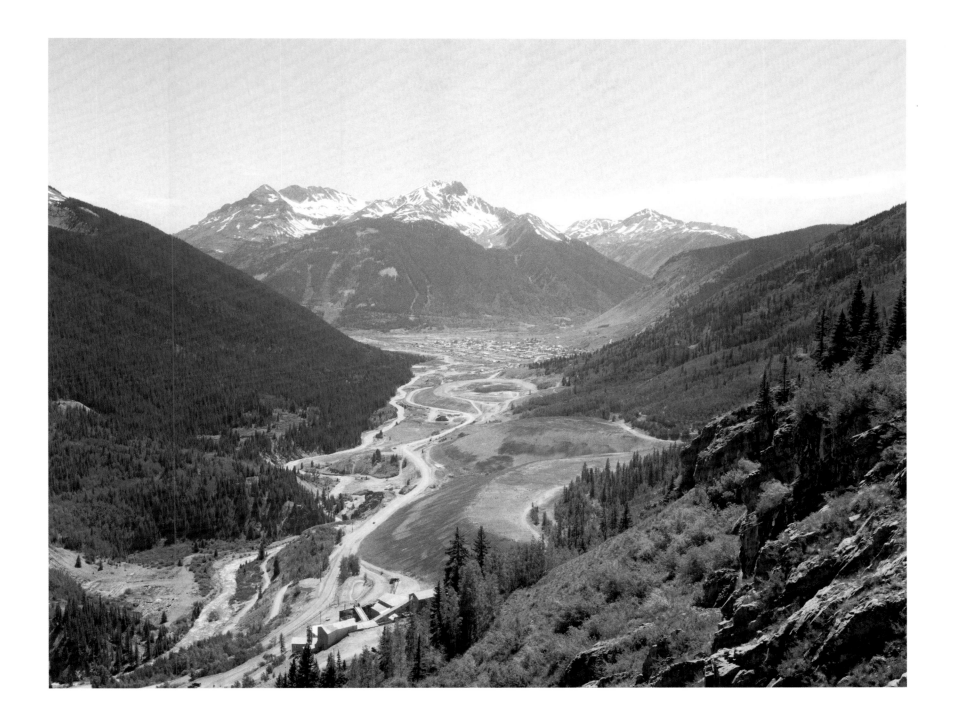

GATEWAY, GARDEN OF THE GODS, COLORADO

The Garden of the Gods is a city park in Colorado Springs. Third View visited this and another site in the park (Montezuma's Cathedral) on the Fourth of July weekend 1997. The Gateway view was made against a sandstone wall, and the camera had to be mounted very high on the tripod because the ground had been slightly lowered by erosion or earthmoving. The Jackson photographs show a well-grazed foreground with a wagon trail crossing from left to right. By 1977 a paved road passed within a few feet of the vantage point, roughly following the same route, and carried drivers through the gate created by the two rock walls in the middle distance. By 1997 the paved road had been removed, though remnants still can be seen of the roadbed and the large rocks that aligned the curb. The park roads were redesigned to circle the park, and the interior areas became accessible only by walking paths. Vegetation growth has increased progressively, and shrubs now obscure the rock outcrop in the center of the gateway.

There were many park visitors on the holiday weekend, and they included climbers, hikers, nature study groups, painters, photographers, and many foreign tourists. Some of the scenes the field team witnessed included a pair of teenage climbers hurriedly driving their car into the parking lot, narrowly missing a woman and child in haste as the driver screamed in both justification and defiance, "I WANT TO CLIMB!" A woman joining a free guided nature walk quizzed her child: "Do you think you can stand being in nature for forty-five minutes without TV or a stereo?" A group of Japanese tourists posed in the middle of the gateway for their photograph.

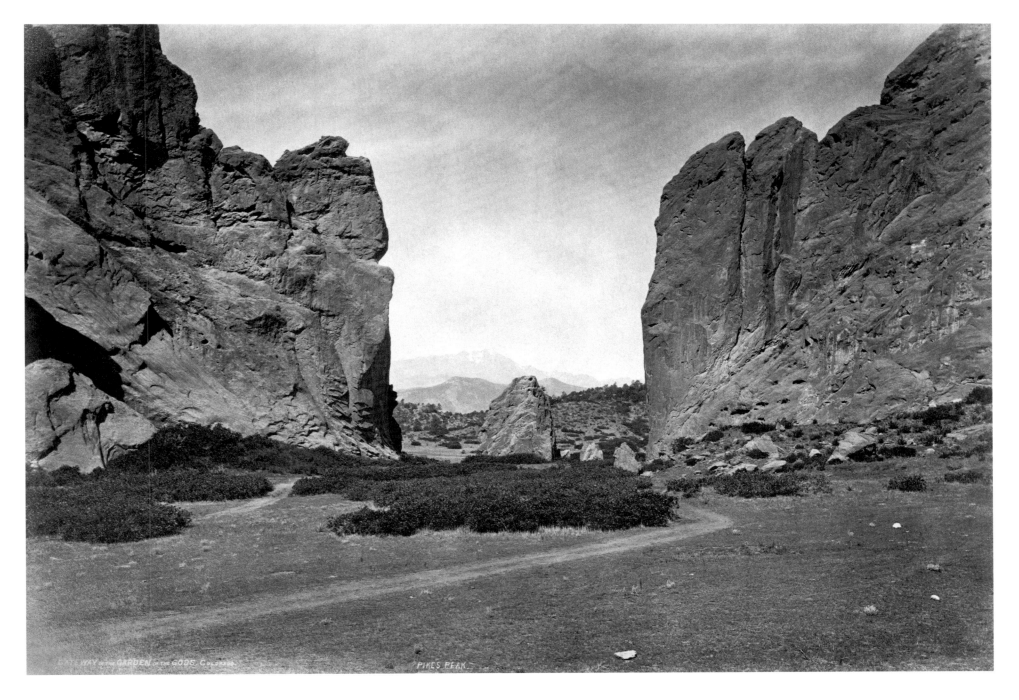

GATEWAY OF THE GARDEN OF THE GODS, COLORADO. PIKE'S PEAK.

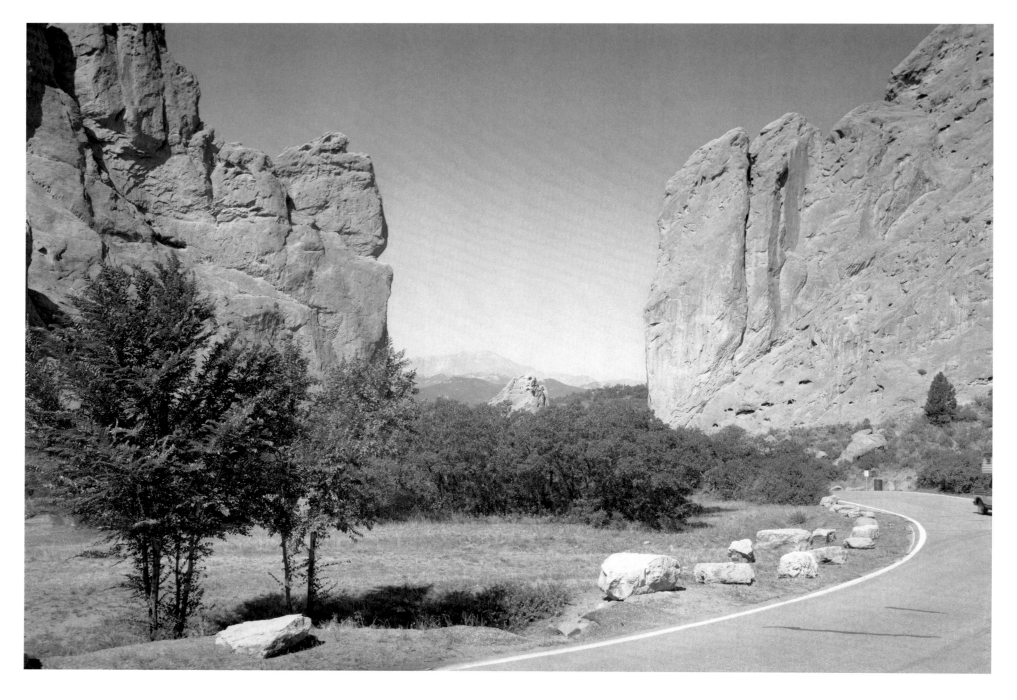

Jackson's photograph was made north of Colorado Springs in an area dotted with housing developments. The three sandstone formations sit above the backyard of a private home on Woodman Road. The Rephotographic Survey Project had visited this site in 1977, and since that time there had been speculation about what had happened to the rock in the middle of the group. One story stated the rock had been deliberately cut off to adorn the driveway of a local country club. Mr. and Mrs. Barron, who own the property, told us the top had fallen naturally before they built their house in the 1960s. Later, one of their sons had tried unsuccessfully, using a jeep winch, to haul one of the flat rocks back onto the top of the remaining rock column.

The Barrons understood the historical and visual legacies of their backyard. Before we left, Mrs. Barron produced a postcard of a Thomas Moran painting made of one of the three rocks, an image fashioned after one of Jackson's 1873 photographs.

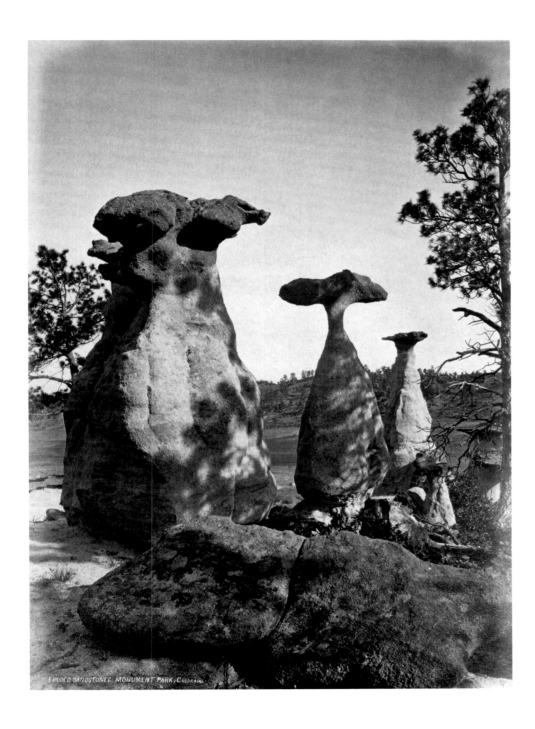

ERODED SANDSTONES, MONUMENT PARK, COLORADO.

35

TWIN LAKES, COLORADO

This view of the Upper Twin Lake was made on the thin gravel spit that divides the Upper from the Lower Twin Lake. In the years between 1977 and 1997, a dam at the east end of the lake was reconstructed, and the water level rose. The land dividing the two lakes, including the camera's vantage point, eroded. All that remains of the foreground in the 1977 photograph is the small clump of earth at the bottom left of the image. The gravel bar on which Jackson's figure stood fishing has been covered by water.

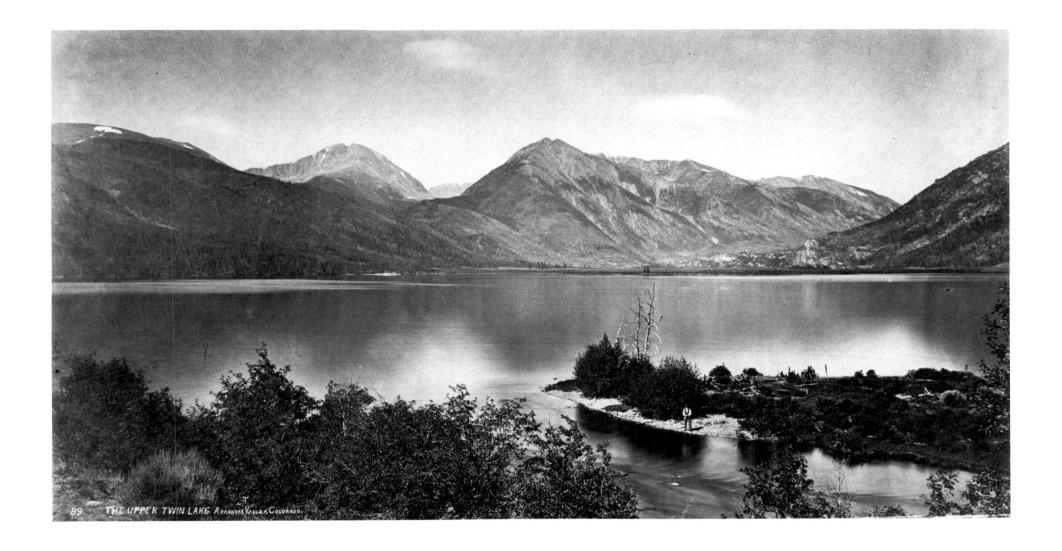

89　THE UPPER TWIN LAKE. Arkansas Valley, Colorado.

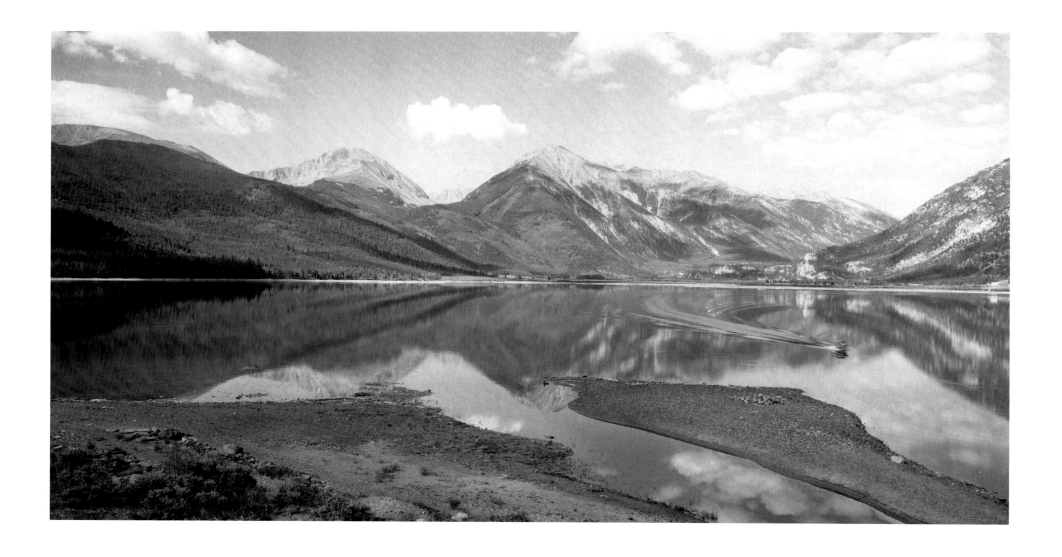

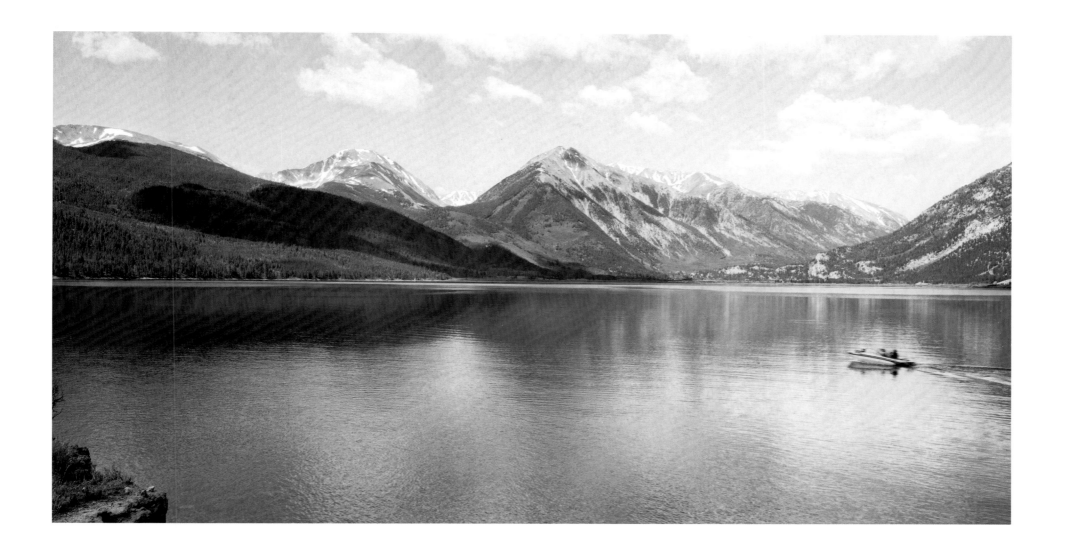

When O'Sullivan photographed the Wasatch Mountains and Camp Douglas in 1869, a small number of houses occupied the background of his photograph. They would form the early development of Salt Lake City, dwarfed by the mountains behind. In 1978 the city's growth had extended to the middle ground of the second view. The vantage point was on a grassy slope north of the state capitol building, where the land had been more difficult to develop. This had changed by the time of the third view, and urban growth moved directly in front of the camera.

We recorded a brief statement from the owner of a lot in this new housing development called Dorchester Pointe, a gated community. He refers to the opening of the property with lots selling in the first few weeks and the interstate highway construction slated for completion in time for the Salt Lake Winter Olympics of 2002. "It's hard to find prop-erty," the owner says. "It's going really fast." Coincidentally, the same day, while driving in traffic after leaving the site, we recorded a clip from National Public Radio's "Talk of the Nation" pro-gram about such communities: "Gates are going up all across America. Some old neighborhoods are closing themselves in, and many new subdivisions are walled off from the traffic and, they hope, the crime of the world at large. . . . More than three mil-lion homes are already behind closed gates, and new gated communities are going up all the time. . . ."

The Salt Lake City photographs show the kind of growth evident in rephotographs made in or near all urban areas visited by Third View, and the three views follow the experience of anyone living in the contemporary West. However, the photographs from Logan Springs, Nevada, may be contrasted with these Salt Lake City photographs, showing the opposite side of western population growth.

Located on Interstate 84 in Weber Canyon, Utah, Devil's Slide is a geologic roadside feature warranting a newly redesigned pullout on the eastbound lane and interpretive plaques. The rocks, parallel walls of an old volcanic dike, were first photographed by nineteenth-century photographers making scenic views along the railroad route passing through nearby Echo Canyon. Jackson made his photograph, with printed-in clouds, sometime later than his first visit to the area in 1869. The site is roughly seventy-five miles east of Promontory, where the meeting of the rails connected the East and West Coasts in 1869.

Changes between the second and third views include a realignment of the highway rest area, including protective railings in front of the creek at the base of the slide. Materials collected at the site include an interview with a man who had stopped his recreational vehicle to take in the scene. He usually stops at such natural attractions, he said, when they're by the side of the road.

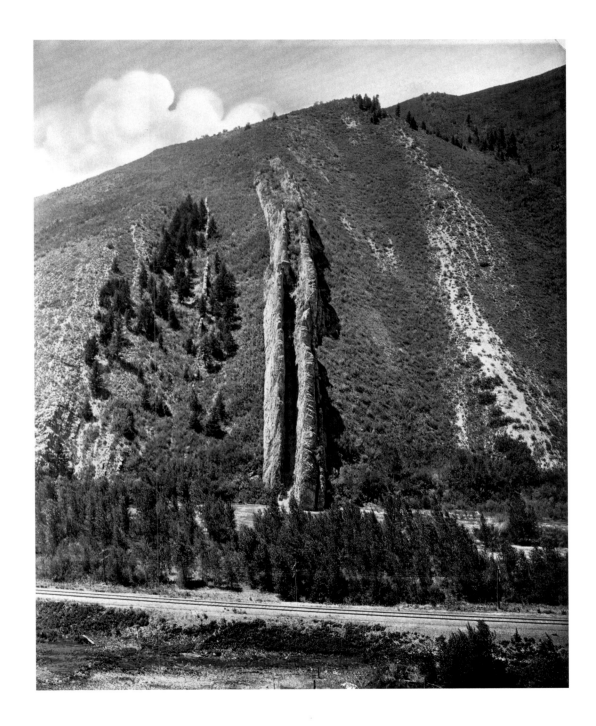

45

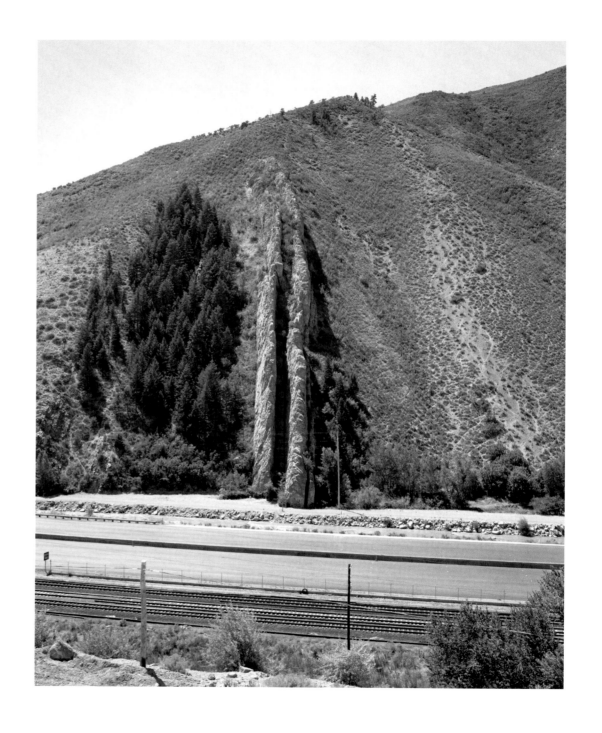

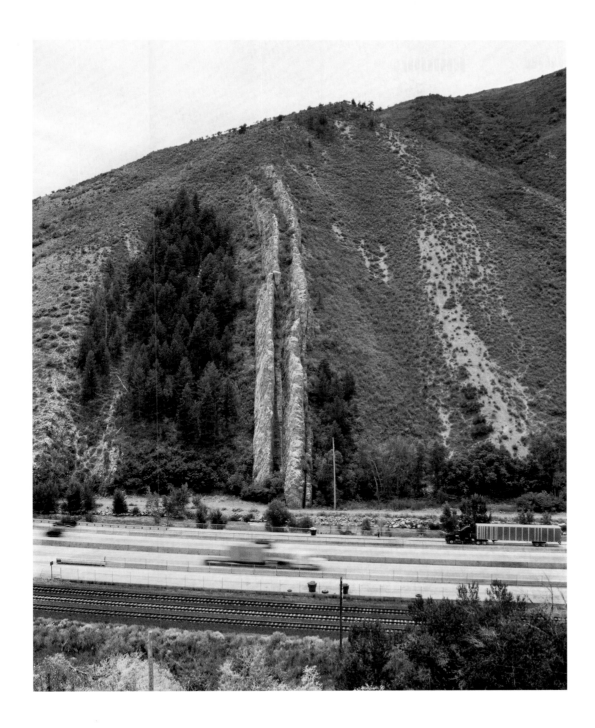

O'Sullivan tilted his camera to make the original photograph of this scene, and it was documented in 1978 by the rectangle drawn around the framing of his view. Both the second and third views were made with level cameras and wide-angle lenses to indicate O'Sullivan's framing. No one is certain why he tilted the camera, which seemed contrary to the assumption that early survey work faithfully documented geological features. He may have wanted to enhance his composition by making the horizon less of a diagonal across the scene. Or he may have liked the somewhat disorienting feeling one gets when looking at the rocks in the photo, something akin to the actual experience of being at the site. In any case, it was evident that O'Sullivan made many choices about how to make photographs, which underscores the idea that photographers are not simply witnesses to the scenes they photograph but active participants. O'Sullivan, in fact, made several views of these rocks, photographing them from different angles and circumnavigating the site. Other photographs from this group include *Conglomerate Column, Weber Valley, Utah,* or what is known as the "Drumstick" seen on the left side of this photograph.

The rocks themselves are remnants of a conglomerate that overlooks the valley to the south, the railroad tracks, and Interstate 84. They are located about five miles from Devil's Slide and were photographed by many nineteenth-century photographers, including Jackson and O'Sullivan. In one of the more surprising botanical changes seen in the years between the second and third views, the sagebrush in the 1978 view has almost entirely disappeared. We found no one who knew the reason for this change, but expert botanists not at the scene speculated that a fire probably had swept through this hillside.

Artifacts found below the rocks included a toy dinosaur in a hole in the "Drumstick"; the five-inch plastic figure held a sign that read "Take Two." Below the base of the rock we found a broken record, *A Place for My Stuff,* by George Carlin.

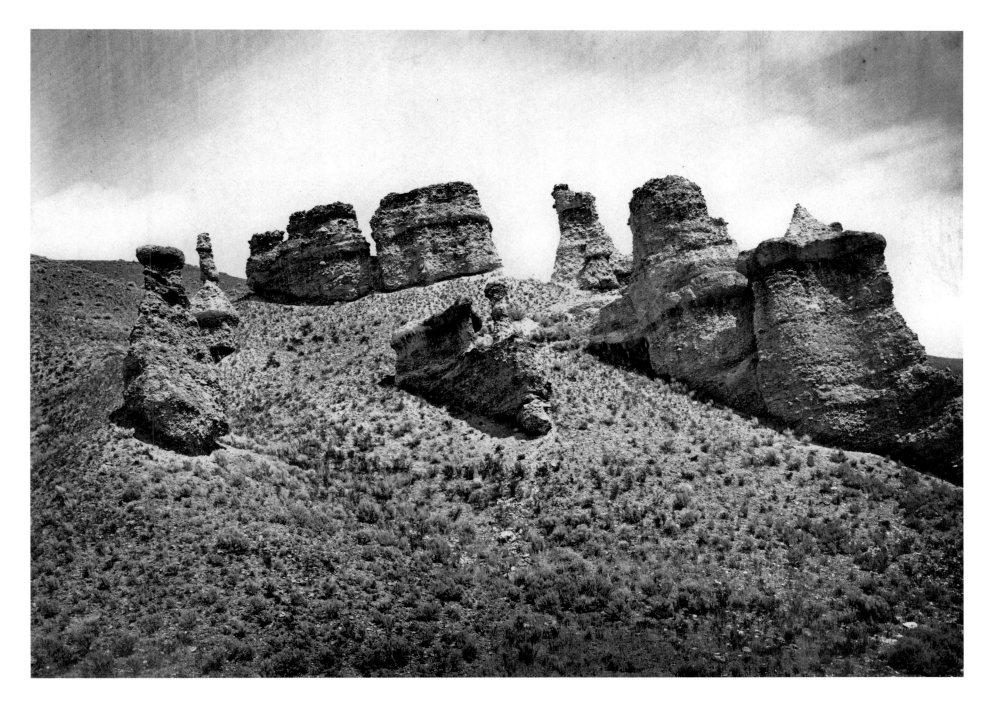

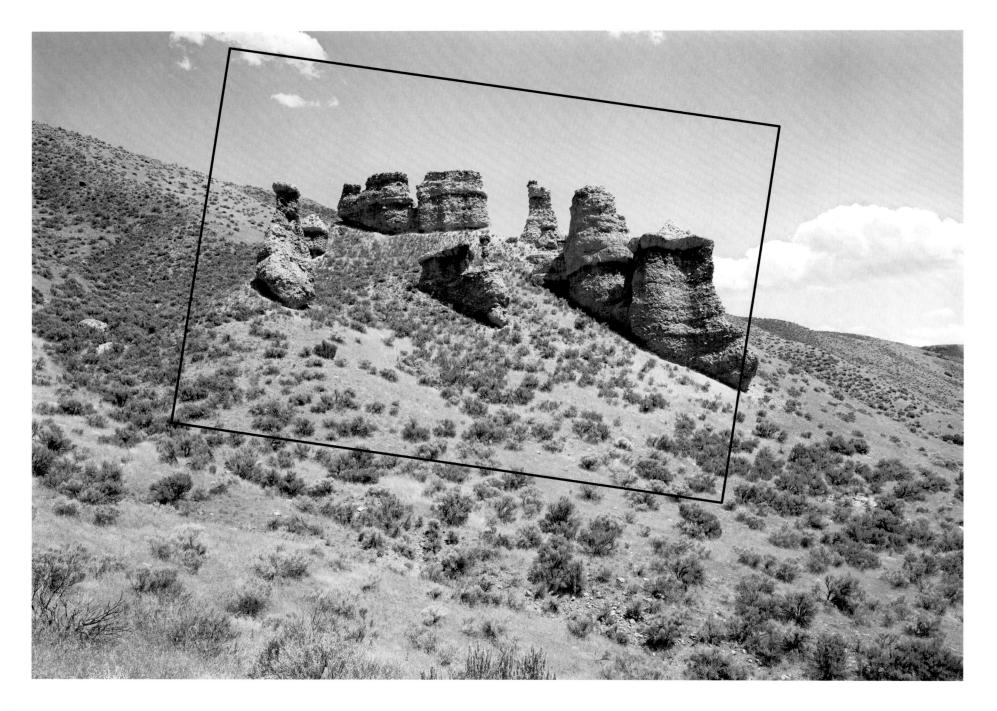

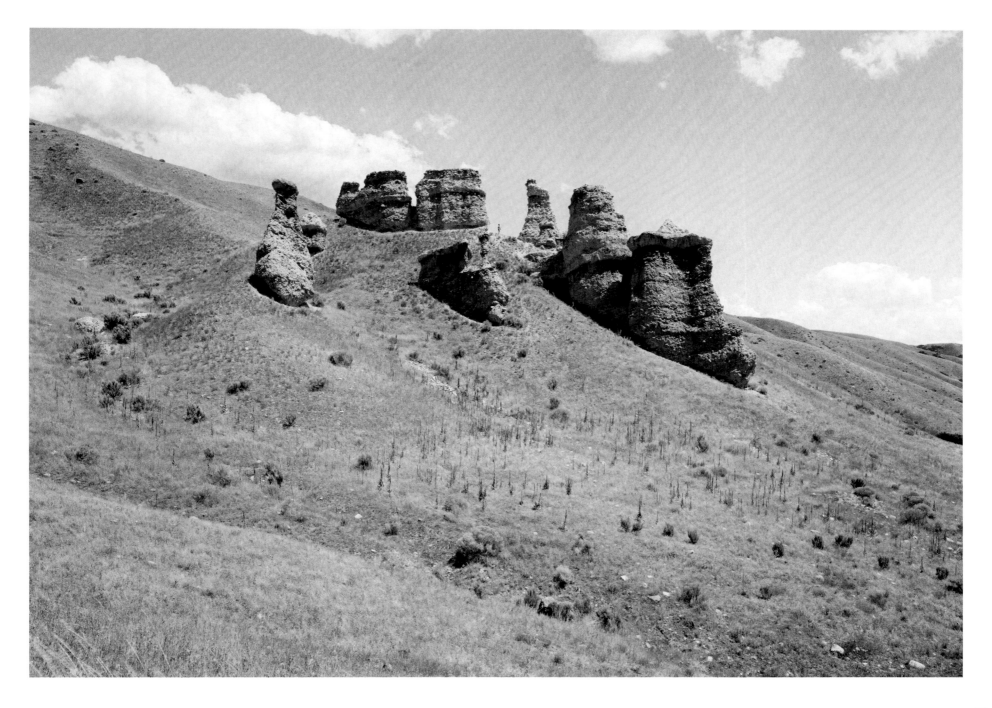

HANGING ROCK, ECHO CANYON, UTAH

Russell's photograph, *Hanging Rock,* illustrates how a photographer, by carefully choosing a vantage point, may create an interesting photograph out of a feature that isn't particularly impressive in scale. The figure appears to be sitting in a cave, but the overhang was actually very shallow and the photographer's perspective and use of a figure created the illusion of a larger feature. The rock to the left in Russell's photo, Pulpit Rock, was one of the most photographed subjects in Echo Canyon, and the railroad tracks ran directly below the foot of this rock (for more, see the entry for Pulpit Rock).

There were great changes between the first and second views, including the removal of Pulpit Rock. The interstate highways were built and displaced the river (I-80 and I-84 meet just to the left of the picture frame). Yet in spite of massive change all around, the farm is located in the same place.

Little appeared to have changed in twenty years since the second view, with the exception of a large house built on top of the hill on the other side of the valley. The outbuildings of the farm also have changed location.

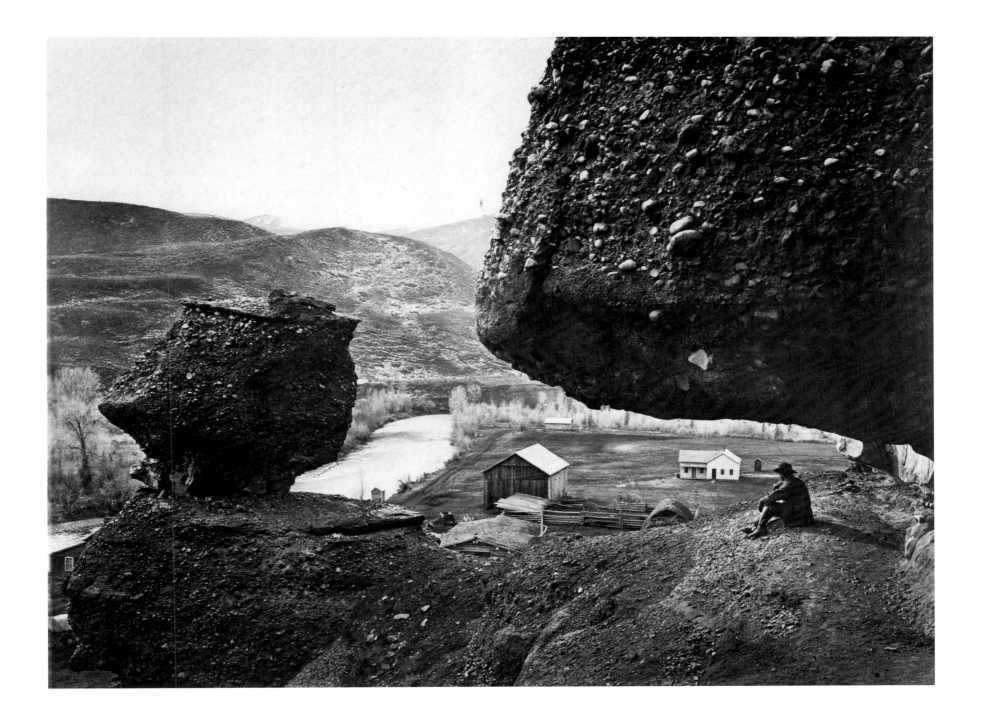

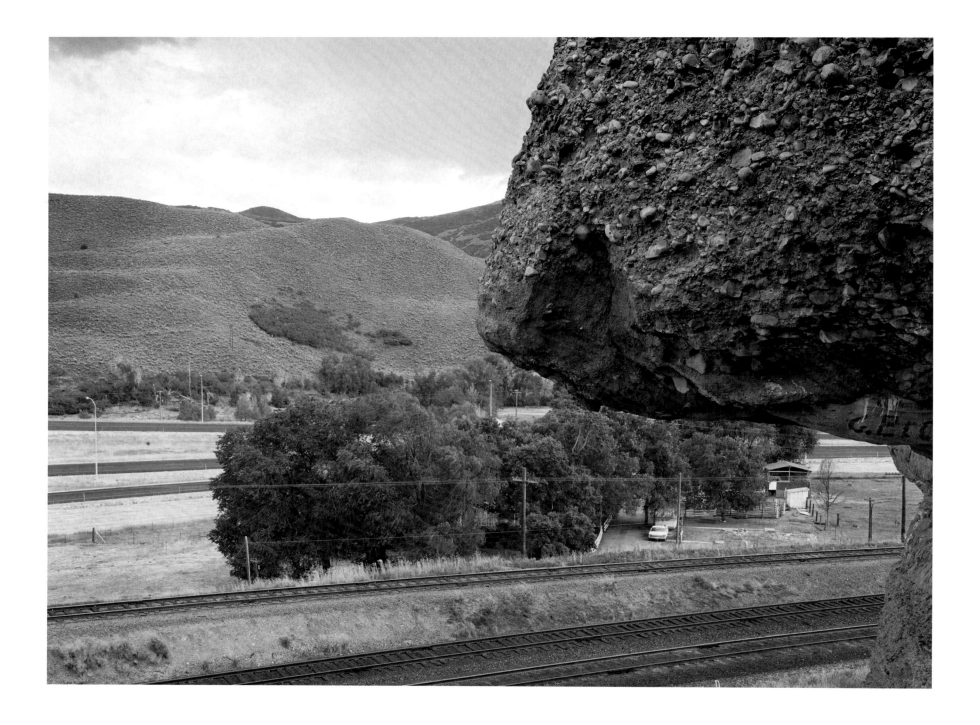

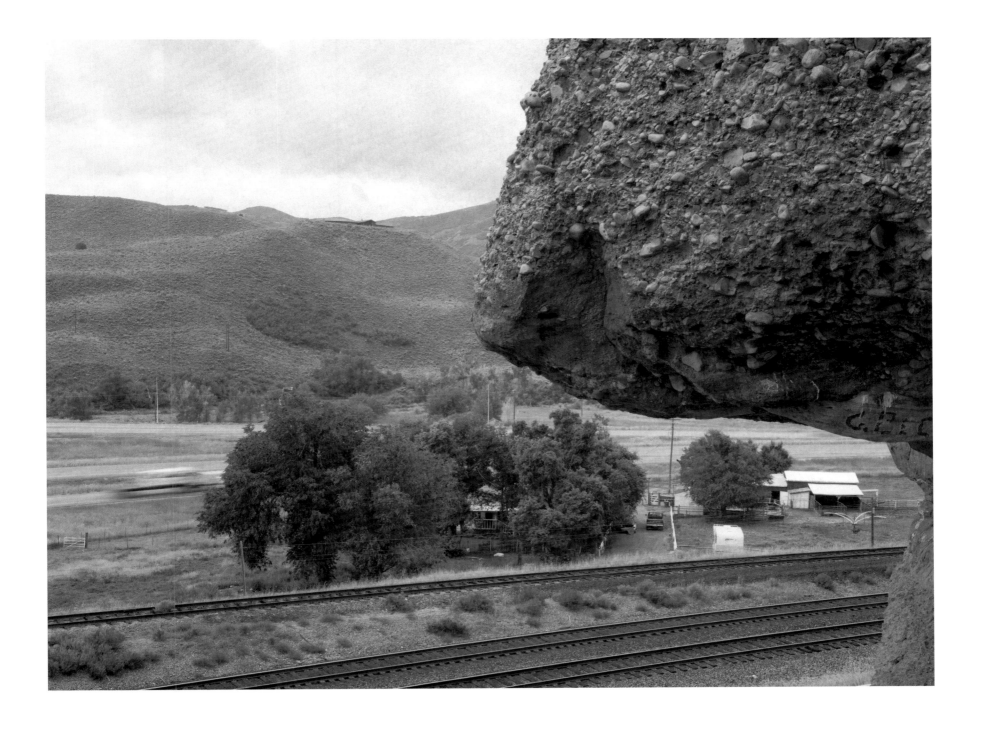

PULPIT ROCK, ECHO CANYON, UTAH

The field team interviewed the owner of the property that held Pulpit Rock, Frank Cattelan, who also owned the local cafe and gas station, was president of the local historical society, and planned to run for mayor of Echo. Cattelan related the tale of Pulpit Rock's demise to Kyle Bajakian, who recorded his story. The rock loomed over both the paved highway and the railroad, and in the 1930s a decision was made to remove it. Cattelan states:

> I think that was blow'd down in about '39, '38, might have been a little before that. This guy, they said his name was Frank Fink from Fallon, Nevada, come over here. And he was the powder man to blow that up. . . .
>
> The railroad says now we don't care if you're going to blow the rock down. . . . I guess the road wanted to get rid of it, but the railroad wanted to get rid of it, too, because it was hanging a little over the track there. . . .

And so, after drilling on it for about five or six months or whatever he had to do, he [Frank Fink] told this Mr. Wheelwright, "Well, you can hit the plunger down and the rock will go." Only when he hit the plunger, he covered the whole track and everything. But the funny thing about it was that Frank Fink, he went right down to the hotel here, grabbed his suitcase, and left. Didn't even pick up his paycheck.

But they found out later, when they was workin' it, the railroad had loaded that rock already . . . there was a double load of dynamite. . . . So it was lucky they didn't get killed drilling into that thing!

The road in the second and third views is now a local road paralleling Interstate 80 just to the south. Between these is the expanded and still active route of the Union Pacific Railroad.

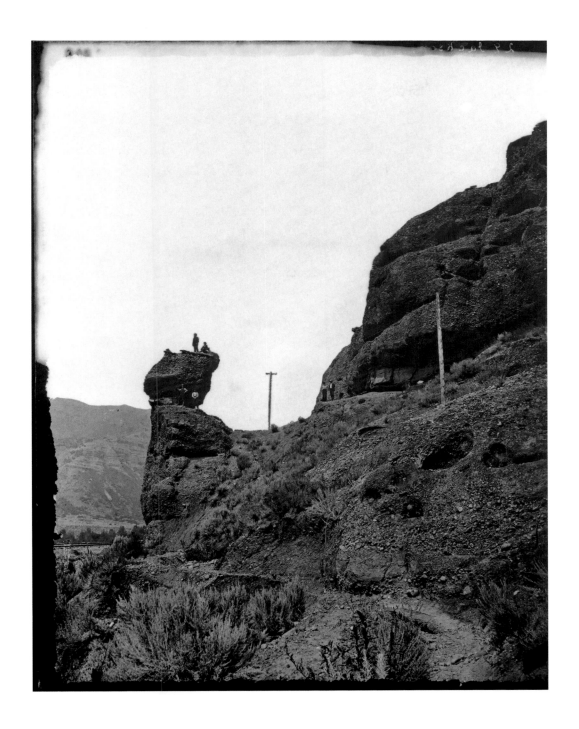

57

"This house has been in our family all my life," said Sharon Rhodes, the owner of the house central to what was O'Sullivan's view below Castle Rock. "When we were kids we would spend days on days up here playing at Castle Rock. We'd take like a bottle of Flavorade or water and some graham crackers, and we'd go up there and play all day. Anyway, well, now once in a while you'll see kids go up there, but when they do they're usually up to mischief, throwing rocks or whatever."

The city of Green River expanded long ago to the base of Castle Rock, one of the most prominent features of the bluffs overlooking this early railroad town. Interstate 80 passes though a tunnel cut into the hill below the rock and above the homes in the photo. The rock is still a symbol of the community. The local diner calls its hamburger special the "Castle Rock Burger."

The houses in the second and third photographs have changed little in twenty years. Gardens have been planted, hedges grown and/or trimmed. The same decorative bottles can be seen in the kitchen window of the Rhodes home.

The vantage point is located in a church parking lot. In 1979 it was called the Green River Bible Church; in 1997 it was a Protestant church serving Asian immigrants to the area.

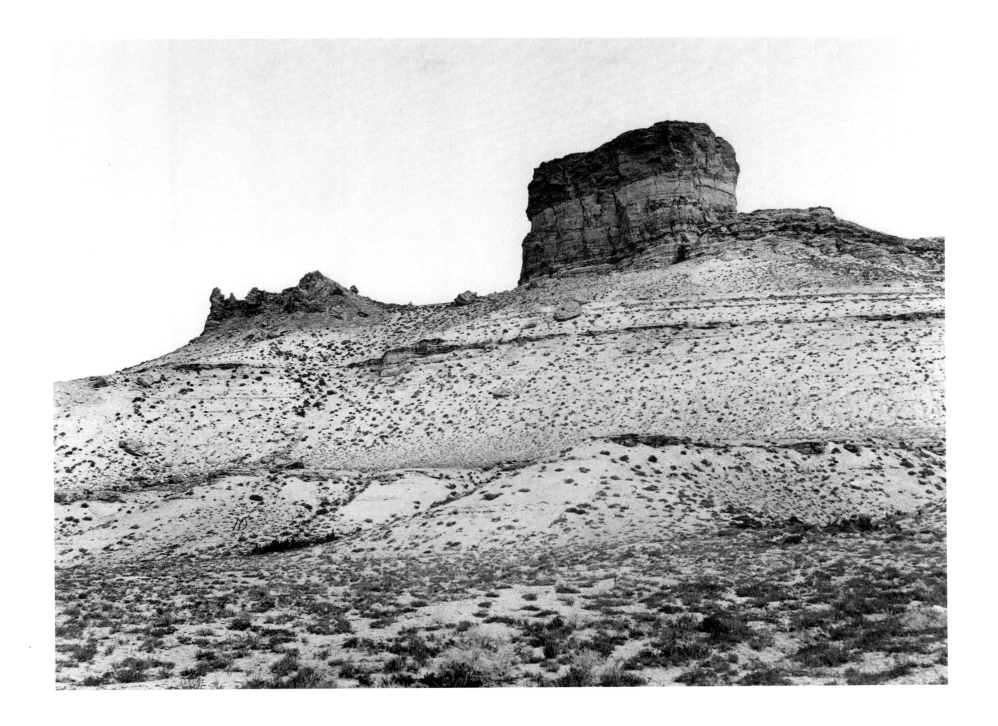

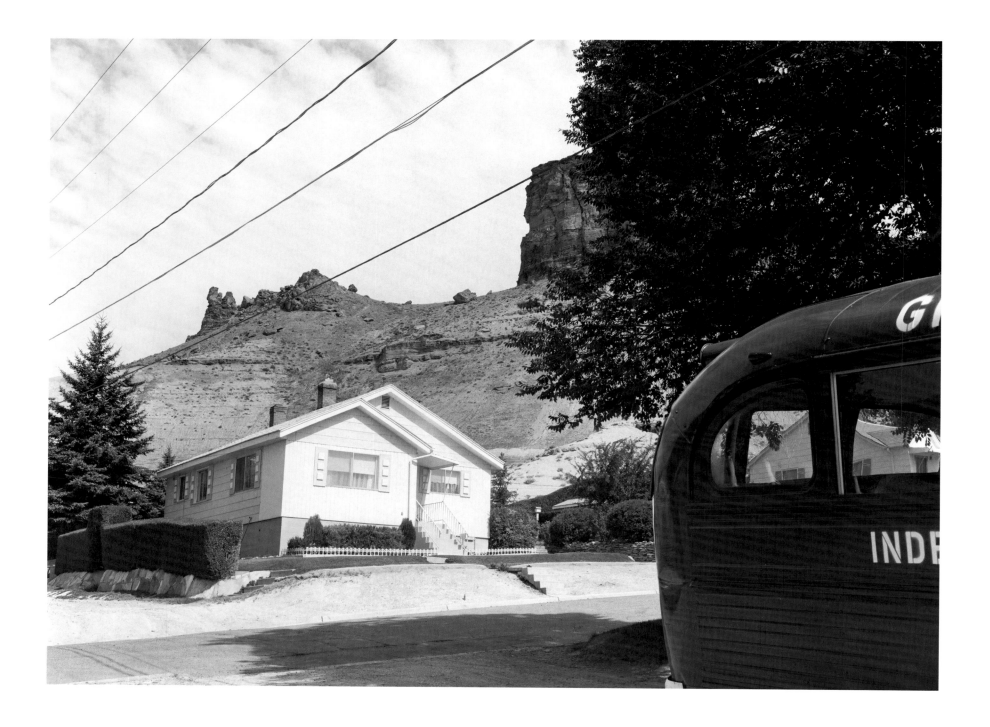

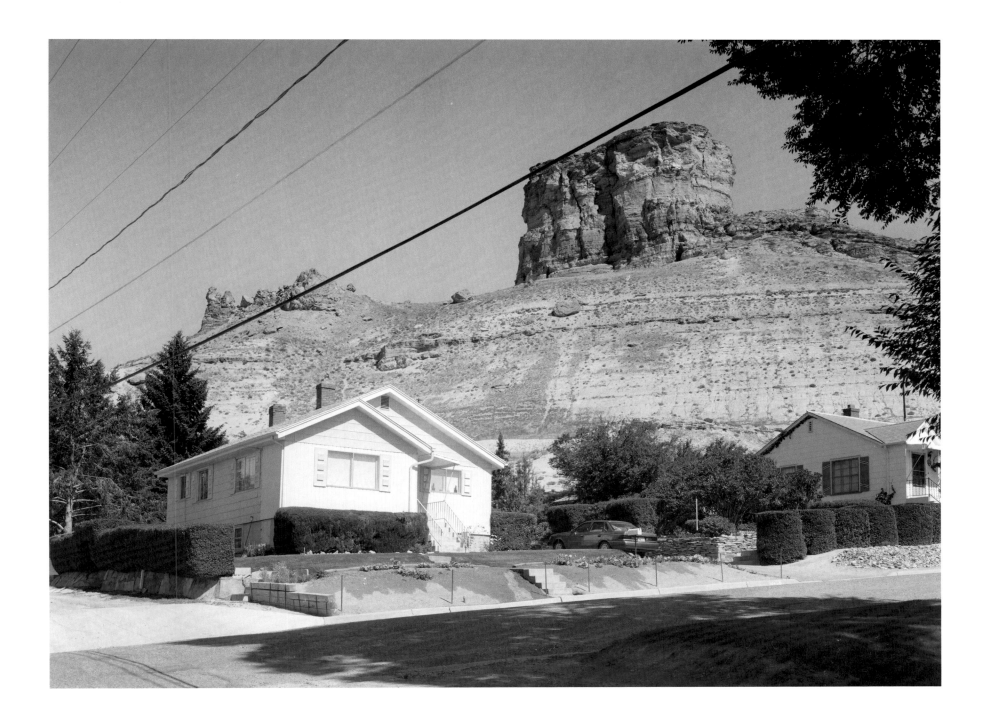

TEAPOT ROCK, GREEN RIVER, WYOMING

Perhaps the second most photographed rock formation besides Castle Rock in Green River, the Teapot was so named for its resemblance to a teakettle in profile. O'Sullivan photographed the Teapot from several vantage points, including the rock form to the north that was labeled the "Sugar Bowl."

Both rocks are clearly visible from Interstate 80 on the northern edge of Green River. Between the second and third views new roads have been started and old roads have been enlarged. A graded gravel road crosses below the interstate highway near the base of the rocks, and a dirt road has been cut below Teapot Rock leading to an overlook on its south side. Drivers climbing the steeper portion of the hill have carved out several four-wheel-drive routes that lead to level ground between the rocks. From the artifacts found at the site, the location appears to be a favorite spot for climbing and partying.

Artifacts found below Teapot Rock include a teacup handle, a broken teaspoon, a badge with the name "Tony," a flashlight peppered by a shotgun blast, and spent fireworks' casings (brand name: "Magnum Repeater"). A photo album was found in the sagebrush along a dirt road on the bluffs east of the rocks; it included a sonogram and pictures of a newborn baby and a funeral.

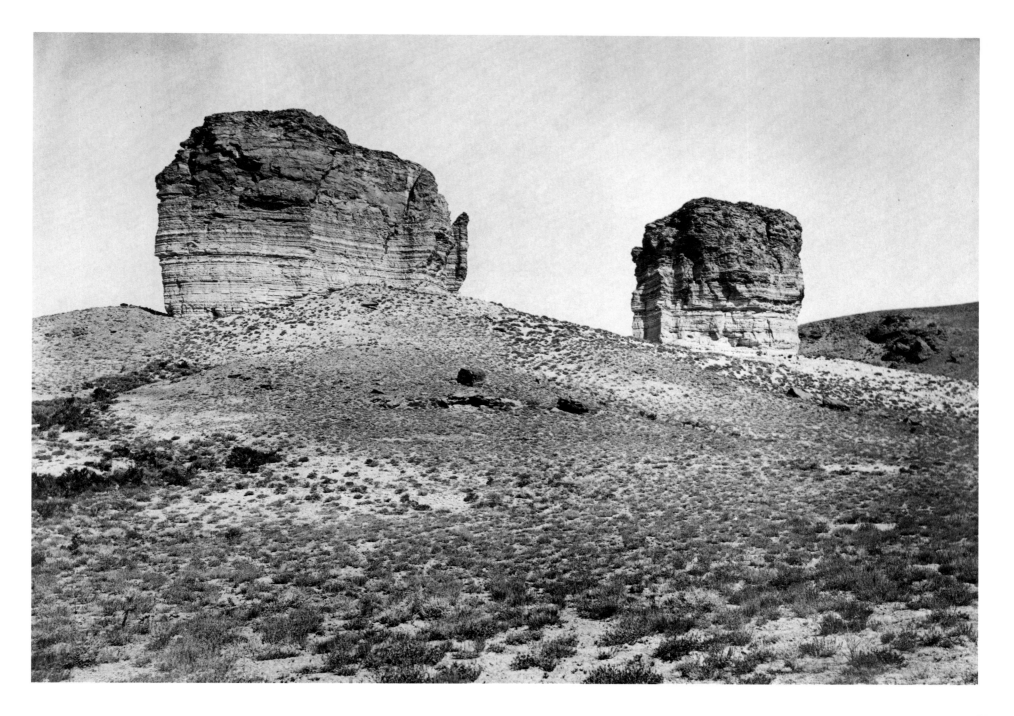

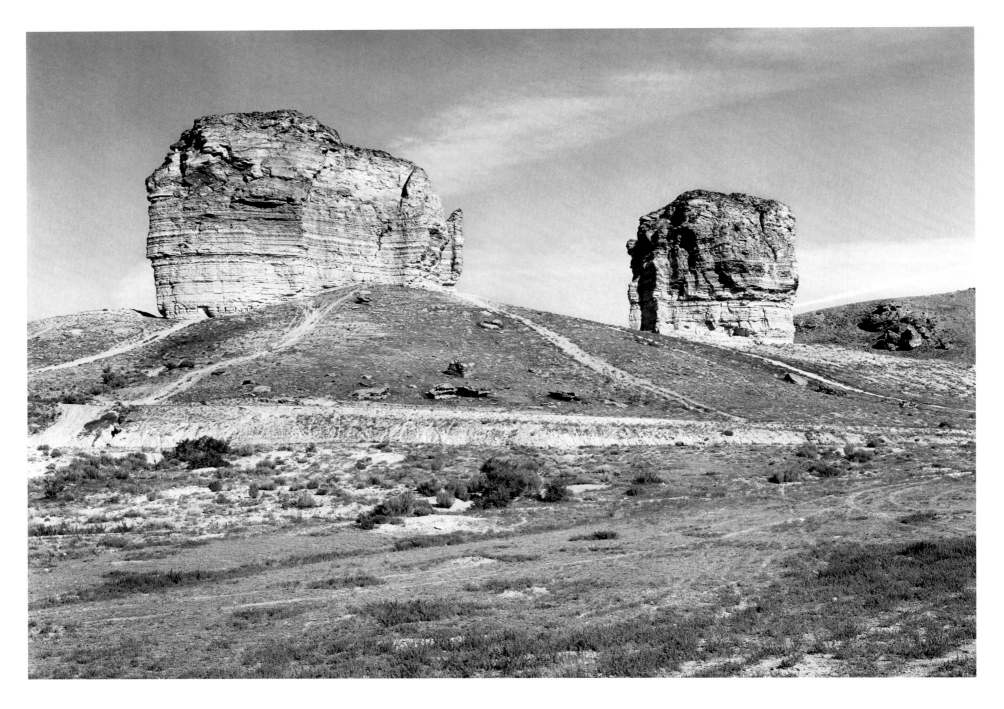

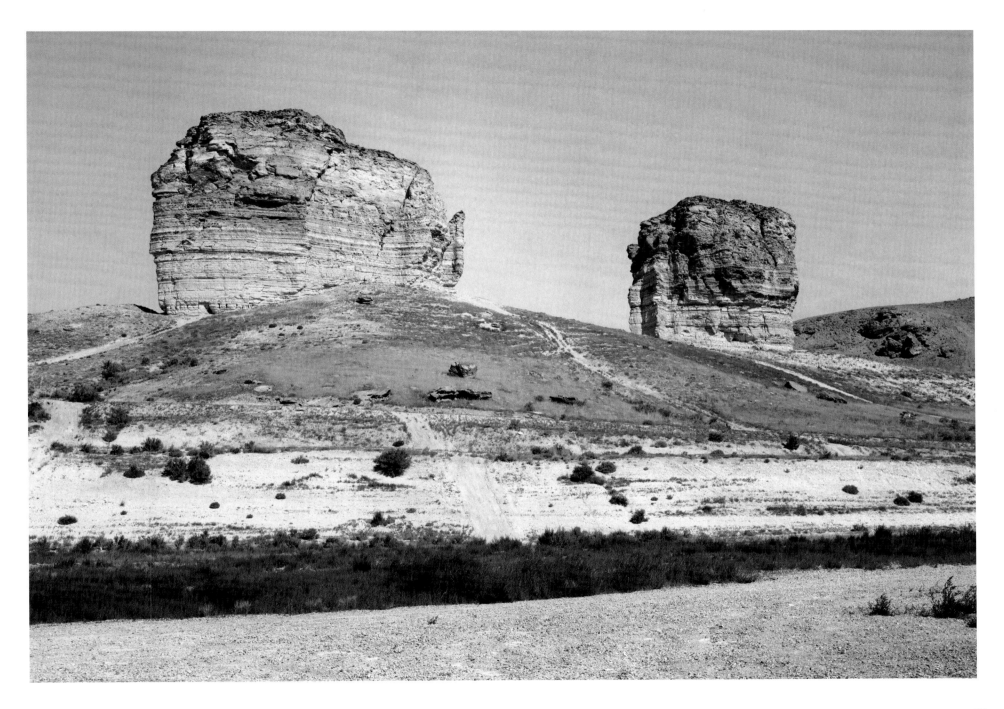

GREEN RIVER BUTTE AND BRIDGE FROM ACROSS THE RIVER, WYOMING

The confluence of the Green River and the intercontinental railroad made this a historic place. Jackson photographed the railroad bridge over the Green River, as did many of his contemporaries, including A. J. Russell. The bridge is near the site where John Wesley Powell set off on the first rafting trip down the Colorado River and where painter Thomas Moran depicted *The Bluffs of Green River*.

This railroad crossing is still very active. Behind the vantage point is a newly constructed water treatment plant for the city.

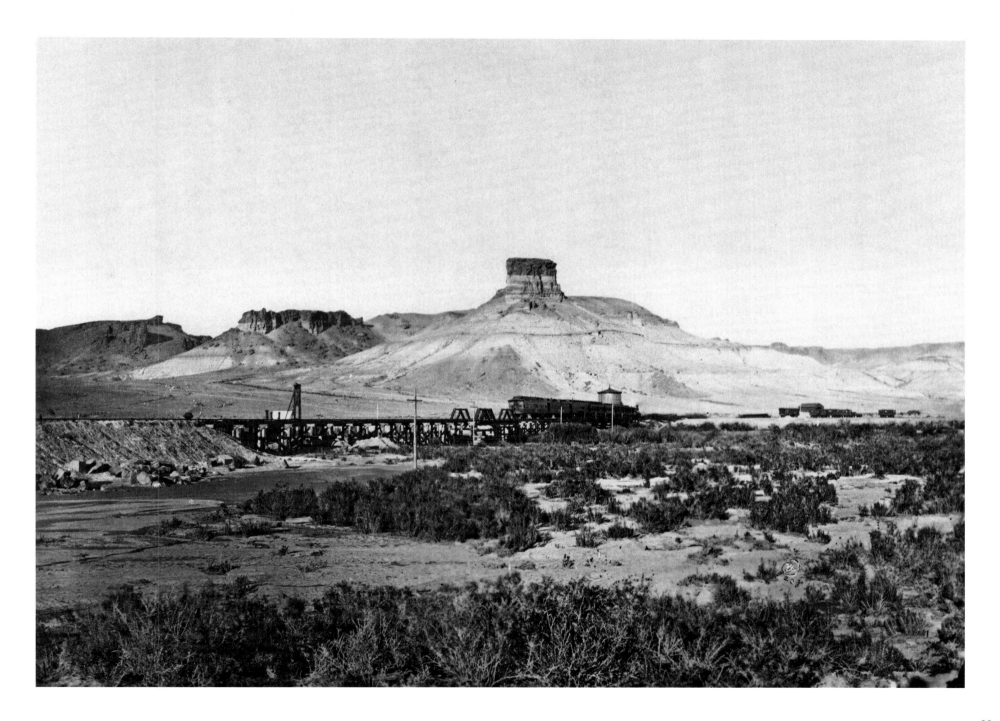

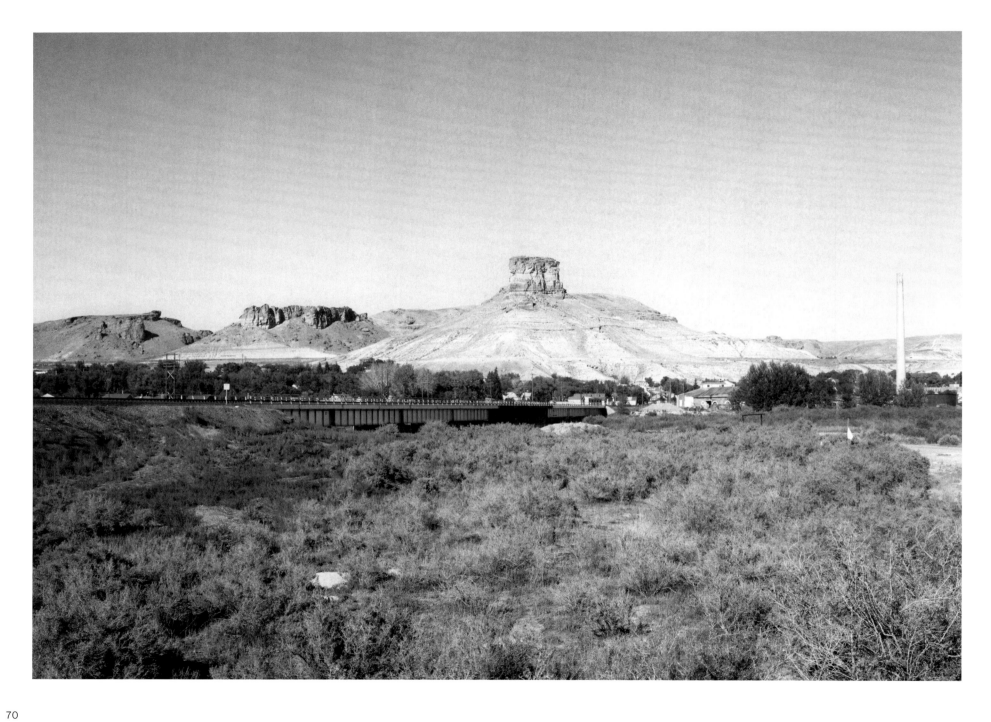

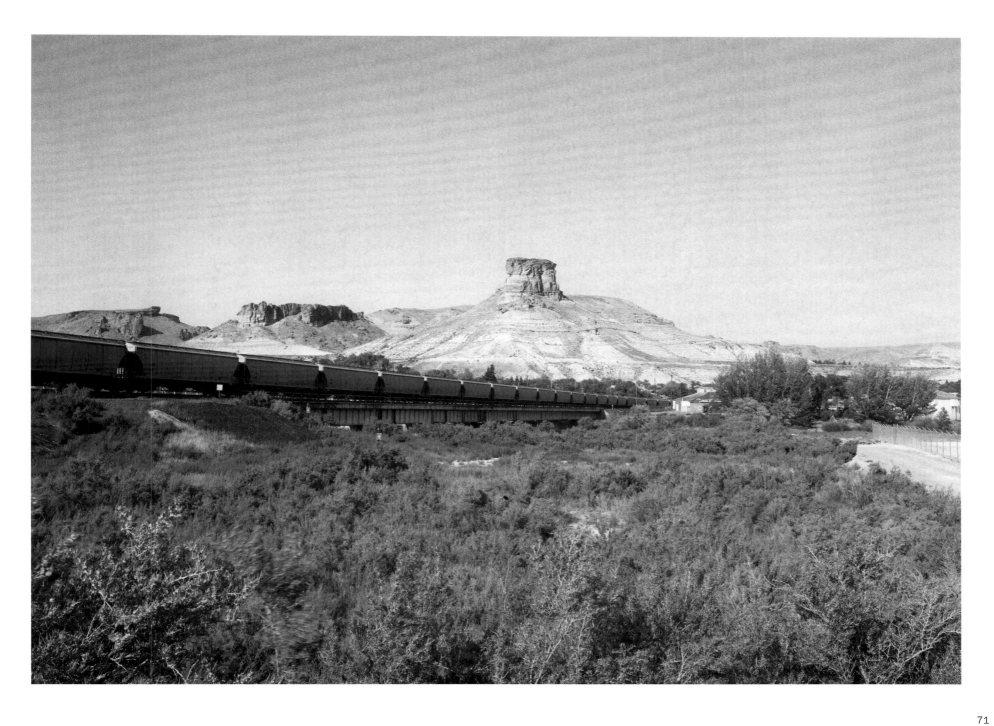

GEORGETOWN, COLORADO

The vantage point is located above the town of Georgetown on a ridge crisscrossed with power lines and old mines. Interstate 70 is visible in the second view, climbing toward Loveland Pass. The view looks north.

Jackson made many views of Georgetown, both for the Hayden Survey and later, including this 1875 view on a large glass plate. His photograph shows the hills surrounding Georgetown almost completely denuded of trees. In the mid-1870s most of the trees within reach were clear-cut for use in the mines, for lumber, and for fuel. By the late 1970s many of these clearings had regrown, and by 1998 the foreground was covered by young aspen and pine trees. The photographs run counter to the expectation that after western settlement the land has always changed for the worse.

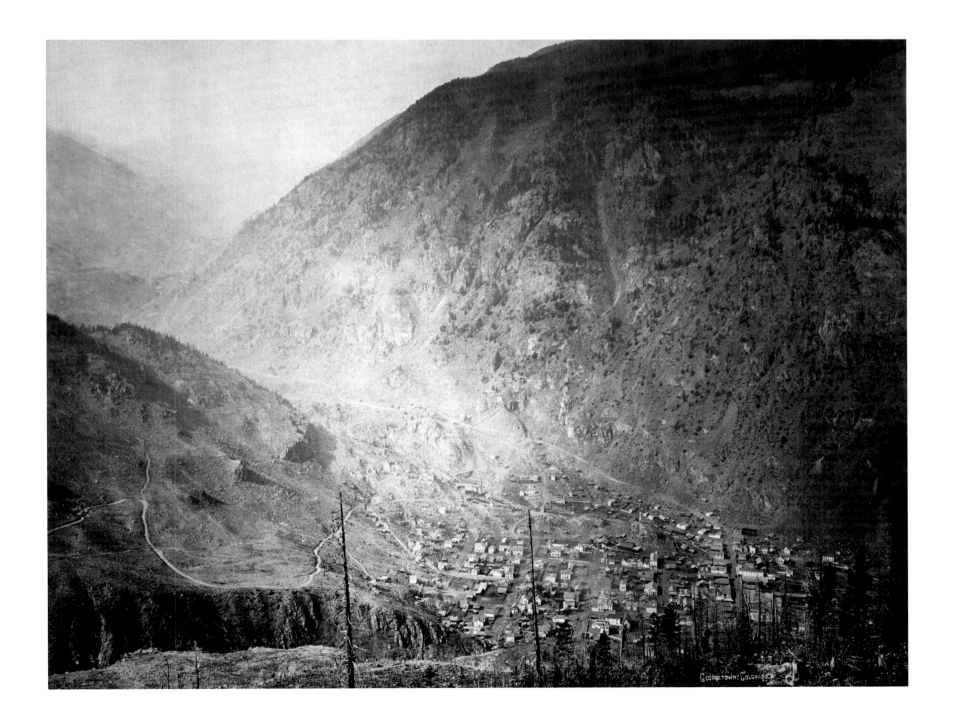

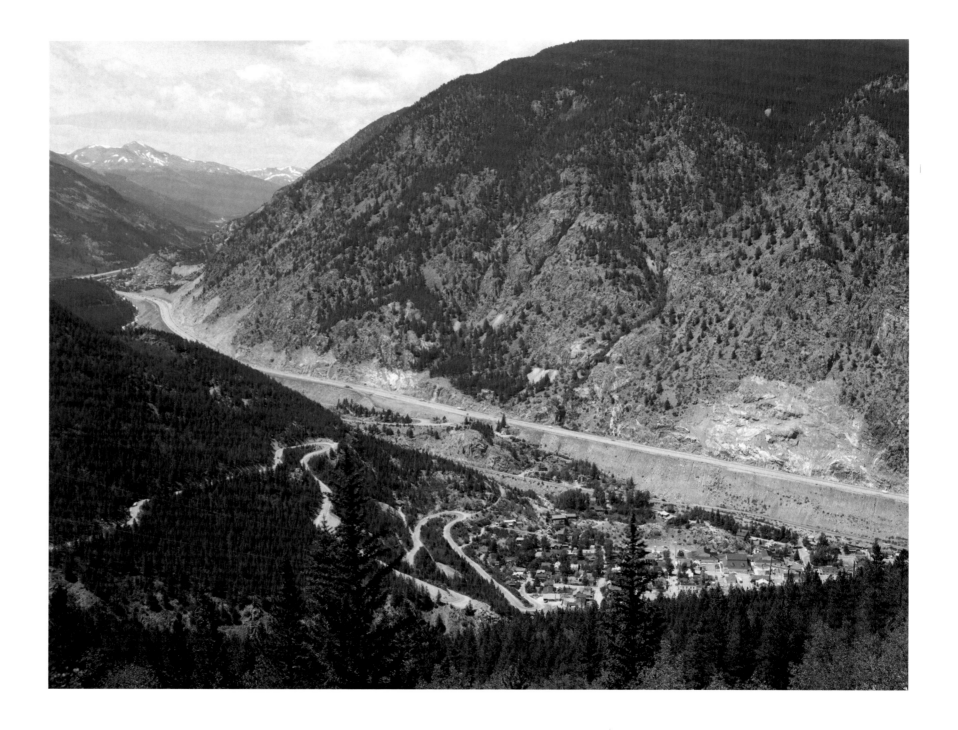

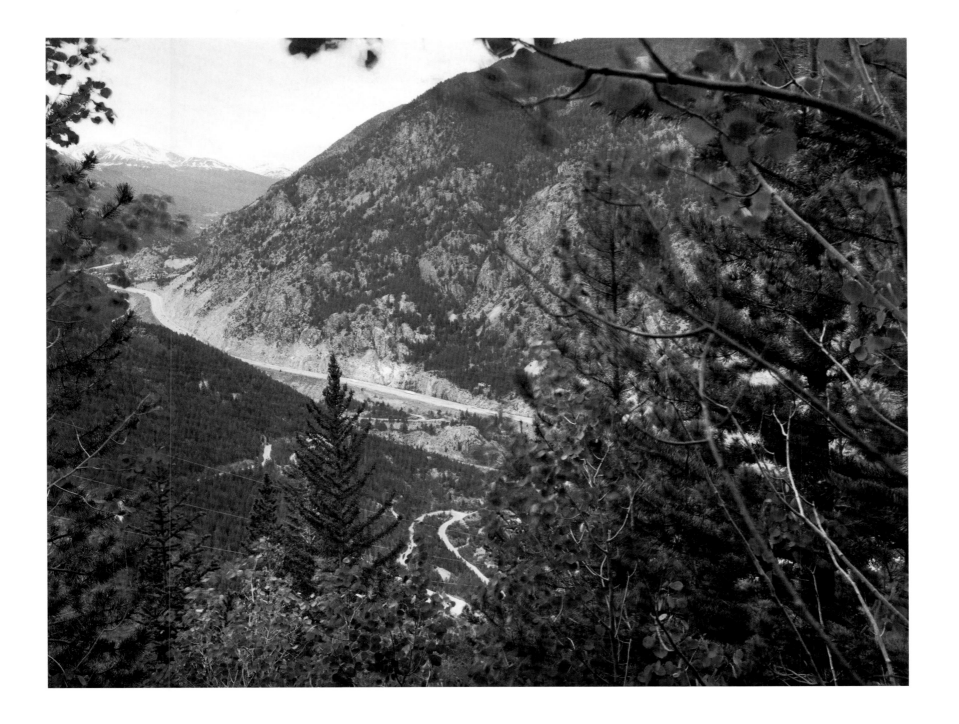

BOULDER CANYON, COLORADO

The rock face in the left of Jackson's photograph is the south side of Castle Rock, a prominent landform in Boulder Canyon off of Colorado Route 119 (not to be confused with the Castle Rock in Green River, Wyoming). The rock has been a favorite spot for local climbers since at least the 1960s. In the second view two pines cover much of the Jackson view, and a figure, photographer John Pfahl, can be seen between the trees. The old route used by Jackson is still visible in the later photographs, but the main road is far to the left on the other side of the rock. By 1998 unknown forces had removed one of the trees. Climbers were active the day the Third View team visited the site, and one gave an interview on the climbing history of the area.

58
BOULDER CAÑON
Near Castle Rock

Logan Springs was not revisited in the 1970s, but a copy of O'Sullivan's photograph taken there sat in the archives of the Rephotographic Survey Project with an estimated location. To get to the site of Logan Springs, the field team drove on a four-wheel-drive track past signs warning DANGER: ROCKETS MAY LAND DURING TESTS, and stopped at midnight on July 4, 1998, on a dirt track in the Irish Mountains approximately three hours north of Las Vegas. Camping on the road below a tall bluff, we awoke to explore an abandoned house at the scene. A video shows the interior of the house and several of the artifacts found (see the *Third View* DVD disk).

The scene suggested the mysterious disappearance of a family once living in a house that was built from the ruins of older buildings. It seemed the occupants had planned to return, but the house had not been used in years. There was nothing to indicate why the site was abandoned or even why it had been occupied in either the nineteenth or twentieth century. We searched for clues that might tell us who had lived there and when and why they left.

The evidence suggested a Mormon family, and a magazine indicated the only date found: 1971. That date was exactly one hundred years after Timothy O'Sullivan made the original photograph of Logan, with its earliest inhabitants standing next to their dwellings. During that time the abandoned house we explored was made from the ruins of the houses in O'Sullivan's photograph, and another family also had lived there and left.

The site links the nineteenth century to the present in a circular repetition of abandonment, and it represented an evolving concern for the project: to visualize how the past, present, and future overlap at common points in space. It seemed to challenge the notion that the West experienced continual growth and was evidence that ghost towns, or buildings, are still being made in the West. Seeing the ruins of what once was a building occupied during the life span of many viewers makes it easier to imagine that ruins from contemporary culture may one day rework the archaeology and romance of western landscapes.

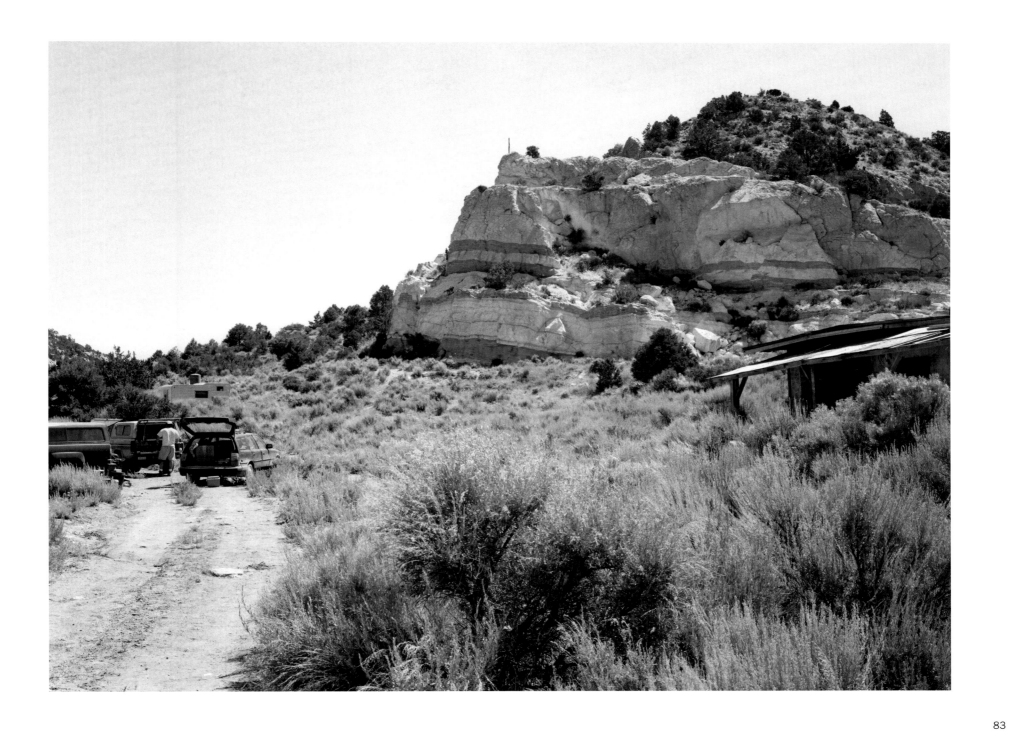

AUSTIN, NEVADA (EAST VIEW)

Austin is a small mining town located off Highway 50, situated near 7,000 feet on the western edge of the Toiyabe Range in central Nevada. O'Sullivan photographed the town near the peak of its population. The second view shows Highway 50, sometimes called "the loneliest road in America," cutting across the center of the view and following the earlier road. The foreground buildings in O'Sullivan's view disappeared, but remnants of mining equipment remained.

By 1998 the middle ground of the view had been converted into a town park and baseball diamond. The ground where the camera's vantage point stood was itself removed sometime between 1979 and 1998, when the road in the foreground was enlarged. The earlier camera positions that had been on a hillside were now literally hanging in space above the current road. To achieve the same height and vantage point, the Third View camera was set up on the roof rack of Kyle Bajakian's truck camper shell and literally driven into the correct position.

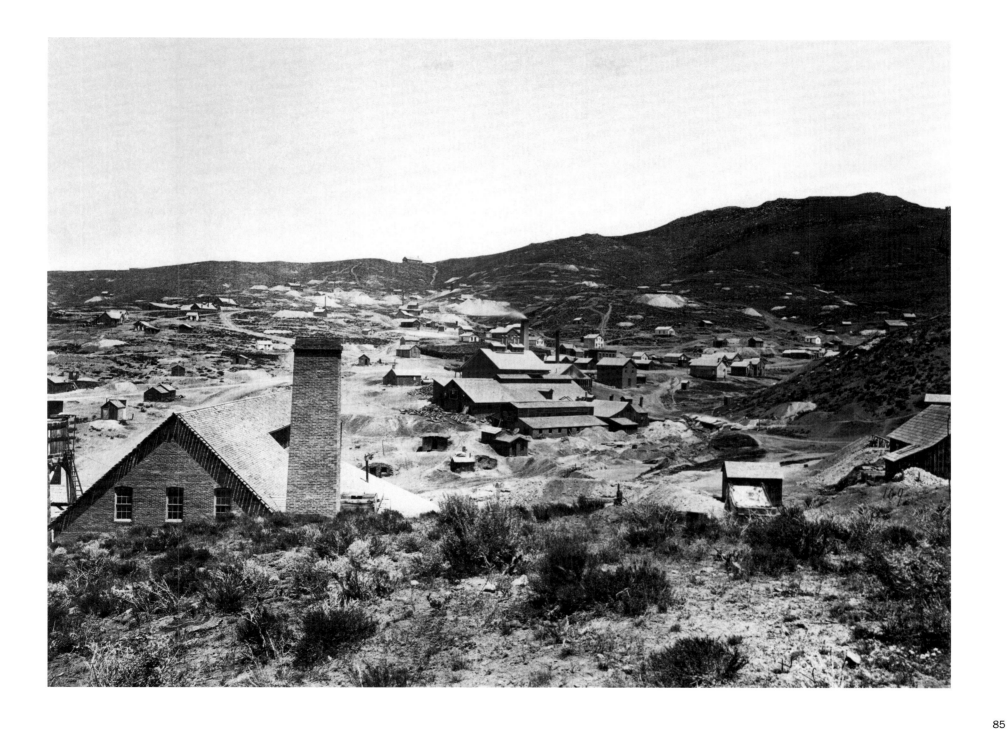

LARGER SODA LAKE, NEVADA (RIGHT SIDE)

Larger and Smaller Soda Lakes lie in side-by-side depressions west of Fallon, Nevada. Their waters are naturally alkaline, thus their "soda" description. In the early twentieth century the Newlands Irrigation Project brought water to the agricultural areas around Fallon, and with it the lakes' water level began to rise. Local residents often use the larger lake for waterskiing and swimming. However, private land rims the lakes to the south, and when the Third View team visited the site in July 1998, the landowner had fenced off access to the lakes, a move that proved very unpopular with others in the area. The fence remained cut and open during our visit.

In O'Sullivan's photographs, two men stand in the foreground holding shotguns. We found the ground near the vantage point covered with recently spent plastic shotgun shells. Many of the individual plants in the foreground of the 1979 view were still visible in 1998 and were used to determine the vantage point for the rephotograph.

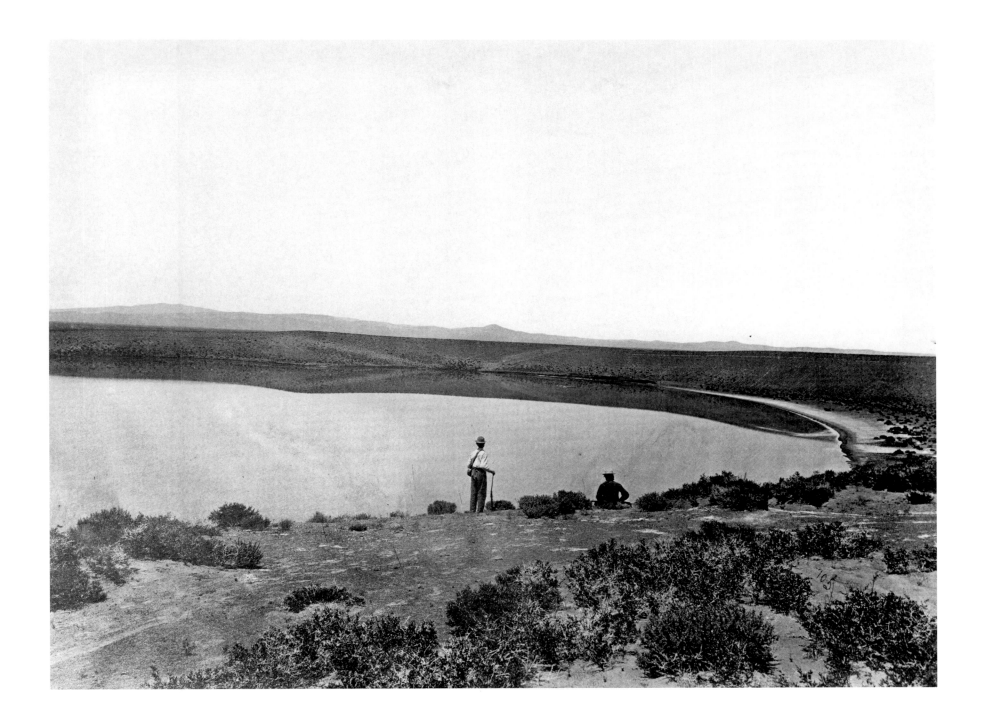

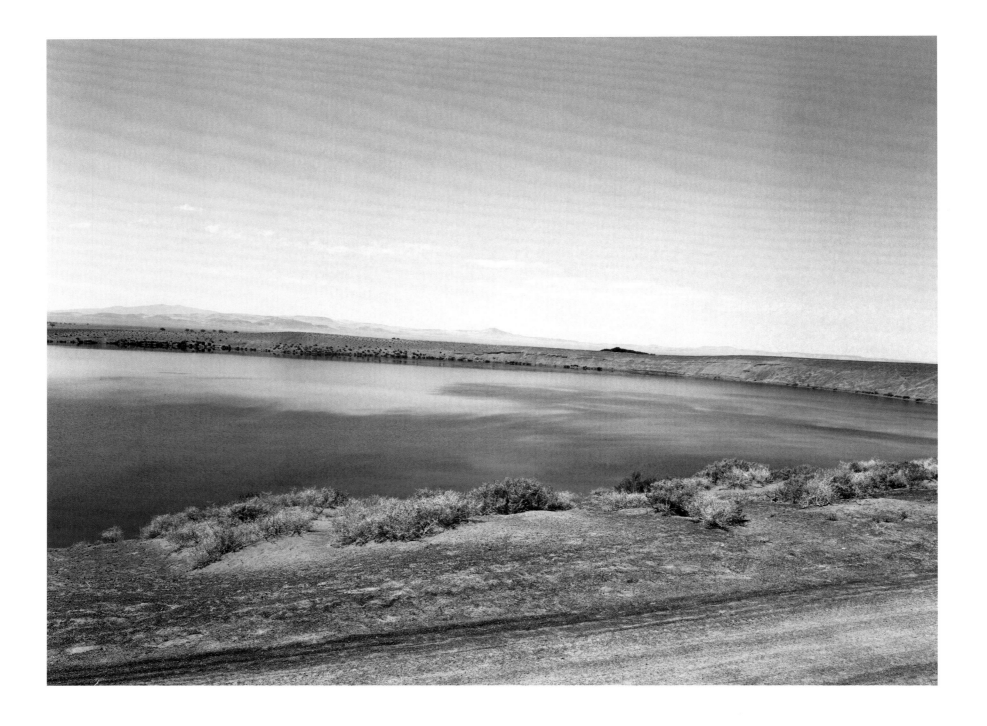

O'Sullivan's photograph, *Karnak Ridge,* was also titled *Crab's Claw Peak*. The former title referred to the Egyptian ruins explored earlier in the nineteenth century.

Although the location is geographically dynamic, there has been little physical change over the 131 years between first and third photographs. A few blocks of the columnar andesite that makes up this ridge have moved in a slow descent down the steep uplift. In the middle of the third view, Byron Wolfe checks a blister on his foot, a result of the ascent. The site is remote, but in the distance the line of Interstate 80 can be seen from other parts of the ridge. The location of this site was originally determined after consulting geologic maps of Nevada and isolating areas that show this rock type and structure. O'Sullivan rotated his camera approximately 10° in a clockwise direction, centering the slope of ridge.

The field team consisted of Mark Klett, Byron Wolfe, and Bill Fox. We had spent much of the previous day looking for this site, and when we arrived at the vantage point on July 9, 1998, we assumed it had had no visitors since Gordon Bushaw for the Rephotographic Survey Project made the second view in 1979. Before we left, several artifacts were placed under rocks at the site in a plastic bag, including a note, Polaroid proof print, and compass. As we left the location, we noticed a small ring of rocks at the top of the ridge only tens of meters above the vantage point. In this ring was a rusted tobacco tin. Inside the can were decaying papers; the writing in pencil was illegible except for the notation: "When a Feller Needs a Friend." It was a reminder that no matter how remote sites may seem, they have many visitors over time.

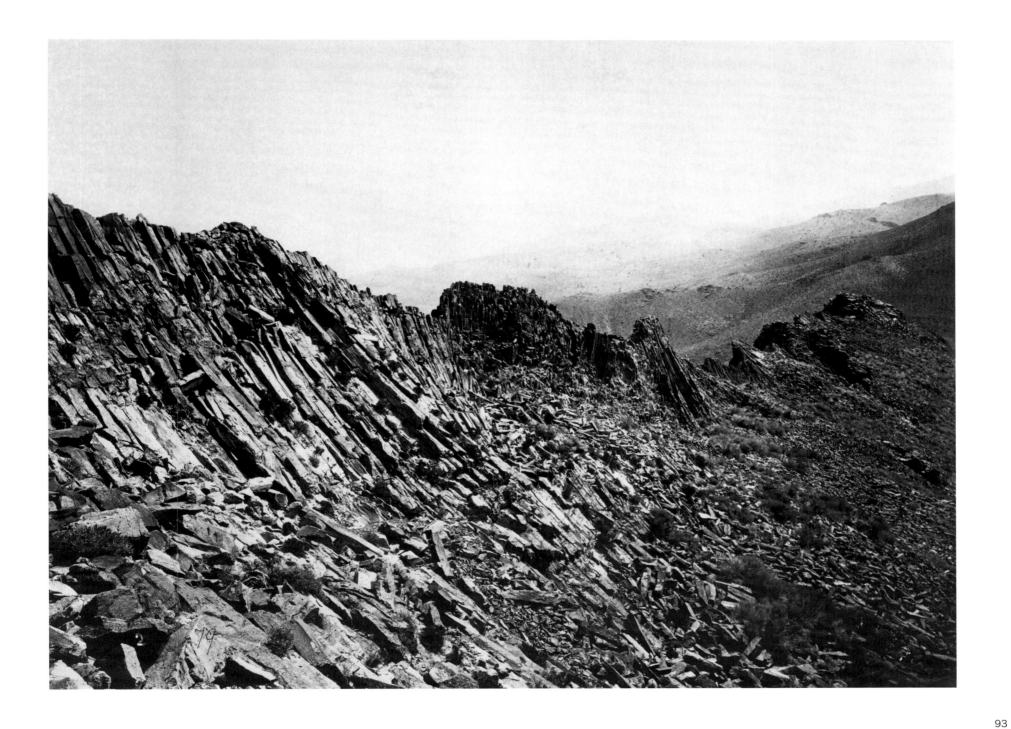

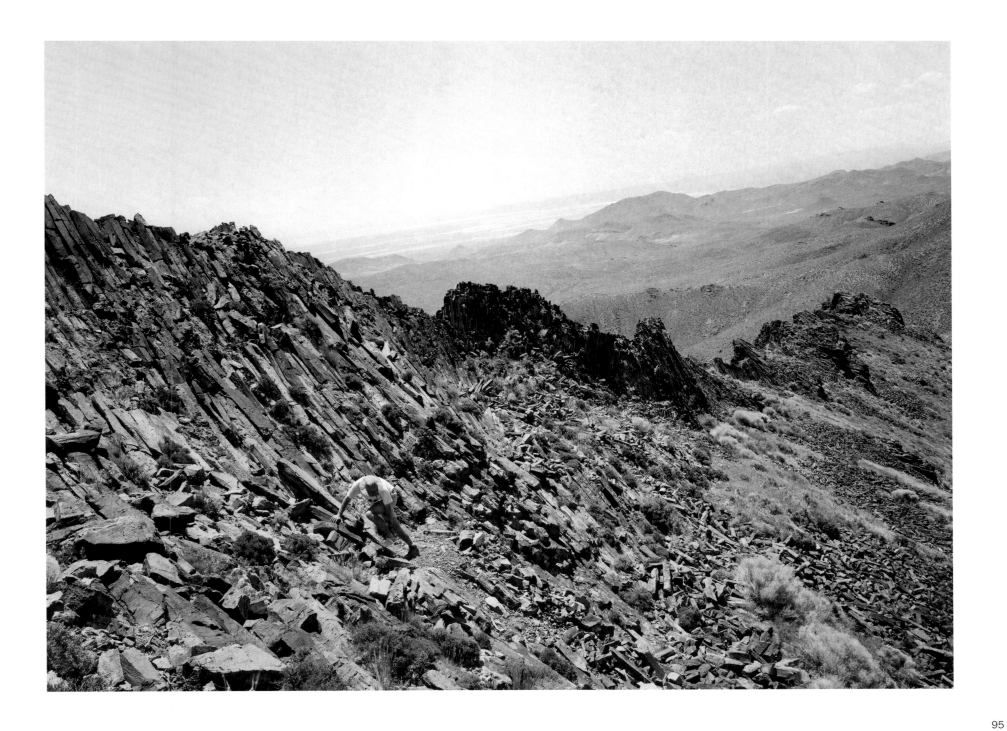

O'Sullivan photographed the Comstock Mines on Gold Hill when it was covered with individual mine shafts. The names of these mines can be read on the larger buildings: the Empire, Imperial, Confidence, and Challenge. Also visible at the lower left of O'Sullivan's photograph is his portable darkroom, a suitcaselike object sitting on a tripod, open with a cloth front. Here O'Sullivan coated, then developed the glass plate used to make his photograph. The wet-plate process required the photographer to coat and develop the plate on the spot while it was still wet. His darkroom-in-a-box opened with an orange calico fabric front and armholes cut to allow the photographer access to the plates and chemistry inside. The hand-coated emulsions were not sensitive to red or orange, only to blue light. Exposures were often twenty seconds or more in length under the bright western sun at midday.

In 1977 the hills of the Comstock gave way to the gaping hole of a strip mine operating at the site. This mine was later abandoned, and the weathered edges of the pit can be seen in the view from 1998. The camera location is directly off Route 341 as it curves down a hill from Virginia City close by to the north. The road is in roughly the same location as in O'Sullivan's time.

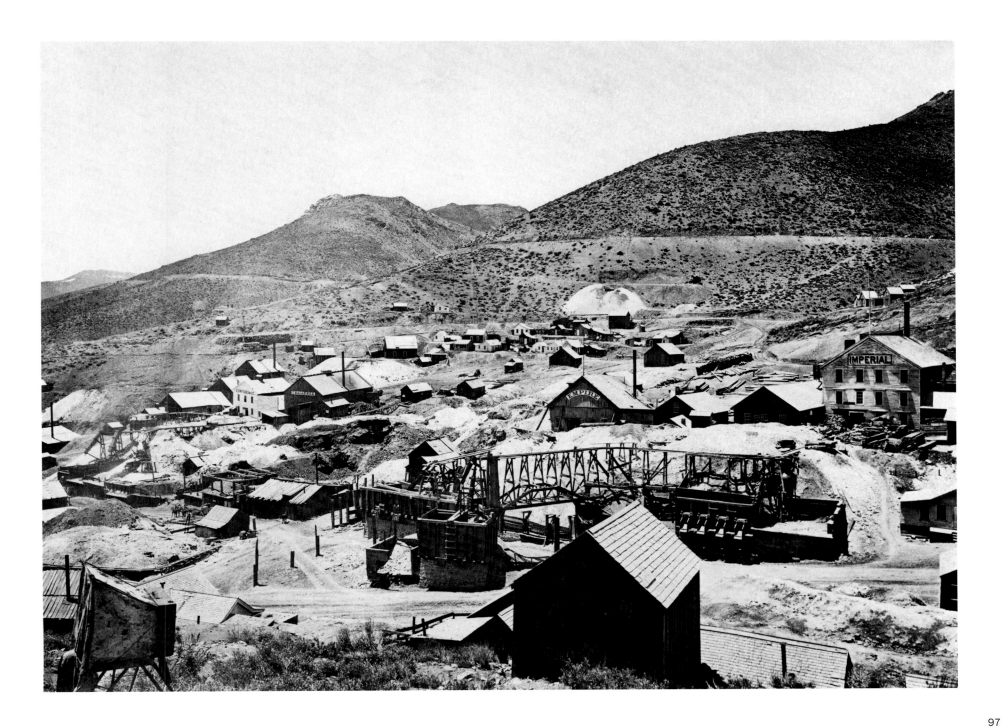

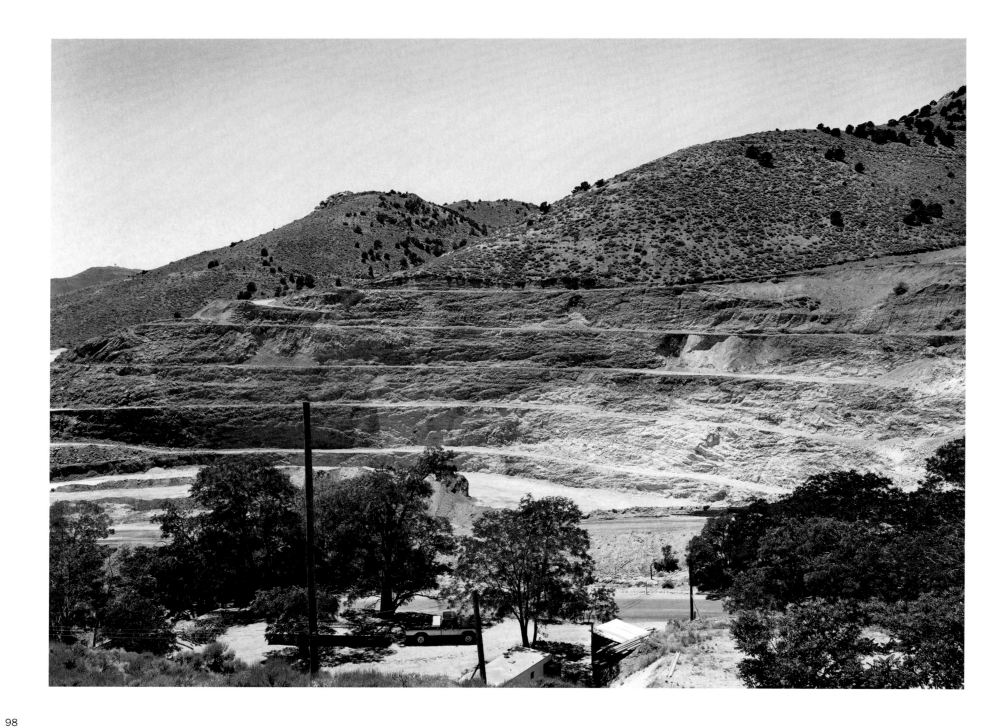

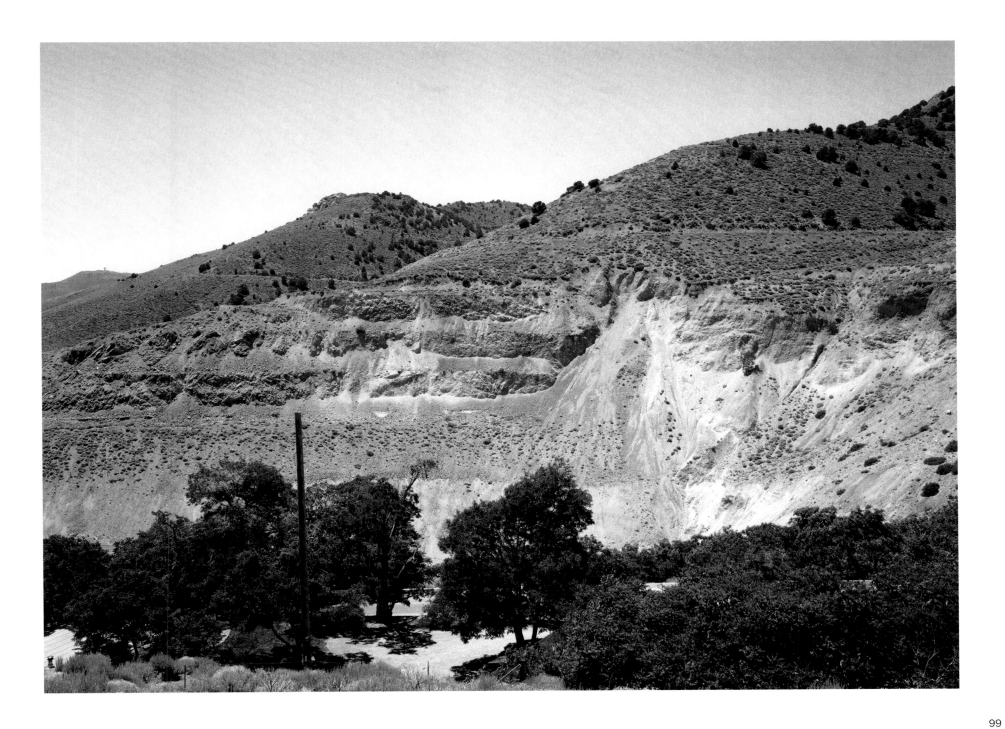

East of Virginia City, in Sixmile Canyon, are the ruins of several mining operations, including this one near Sugar Loaf Rock. Little is left of the structures at the site, only remnants of their foundations. Like other ruins in the area (the subject of the photograph *Quartz Mill near Virginia City* is located only a short distance west on the same road), the wood used to make these structures was removed after it had outlived its usefulness. A FOR SALE sign hung at the parking turnout that is visible in the right of the second view. A small creek runs to the left of the scene, below the small bridge in the O'Sullivan photograph. Weeds had overcome the vantage point and were about five to six feet high.

SUGAR LOAF ROCK, NEVADA

PAGE 102
TIMOTHY O'SULLIVAN, 1867. SUGAR LOAF MINING DISTRICT, WASHOE, NEVADA (U.S. GEOLOGICAL SURVEY)

PAGE 103
MARK KLETT AND BYRON WOLFE FOR THIRD VIEW, 1998. SUGAR LOAF ROCK, SIXMILE CANYON, VIRGINIA CITY, NV

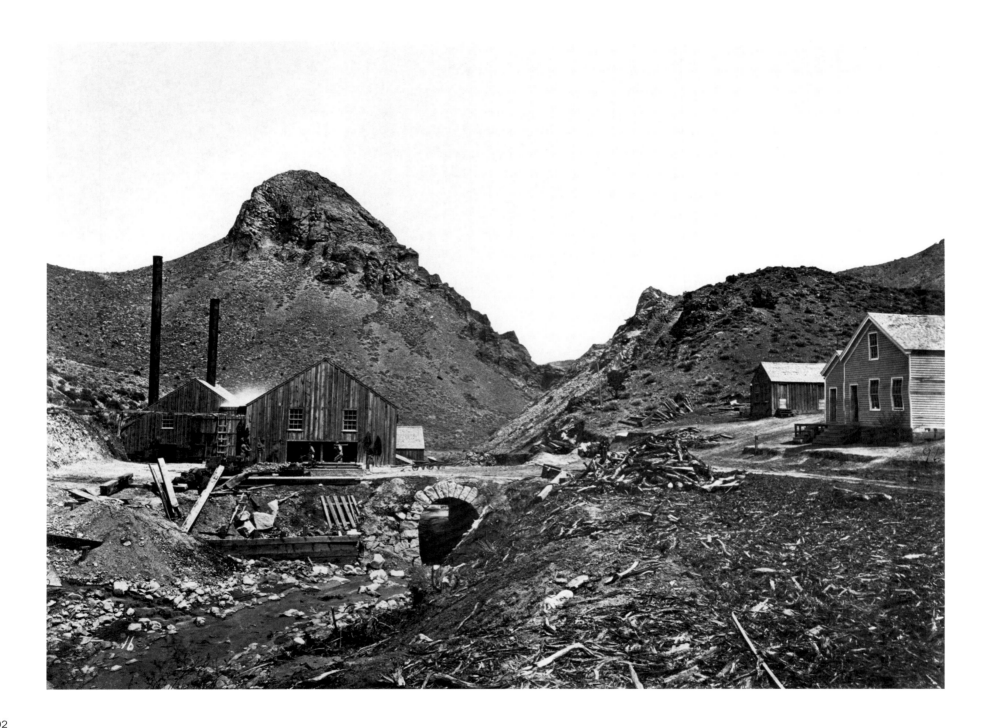

STEAMBOAT SPRINGS, NEVADA (DISTANT VIEW)

PAGE 105
TIMOTHY O'SULLIVAN, 1868. STEAMBOAT SPRINGS,
WASHOE VALLEY, NEVADA (U.S. GEOLOGICAL SURVEY)

PAGE 106
MARK KLETT FOR THE REPHOTOGRAPHIC SURVEY PROJECT,
1979. STEAMBOAT SPRINGS, NV

PAGE 107
MARK KLETT AND BYRON WOLFE FOR THIRD VIEW, 1998.
STEAMBOAT SPRINGS, NV (DISTANT VIEW)

This site is in an active geothermal area, which by 1998 had become private property and was fenced off from Route 395 between Reno and Carson City. The highway can be seen to the right of both the second and third views. It was a wagon road in O'Sullivan's photograph, and he pulled his darkroom/wagon onto the light-colored crust of active steam vents and included it in his picture.

The area around the photograph has seen much development in the twenty years since the second view was made, as housing has stretched south of Reno. An endangered buckwheat plant grows below the steam-emitting vents. The private company operating the site had erected signs warning trespassers but allowed us to enter the property for rephotography.

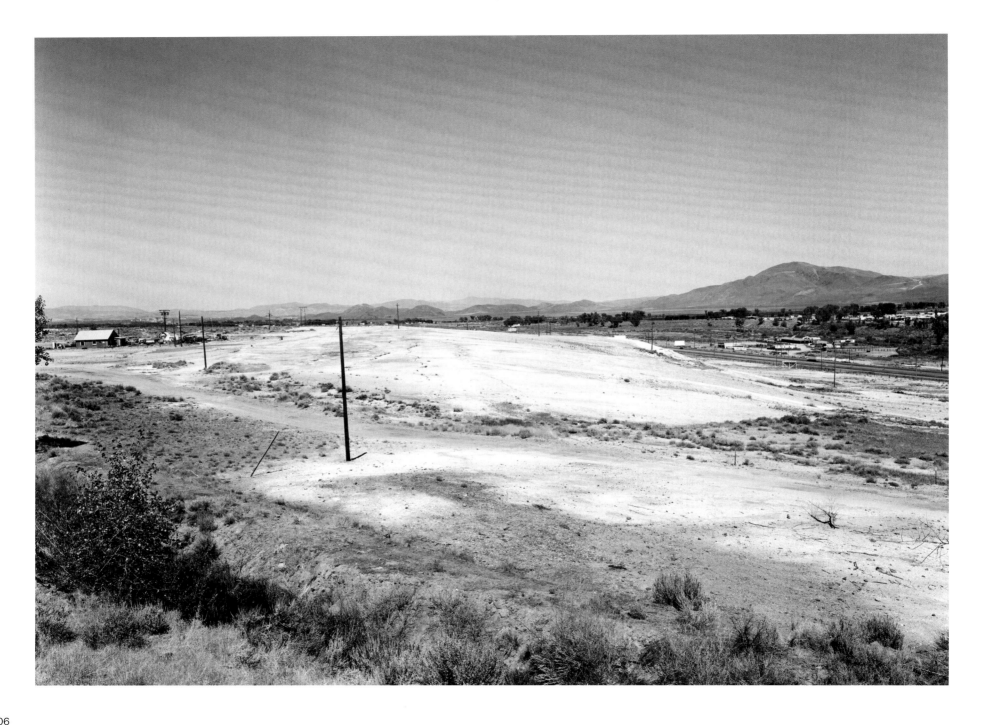

106

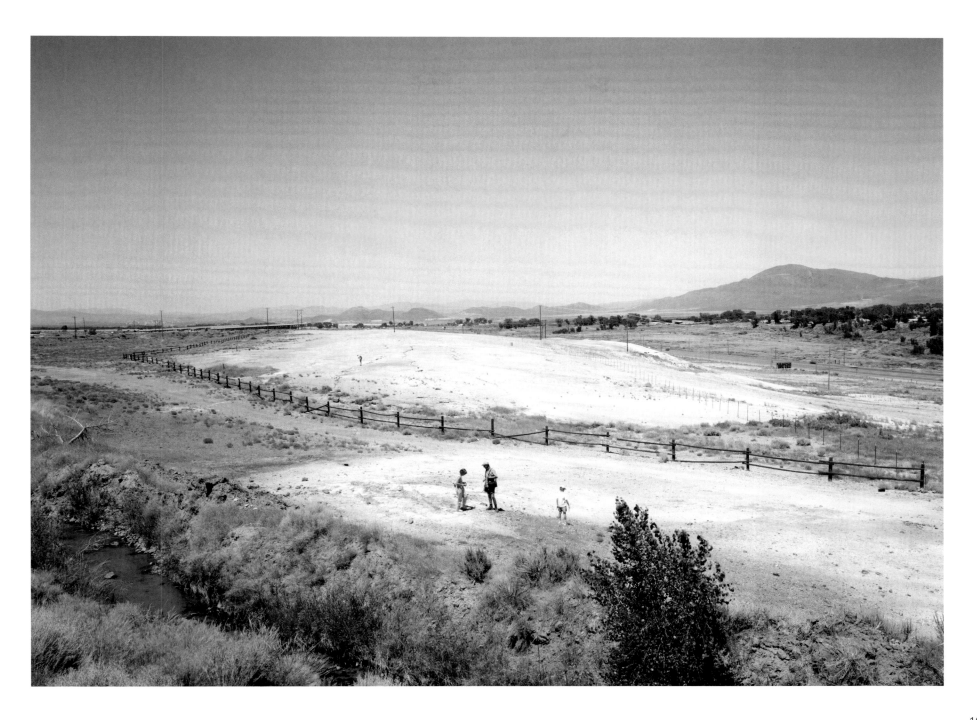

STEAMBOAT SPRINGS, NEVADA, FISSURE CLOSE-UP

PAGE 109
TIMOTHY O'SULLIVAN, 1868. UNTITLED (U.S. GEOLOGICAL SURVEY)

PAGE 110
GORDON BUSHAW FOR THE REPHOTOGRAPHIC SURVEY PROJECT, 1979. FISSURE, STEAMBOAT SPRINGS, NV

PAGE 111
MARK KLETT AND BYRON WOLFE FOR THIRD VIEW, 1998. FISSURE (INACTIVE), STEAMBOAT SPRINGS, NV

This hot springs fissure was active when O'Sullivan made his exposure, and steam is visible in the second view as well. But by 1997 the crack had become dormant. The geothermal area below the white crust of the photograph is still active and the ground itself was hot, but the soft deposits erode quickly while the edges of the crack have steadily crumbled.

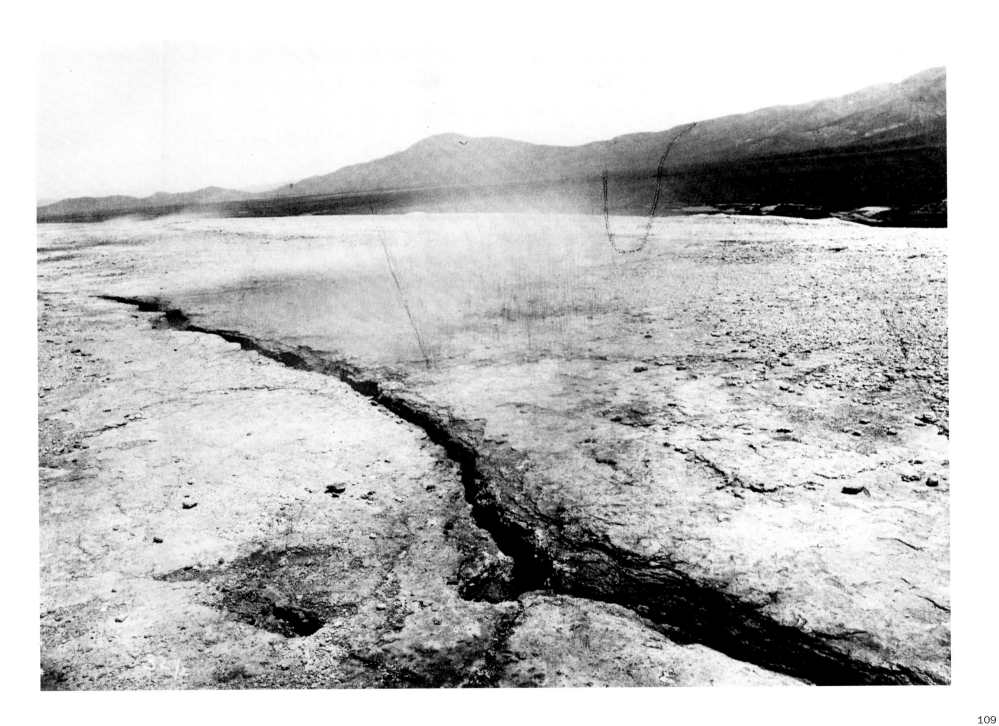

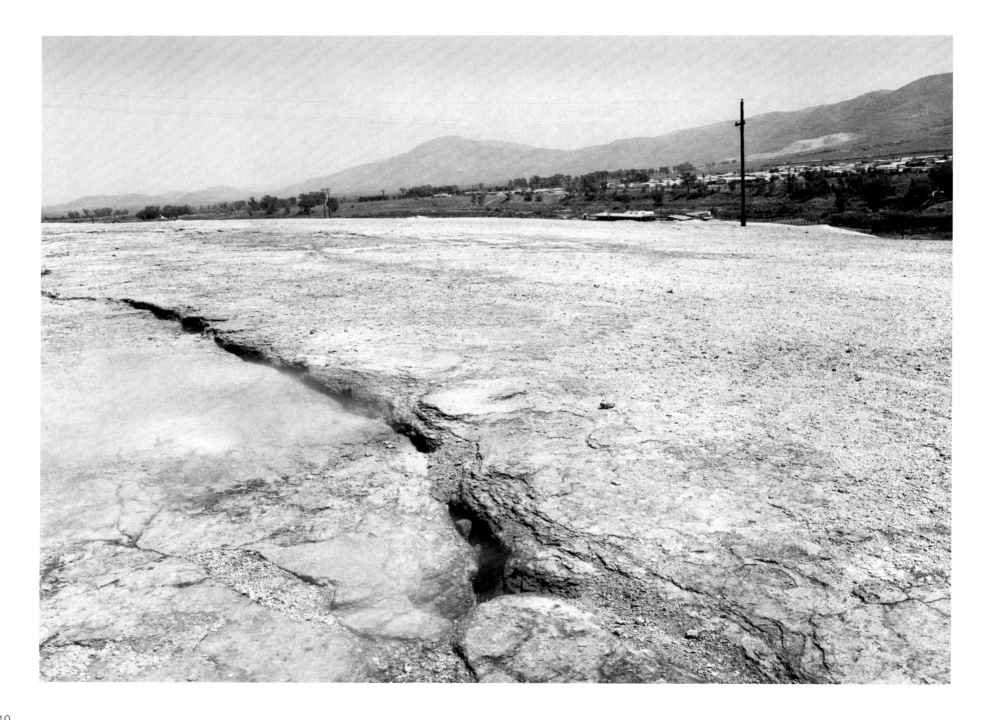

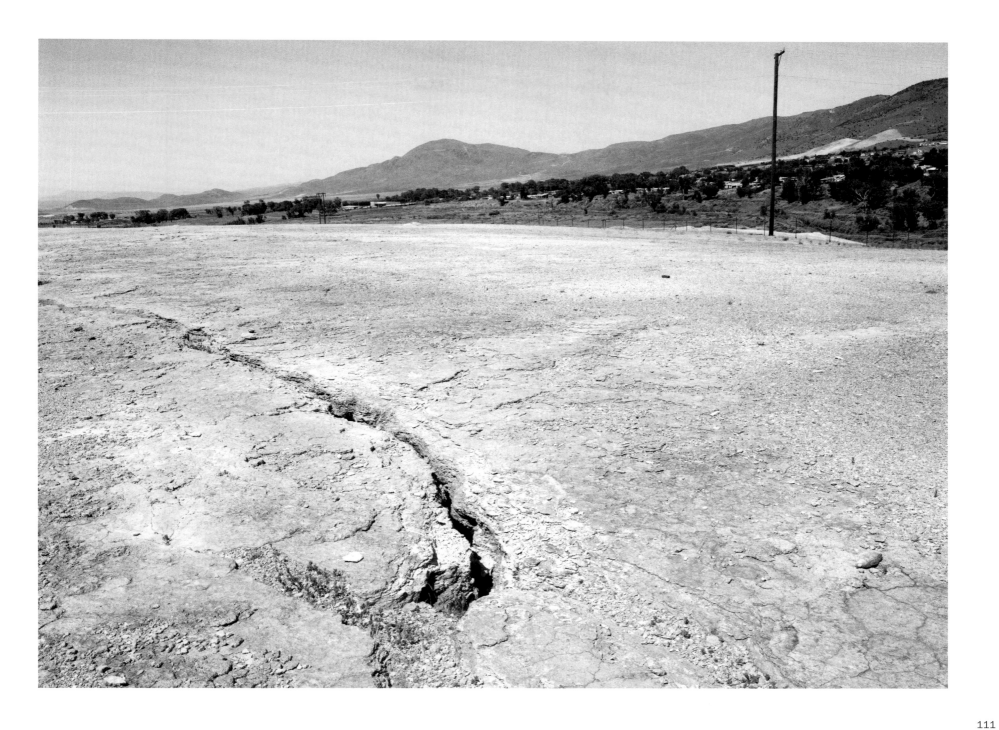

BIG COTTONWOOD CANYON, UTAH

The entrance to Big Cottonwood Canyon sits at the eastern edge of developed Salt Lake City. Big Cottonwood Canyon and its watershed are part of the city's water supply, which accounts for some of the development and access restrictions the field team encountered. The water runs for miles through the quartzite canyon walls of the Wasatch Mountains, and O'Sullivan made this photograph of rock formations, including the stream, a bridge, and his wagon.

This was one of three views O'Sullivan made near this site, each facing a different direction. Along the paved road that roughly parallels O'Sullivan's route, there are several campgrounds and pay-per-visit picnic areas. Fish are stocked in the stream for anglers, and a sign at the entrance to the canyon announces whether campsites are open, as well as the regulations governing them. Reservations are generally required for camping during the summer months.

In 1978 the camera position had been altered by the built edge of a small reservoir at Storm Mountain. By 1999 a fence had been erected at the edge of the reservoir, blocking both the original and second views.

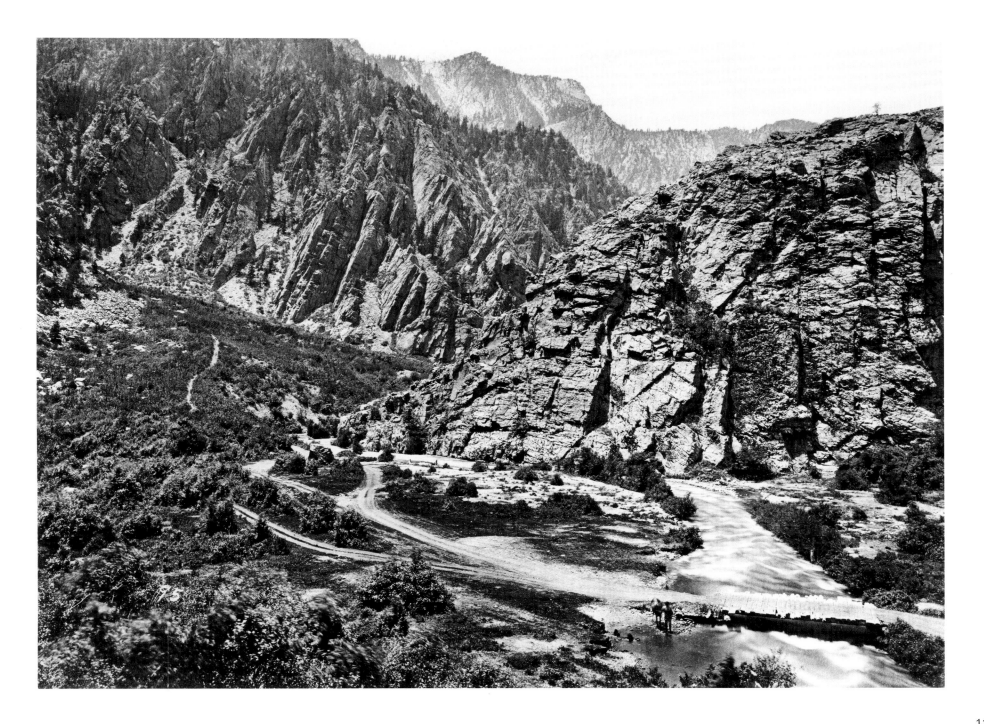

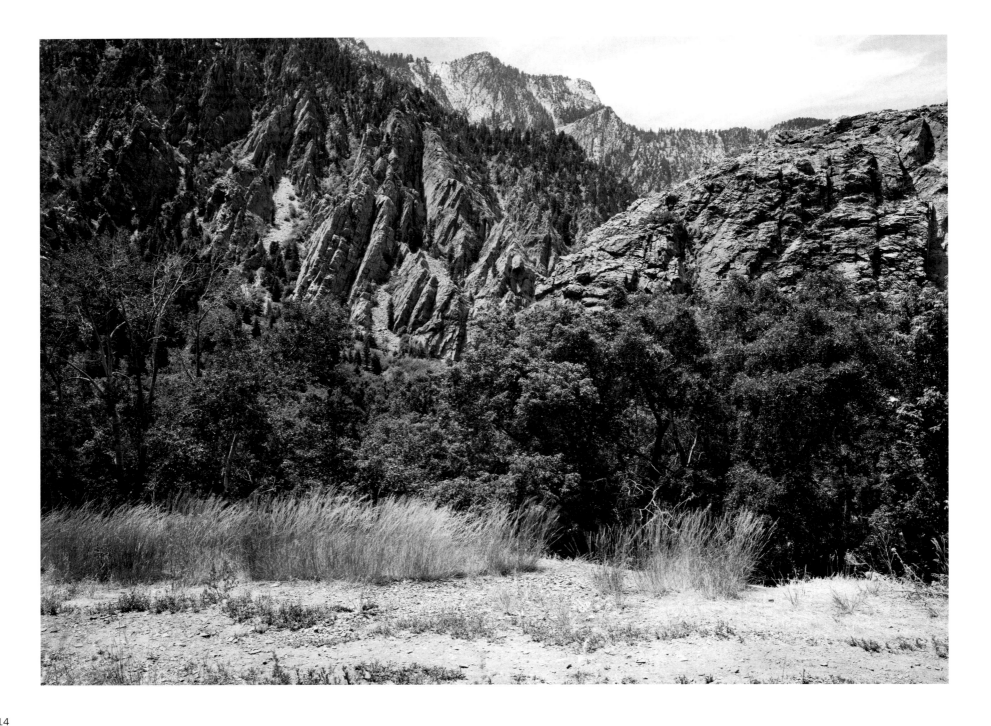

LITTLE COTTONWOOD CANYON, UTAH, GLACIER-WORN GRANITE

PAGE 117
TIMOTHY O'SULLIVAN, 1869. LITTLE COTTONWOOD CAÑON, WAHSATCH MOUNTAINS, UTAH, GLACIER-WORN GRANITE (U.S. GEOLOGICAL SURVEY)

PAGE 118
GORDON BUSHAW FOR THE REPHOTOGRAPHIC SURVEY PROJECT, 1979. GRANITE, LITTLE COTTONWOOD CANYON, UT

PAGE 119
MARK KLETT AND BYRON WOLFE FOR THIRD VIEW, 1999. GRANITE, LITTLE COTTONWOOD CANYON, UT

Little Cottonwood Canyon parallels Big Cottonwood Canyon to the north and also carries a stream west from the Wasatch Mountains. Little Cottonwood Canyon hosts greater private development, including the genealogical records for the Church of Jesus Christ of Latter-day Saints, which is carved into one of the rock walls opposite where O'Sullivan took the original photograph. From this vantage point, he focused on the granite walls of the canyon's south side that had been polished by glaciers. The view looks toward the water, and trees have grown thicker in the drainage. A telephone pole is visible in the third view, and at its base is a trail well used by hikers and mountain bikers. Further east toward the mountains, the Little Cottonwood Canyon road (Route 210) ends at the Alta Ski Resort.

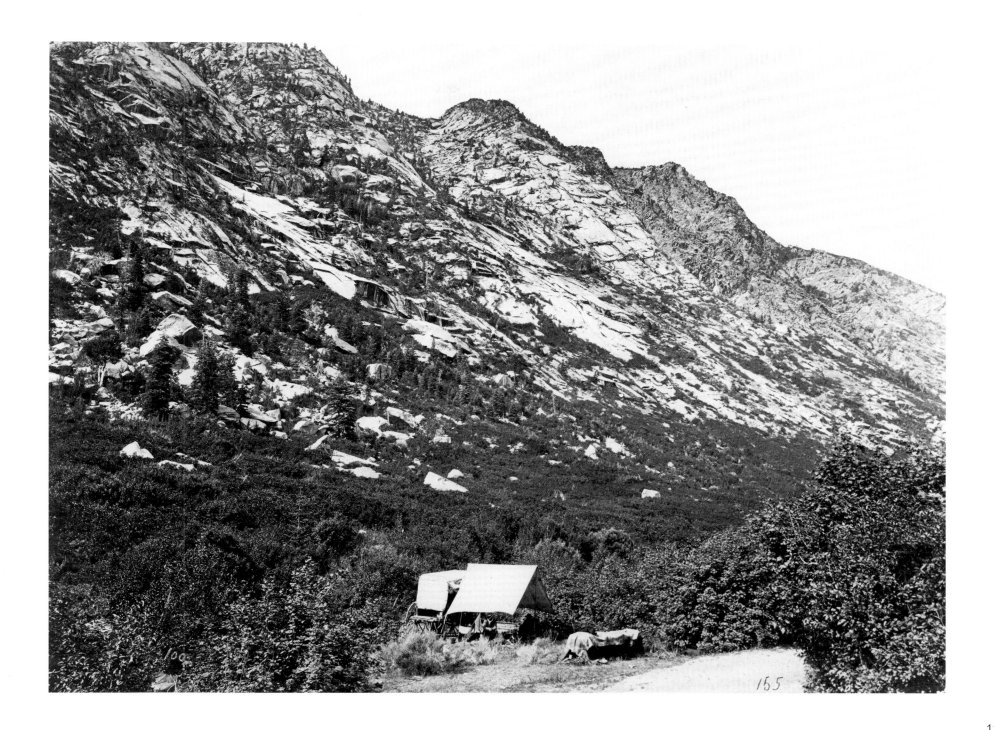

155

The City of Rocks is located in southeastern Idaho, and it has become a favorite place with rock climbers. In 1979 few people visited the park, and there were fewer still regulations. In 1999 camping was restricted to designated, numbered campgrounds that were outfitted with picnic tables and fire grates.

O'Sullivan stood upon a granite outcropping to make his photograph, gaining an elevated vantage point for the view northwest. The camera position was within several meters of the unpaved road that bisects the park. Juniper and piñon trees had grown numerous and taller by 1979, and a jeep track was visible in the left edge of the photograph. By 1999 a cable fence cut off access to the area in the photograph, and the track had all but disappeared. The figure in the third view is Toshi Ueshina recording video footage for the project.

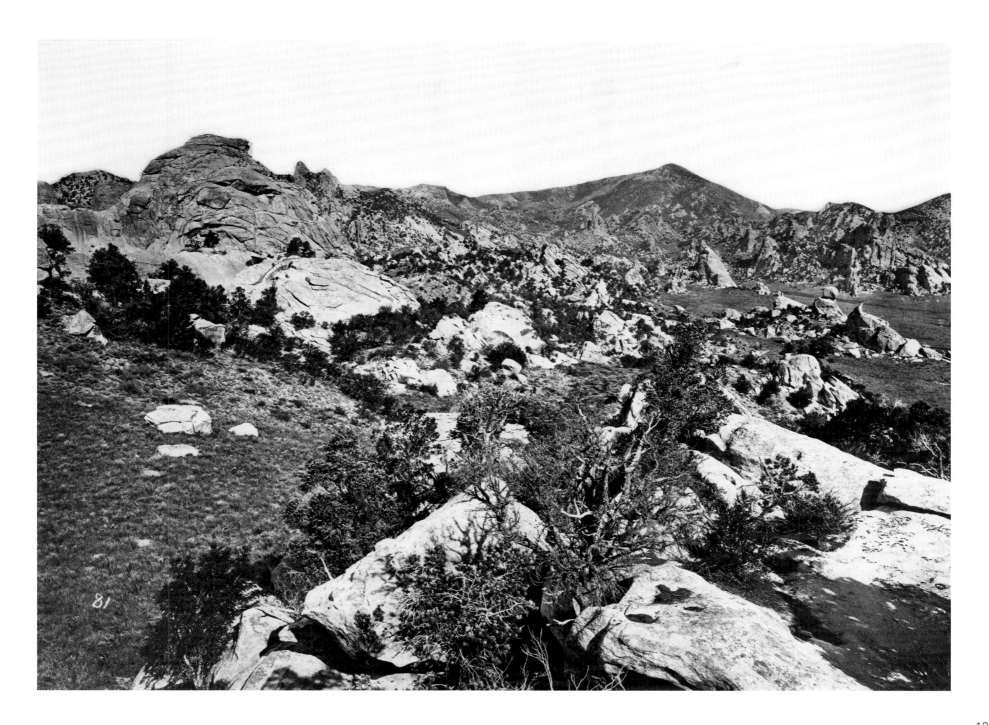

81

121

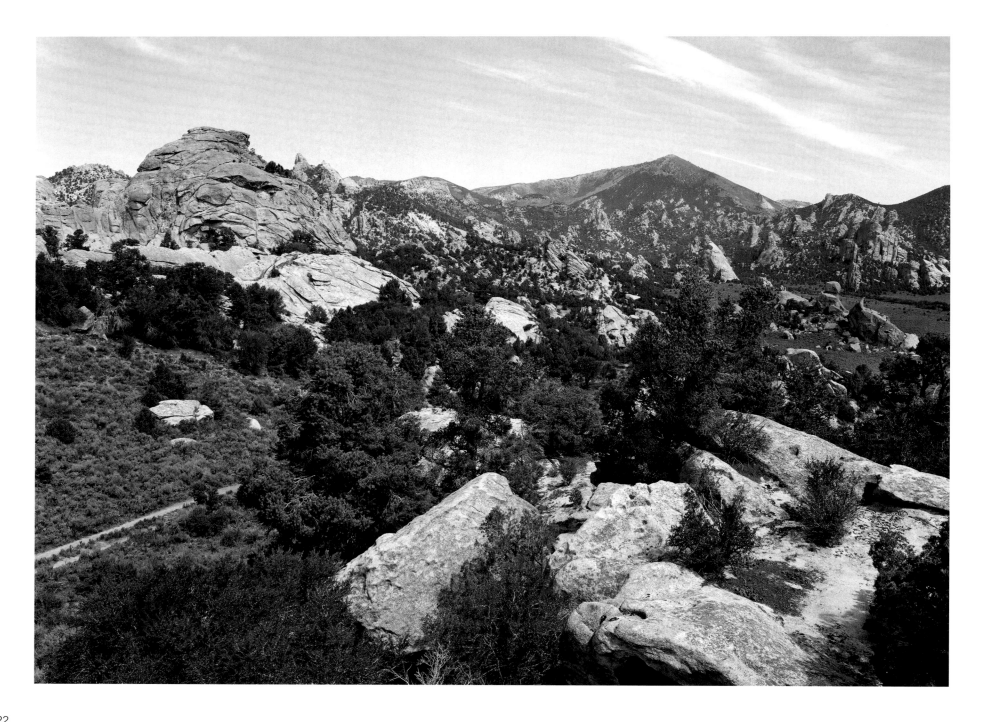

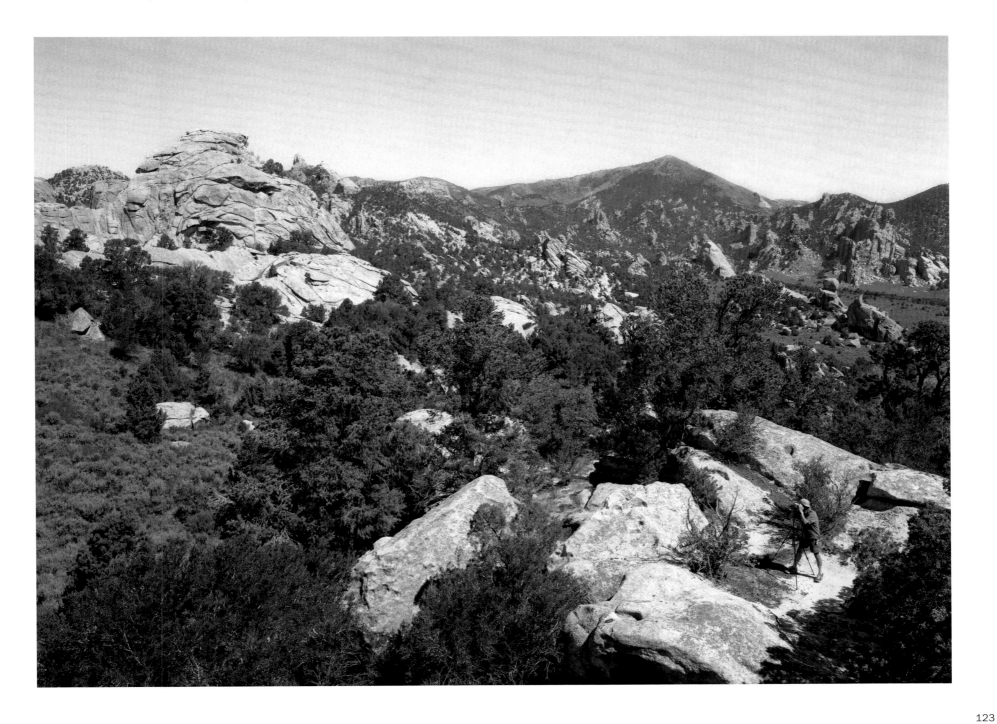

Shoshone Falls on the Snake River is a city park several miles east of Twin Falls, Idaho. This is the only location O'Sullivan photographed twice in his work as a survey photographer. He visited once for the King Survey in 1868 and again for the Wheeler Survey in 1874.

The view in 1999 was totally obscured by trees, but the rephotograph accurately replicates the vantage point, found by circumnavigating the location and narrowing down the range of possible camera positions. This almost totally covered view (there is a small piece of the opposite canyon wall visible in the upper left) is the result of planted trees and irrigation. Obscured views, once a reason for not making a rephotograph in the 1970s, were sometimes judged by the Third View crew to be an excellent reason to make them.

The Rephotographic Survey Project did not repeat this photograph in the 1970s in part because it did not have a copy of the image. We found the photo on the website of the National Archives while using computers at the public library in Twin Falls. This image, and the view of Shoshone Falls from above were our first examples of Web-based photo research done while on location.

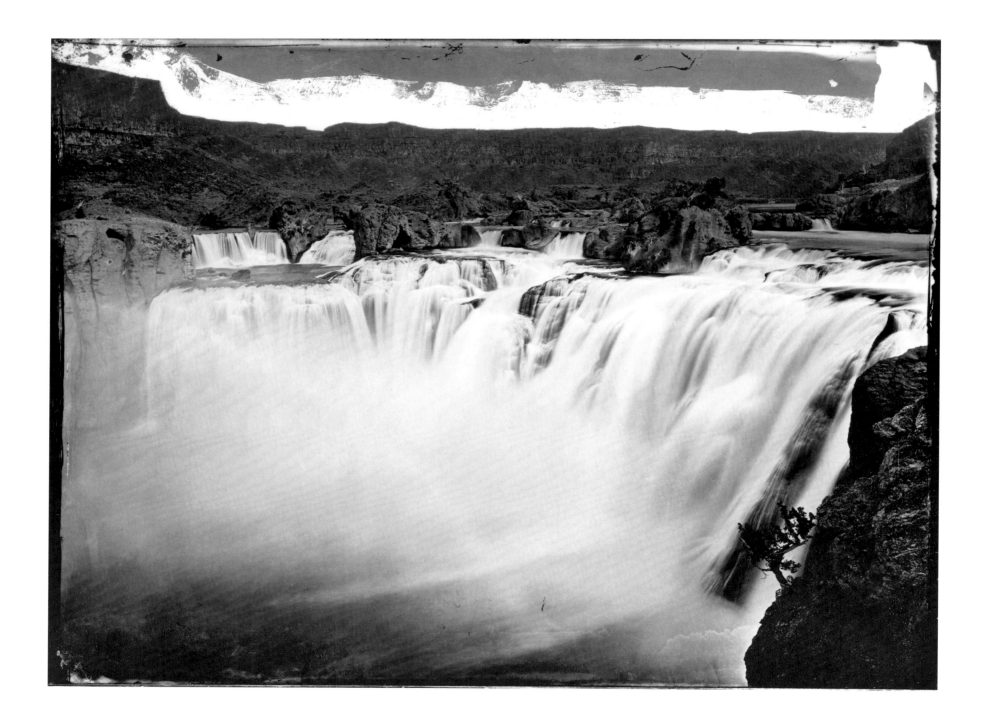

SHOSHONE FALLS (FROM THE EDGE)

Early accounts of Shoshone Falls mention the deafening roar of the water, which could be heard miles away. To some observers that sound was frightful, yet others were impressed enough to depart from the Oregon Trail in order to experience it. The total drop (212 feet) is larger than that of Niagara Falls, which was the nineteenth-century eastern standard for awesome natural wonders. Today a brochure still describes the falls as the "Niagara of the West."

O'Sullivan made many views of the falls from almost every angle, above and below, and in this case the edge of the water itself. The rock in the lower center is at the brink of the drop, and to make it O'Sullivan positioned the camera low and very near the precipice. The rocks at the edge are covered with slippery algae, and there are stories of people who, while swimming in the small holes and pockets of water above the falls, were carried by swift currents and, unable to gain a hold on the slimy rocks, were swept over the edge to their death. In 1999 a fence secured the area.

The amount of water going over the falls varies greatly depending on the year and time of year. Above the park, diversion dams take the waters of the Snake River for agricultural and hydroelectric purposes, and during the summer little of it makes its way over the edge. In 1980 the water was almost shut down when the second view was made. In 1999 the water flow appears somewhat stronger, but the fluctuation is temporary and controlled.

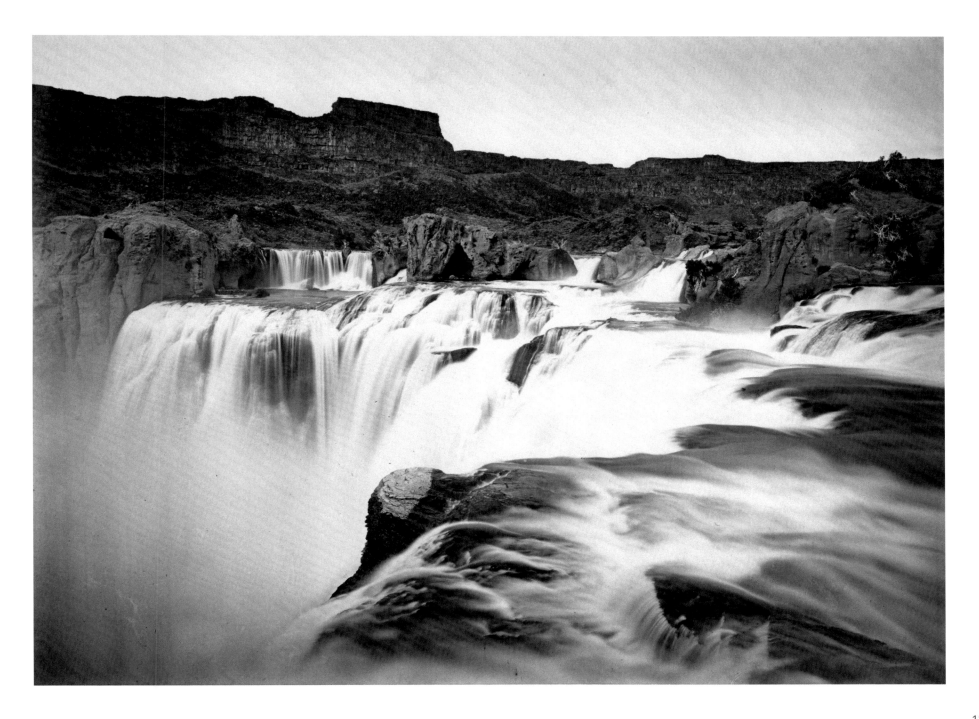

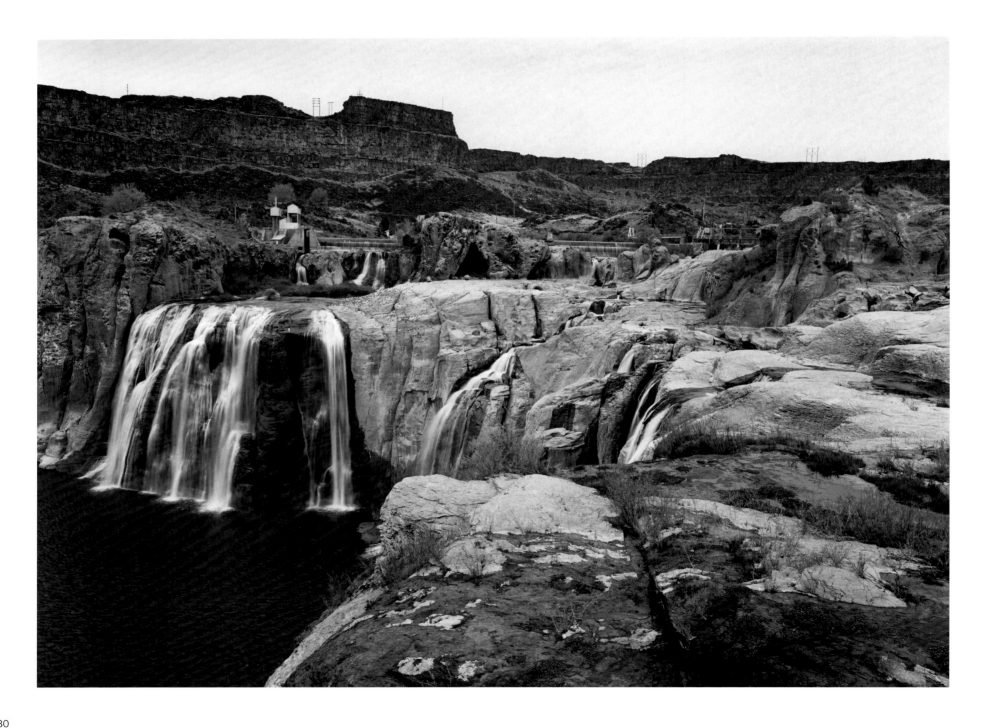

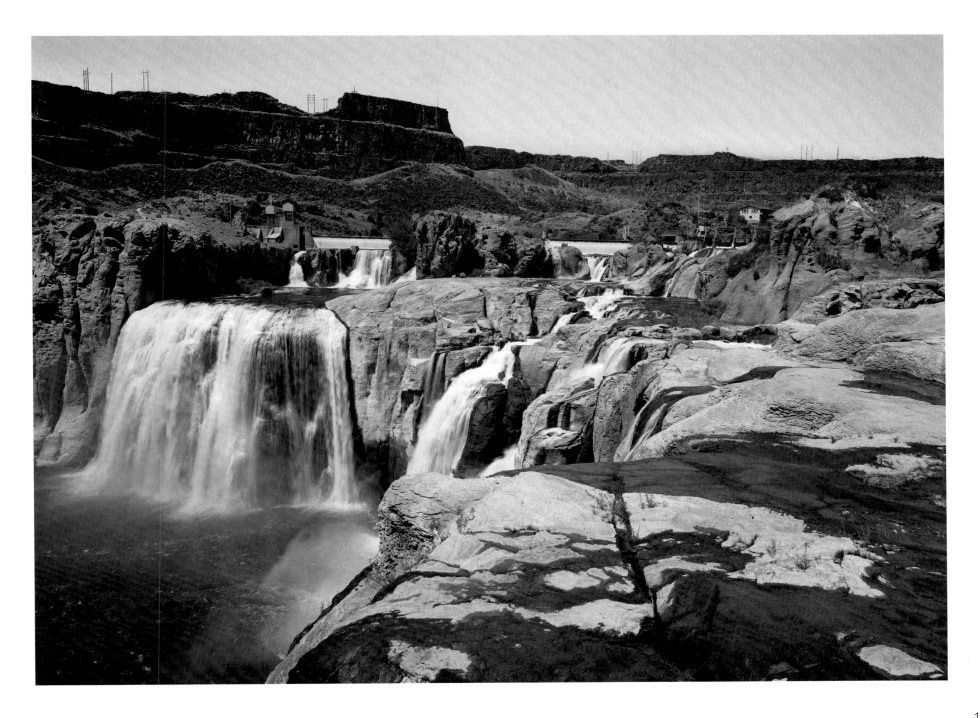

In O'Sullivan's photograph a man sits on a rock outcrop above and to the west of Shoshone Falls and writes or draws. This is the highest of the vantage points O'Sullivan chose, and it is his most distant view of the falls and the surrounding Snake River canyon. The photograph, in lithographic form, was reproduced in the King Survey geological report.

The Rephotographic Survey Project did not repeat this photograph in the 1970s. Again, the original was found on the National Archives website while searching for photos of the region at the Twin Falls Public Library. The image was downloaded and taken to the site on a laptop. The laptop's screen was then used to line up the vantage point and make the rephotograph. This was the project's first (and only) use of an electronic image in the field for making rephotographs. In the second view Byron Wolfe sits in the same place as O'Sullivan's figure and looks at the original image on the laptop's screen. The screen image was almost impossible to see in bright daylight, so he used the cover of a dark T-shirt to view the screen while aligning the vantage point.

We anticipate that future rephotographic work will be done through electronic means. Using a digital camera at the site and overlapping the photograph with a copy print of the image will quickly and visually verify the accuracy of vantage points. Although the technology to do this electronically was available at the time this Third View rephotograph was made, it was not quite good enough for convenience or high-quality work. Quality digital backs for the view cameras used by the project existed but were well beyond the range of the project budget.

SHOSHONE FALLS (FROM ABOVE)

PAGE 134
TIMOTHY O'SULLIVAN, CA. 1868. SHOSHONE FALLS, IDAHO
(NATIONAL ARCHIVES)

PAGE 135
MARK KLETT AND BYRON WOLFE FOR THIRD VIEW, 1999.
SHOSHONE FALLS FROM ABOVE THE PARK, TWIN FALLS, ID

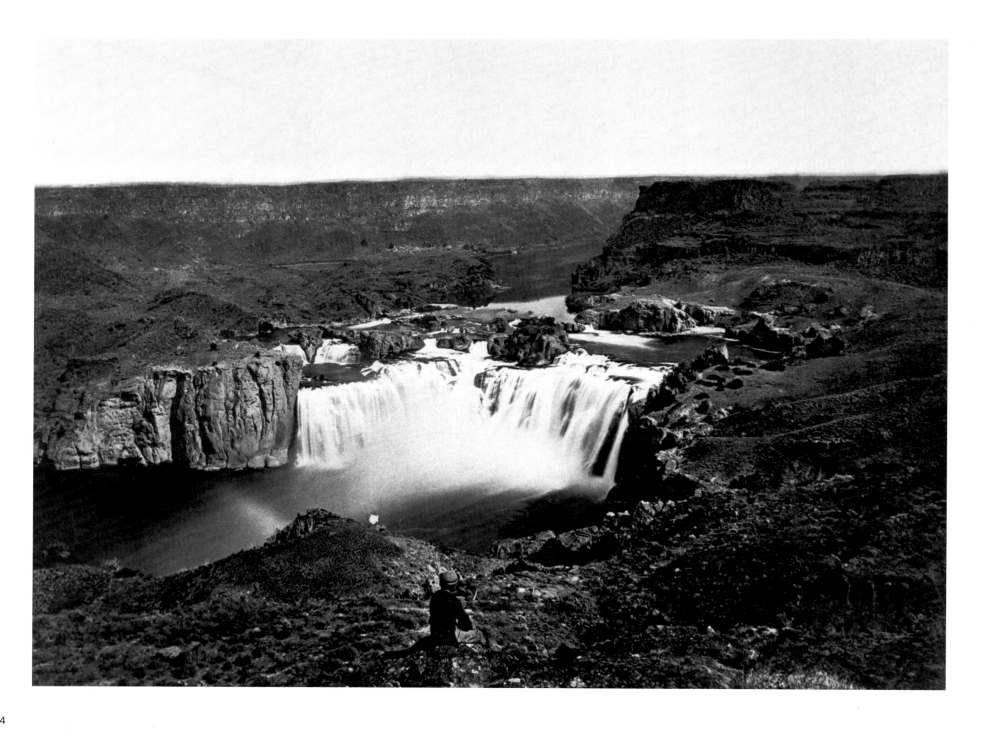

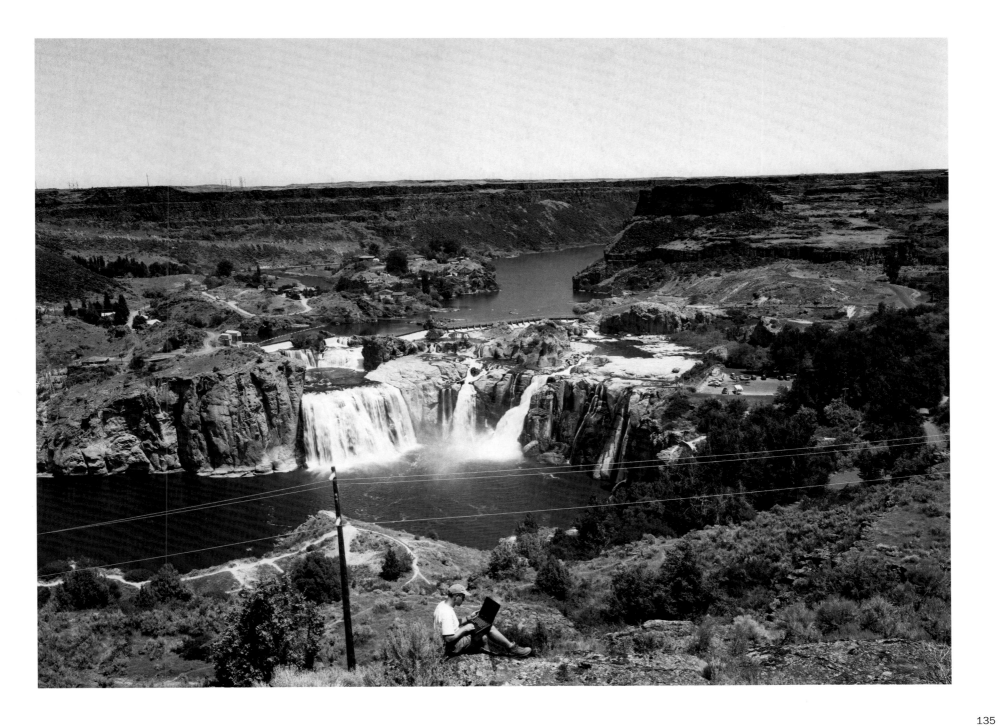

HORSESHOE BEND, FLAMING GORGE, UTAH

PAGE 137
TIMOTHY O'SULLIVAN, 1872. GREEN RIVER CAÑON, UPPER
CAÑON, GREAT BEND, UINTA MTS. THE HORSESHOE AND
GREEN RIVER BELOW THE BEND FROM FLAMING GORGE
RIDGE (U.S. GEOLOGICAL SURVEY)

PAGE 138
MARK KLETT FOR THE REPHOTOGRAPHIC SURVEY PROJECT,
1978. FLAMING GORGE RESERVOIR FROM ABOVE THE SITE
OF THE GREAT BEND, UT

PAGE 139
MARK KLETT AND BYRON WOLFE FOR THIRD VIEW, 1999.
FLAMING GORGE RESERVOIR FROM ABOVE THE SITE OF THE
GREAT BEND, UT

This was the site of what was called in early photographs the "Great Bend" on the Green River. O'Sullivan stood high above the river along a sharp divide. In front of his camera the rocks dropped precipitously to the river five hundred feet below. Behind him the edge sloped sharply away in an incline of brightly colored red, yellow, and brown upturned sedimentary rock. The vantage point sits atop a small knob near the edge of the precipice, just large enough for a tripod and photographer.

The most startling change occurred between 1872 and 1978, when the Flaming Gorge Reservoir was constructed. In fact, the most dynamic changes documented by the Rephotographic Survey Project and Third View involved water, such as its impounding in this case, but also its draining or transportation. Water- and fire-related events are responsible for the largest physical changes in the nonurban western landscape. In 1999 the reservoir's level was slightly higher than in 1978. A boat cruises below the vantage point where water-skiers had played for several hours.

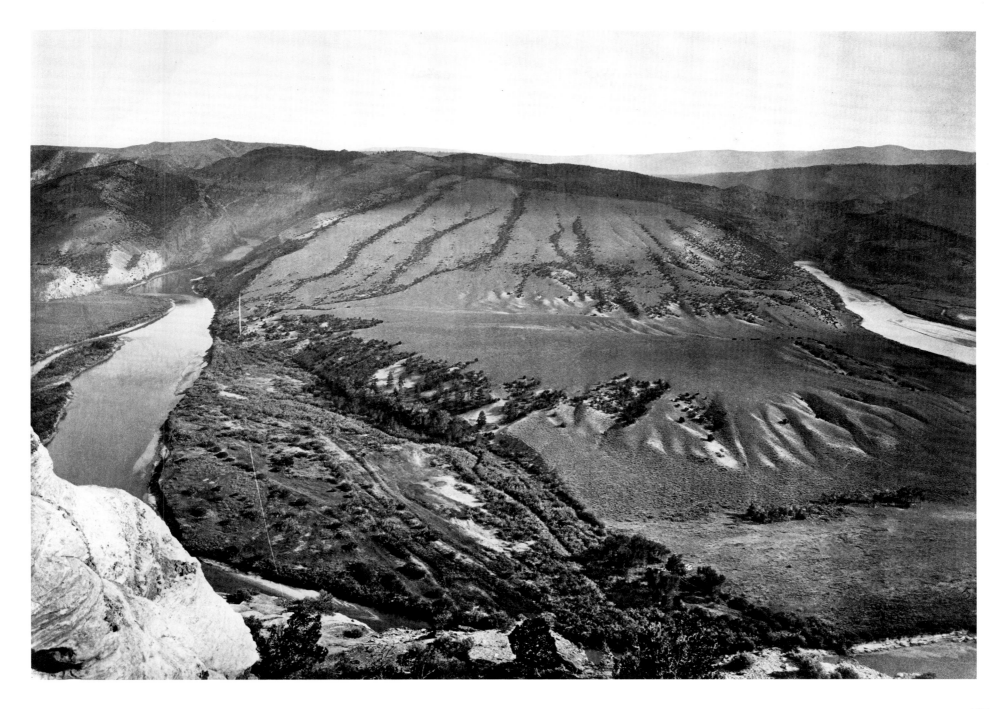

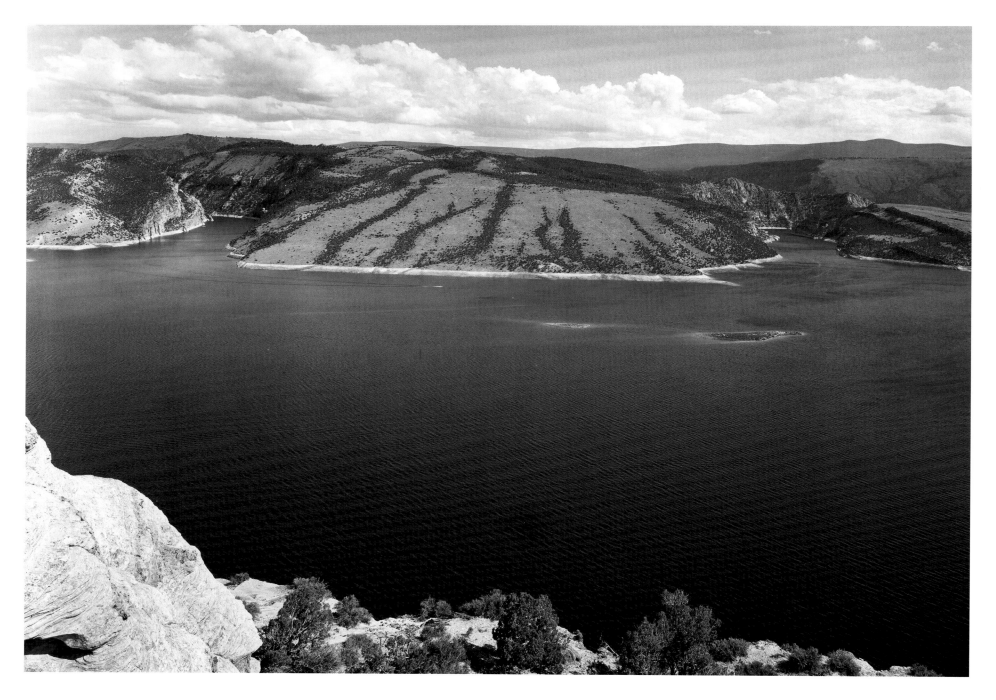

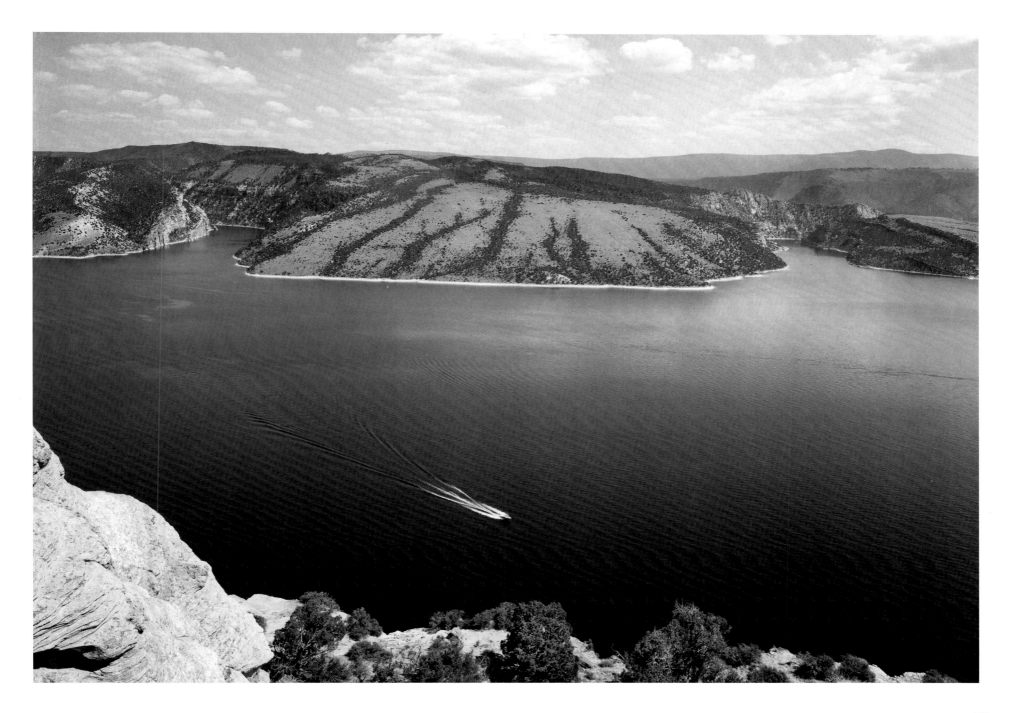

The vantage point for this photograph lies about twenty-five meters to the north of the Horseshoe Bend site and along the same sharp ridge. The photograph was reproduced lithographically as Plate I in the King Survey report, *Descriptive Geology*. The sandstone overhang is dramatic, and its top is the vantage point of another O'Sullivan photograph looking northeast toward the river.

All the locations on this ridge are extremely remote and difficult to climb to. We saw few signs of visitors to the ridge tops. At this site Kyle Bajakian found a piece of flat glass, purple with age, where O'Sullivan's camera stood on its tripod. No other pieces were found. It was the consensus of the field crew that this glass could have been part of a broken O'Sullivan plate.

FLAMING GORGE, UTAH (CLIFF VIEW)

PAGE 142
TIMOTHY O'SULLIVAN, 1872. HORSESHOE CURVE, GREEN RIVER (NATIONAL ARCHIVES)

PAGE 143
MARK KLETT AND BYRON WOLFE FOR THIRD VIEW, 1999. FLAMING GORGE RESERVOIR FROM FLAMING GORGE RIDGE, UT (LOOKING SOUTH)

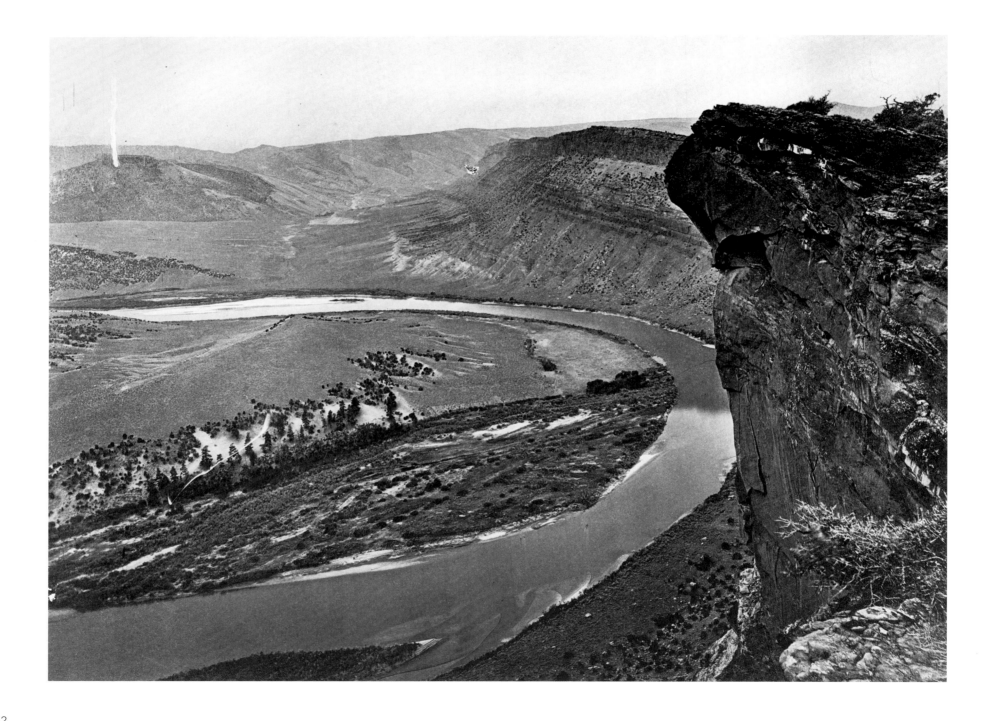

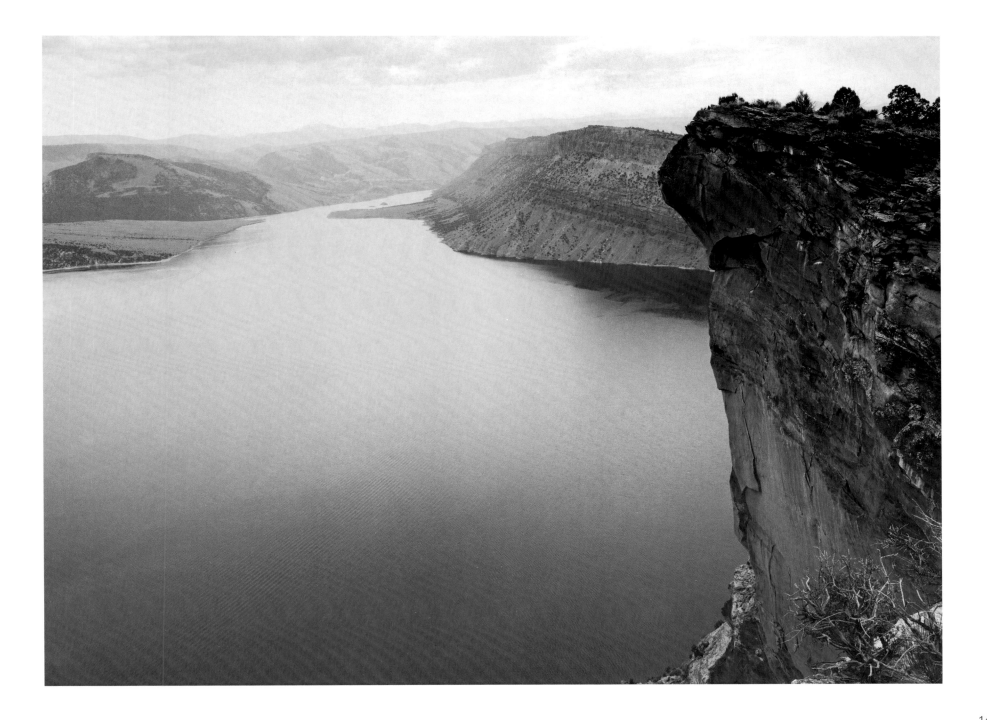

The site of this photograph is south of the paved route to the Golden Spike National Historic Site near Promontory, Utah. The railroad grade still can be found, although the trestle was removed only a few years after Russell made his photograph. The structure was the result of competition between two rival companies racing to the point where the rails from the East Coast would meet those approaching from the west. In the Russell photo, the grade following the contours of the surrounding hills had already been laid, and bridging the gap with a trestle became the most expedient option in the race to Promontory. Nearby, the historic site celebrates the 1869 completion of the intercontinental railroad with about one mile of relaid track and train engines that were re-created to within a fraction of an inch of the nineteenth-century originals.

Russell made the photograph as part of his series for the railroad, not for one of the geological surveys. The Rephotographic Survey Project did not repeat the photograph in the 1970s, and the Third View team made the second image only after visiting and considering the location of the site. Visible in the background of the second view are the buildings of Morton Thiokol, the maker of rocket boosters, including those for the space shuttle. Ten miles past the visitor's center of the national site, in the other direction on the edge of the Great Salt Lake, is the celebrated and often submerged earthwork *Spiral Jetty*, by artist Robert Smithson.

The Field Notes indicate the importance of this site to the project and the confluence of history, technology, and art around the location of the disappearing trestle. When we visited it on July 4, 1999, a reenactment of the driving of the Golden Spike was held, marking the 130-year anniversary of the event. The actors playing the historic characters in the reenactment asked us to participate, and with cameras set up, we became players in the historical drama, the "famous photographers who came from around the world."

**TRESTLE AND THE 119,
NEAR PROMONTORY, UTAH**

PAGE 146
ANDREW J. RUSSELL, 1869. BIG TRESTLE AND THE 119
(OAKLAND MUSEUM)

PAGE 147
MARK KLETT AND BYRON WOLFE FOR THIRD VIEW, 2000.
SITE OF THE BIG TRESTLE, HALFWAY BETWEEN GOLDEN
SPIKE NATIONAL HISTORIC SITE AND MORTON THIOKOL
CORPORATION, NEAR PROMONTORY, UT

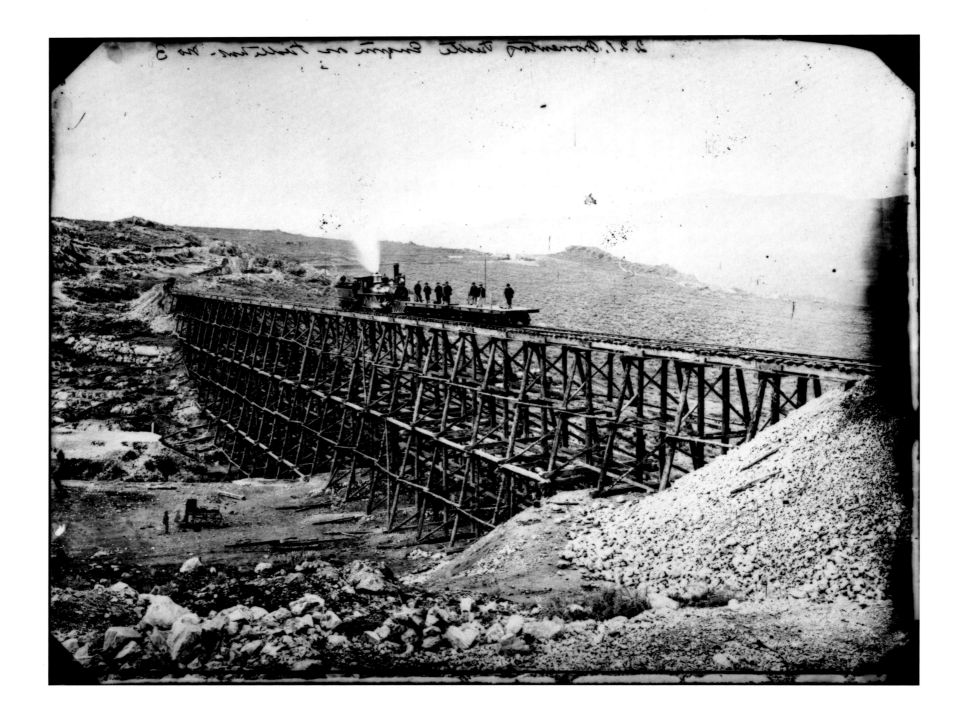

HOT SPRINGS AND CASTLE GEYSER, YELLOWSTONE NATIONAL PARK, WYOMING

William Henry Jackson was the first photographer of Yellowstone for the Hayden Survey in 1871. He returned the next year to make this photograph and many other precedent-setting images of natural features. In one of the earliest acts of political activism by a landscape photographer, Jackson printed copies of his photographs for members of Congress and thereby influenced their vote in favor of creating the first national park at Yellowstone.

The Crested Hot Springs lie adjacent to the Castle Geyser, located on the boardwalk-covered trail through the Upper Geyser Basin, one of the most popular places for visitors to the park. By 1978 an elevated walkway with guardrails had been constructed over previously open paths; before that, at least one accidental death occurred at this site. By 2000 the walkway had been moved slightly and somewhat enlarged.

A separate view of the Castle Geyser shows subtle changes in the body of the geyser and surrounding platform. The mineral-rich waters add to the surrounding rock through accretion, in opposition to the forces of erosion. Early tourists chipped souvenirs off geyser fountains before such vandalism was prohibited.

The site is precedent setting because it was among the first views of Yellowstone. As such, it raises questions about the influence of Jackson's photography. In many cases walkways have been built almost to the exact location of Jackson's photographs. Is this because there are only certain geographic places to build walkways, and they just happen to be near Jackson's vantage points? Or is it because, as the first photographer of Yellowstone, Jackson's vision became pervasive and influenced all those who followed, creating somewhat standardized viewing locations for park features? Without being conclusive, evidence would suggest a mix of both. Jackson's work in Yellowstone, like many photographs by other nineteenth-century photographers, helped craft twentieth- and twenty-first-century views of both Yellowstone and the American West.

To make the second and third views, permission and permits from the U.S. Park Service were required. A park ranger accompanied the field team off the walkways to the vantage point at this and other sensitive locations in the park.

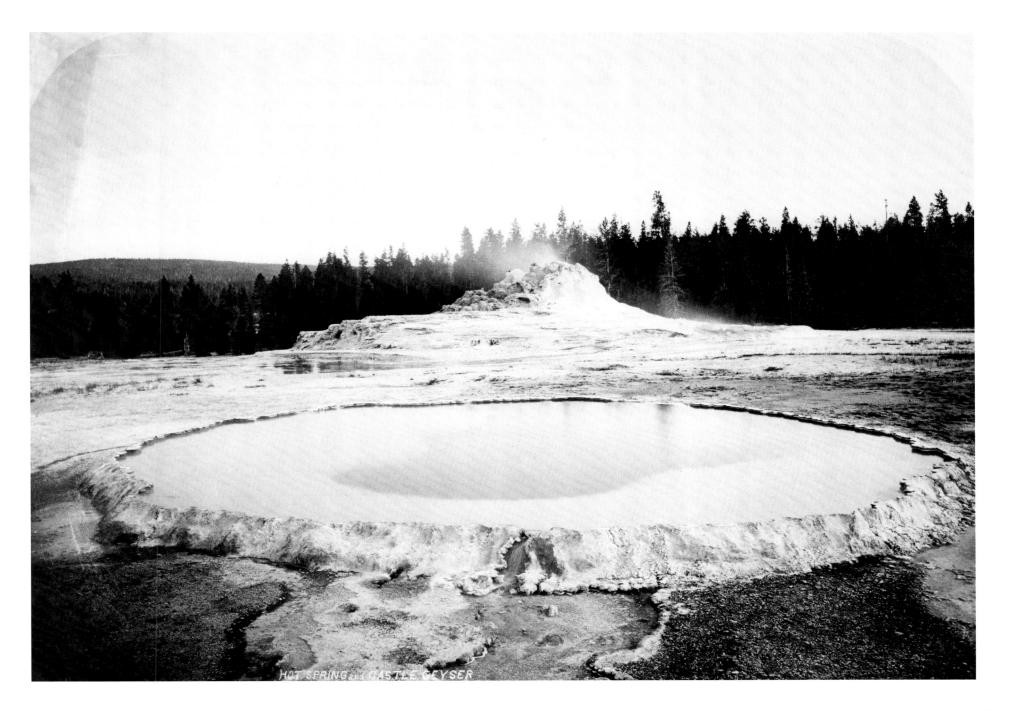

HOT SPRING and CASTLE GEYSER

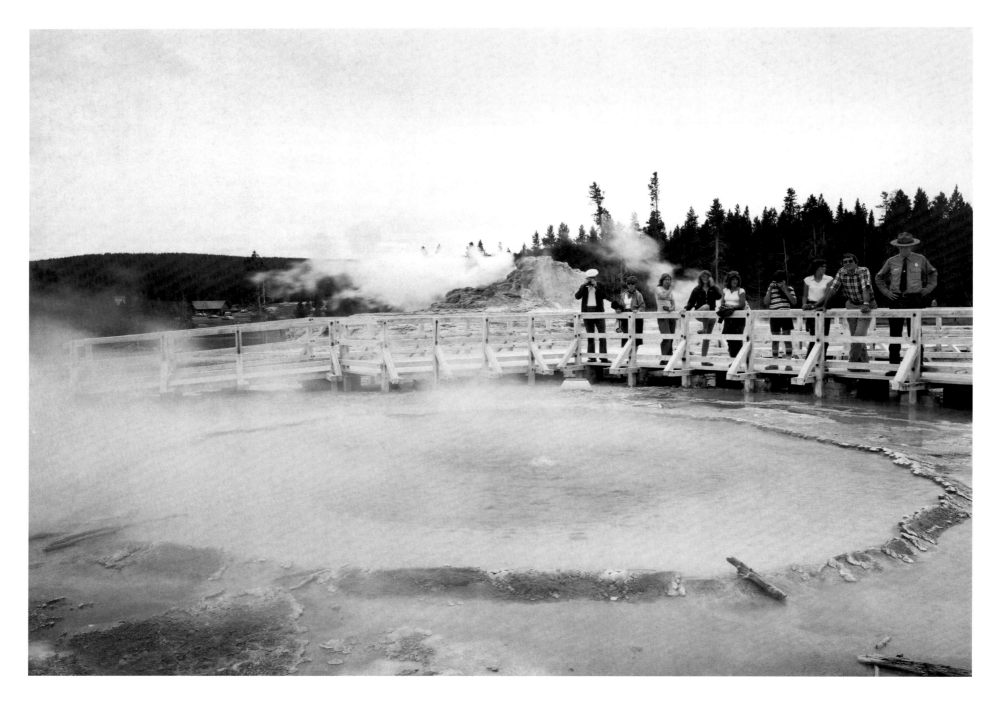

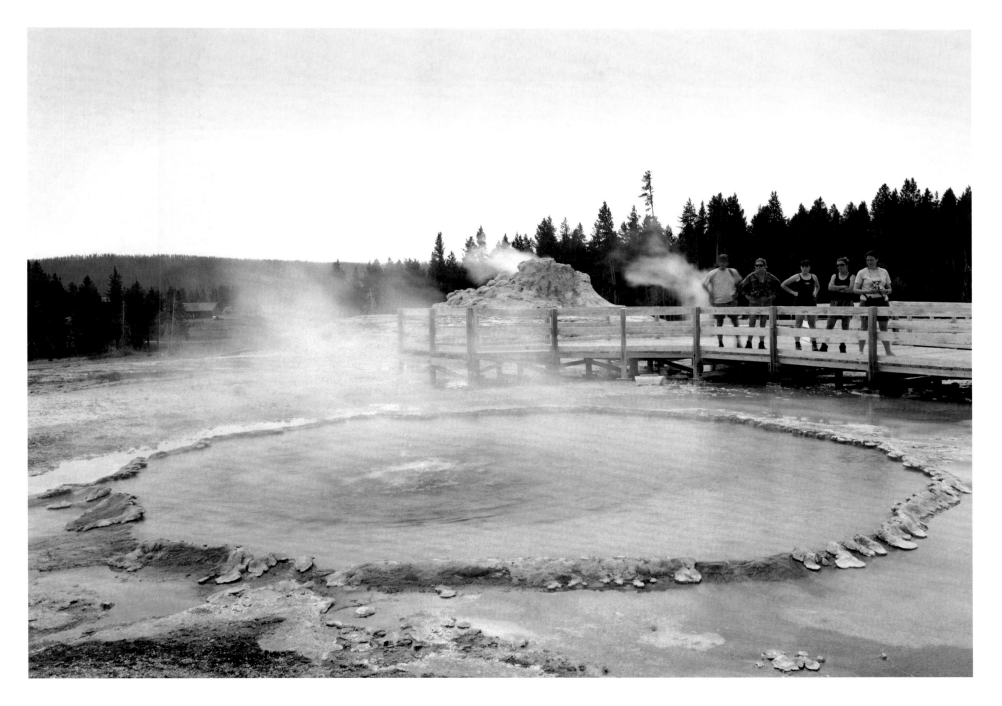

The vantage point for Jackson's version of Old Faithful is off the existing walkway, closer to the vent of the geyser. A park ranger accompanied the two-person field team to the location and answered visitor questions about the project. In August there are hundreds of visitors for each daytime eruption. There was some resentment on the part of a few visitors that we would appear in their photographs.

The geyser vent has changed as a result of the minerals precipitated out of the hot water. Rephotographing the water plume itself is something of a conceptual exercise. The shape and size of the plume vary naturally with each eruption and are influenced by the wind direction and temperature. Jackson's photograph seems to show more steam and probably was made on a cooler day.

The placement of figures in Jackson's photograph is telling about his point of view. They stand very close to the vent, much closer than would be allowed for safety, even by special permit, under current regulations. Their body positions suggest they are unconcerned by any danger, and together they appear in confident control.

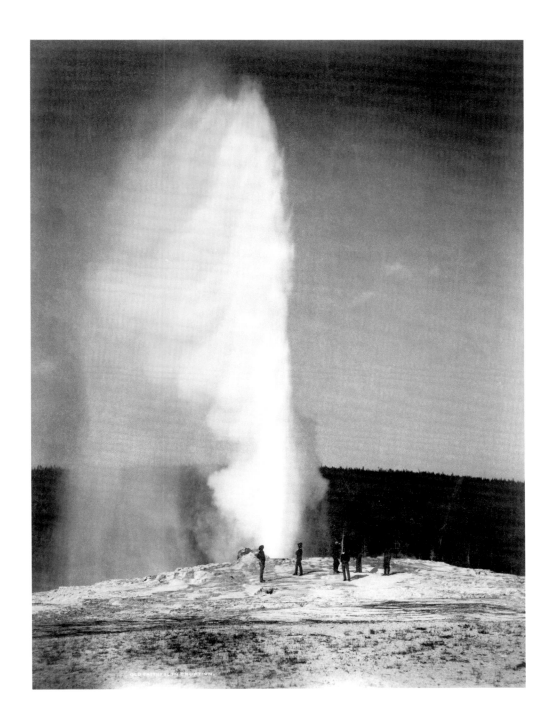

OLD FAITHFUL IN ERUPTION.

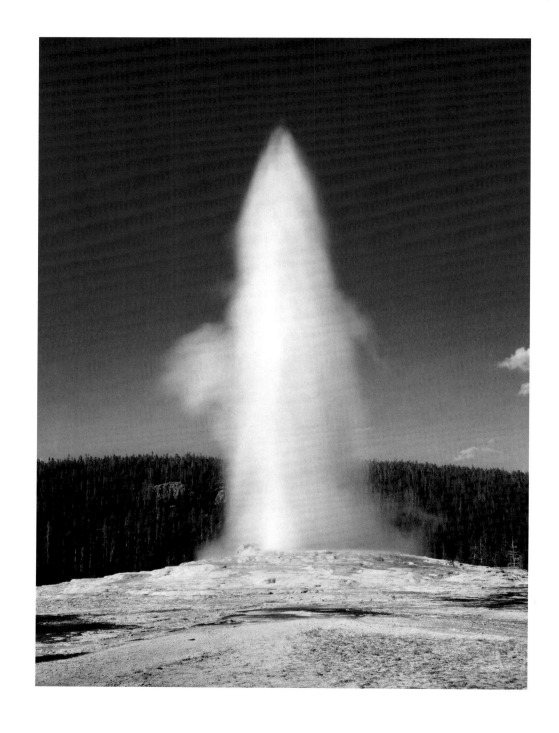

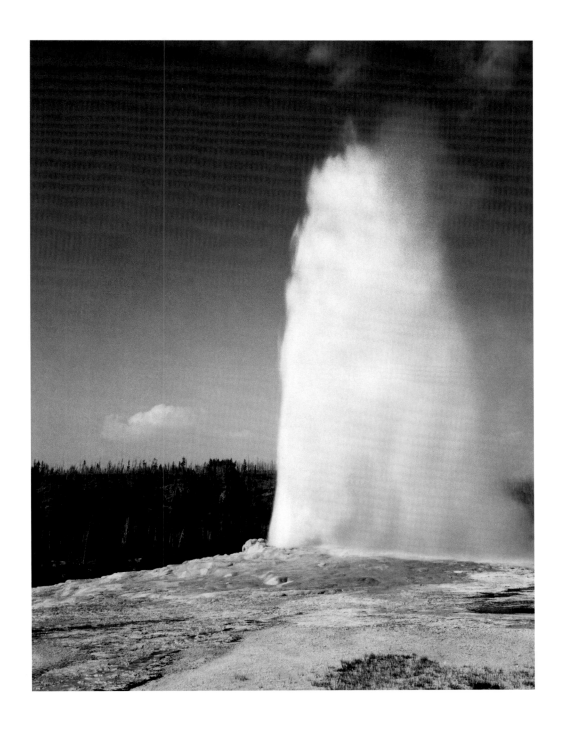

COLUMNAR BASALTS, YELLOWSTONE NATIONAL PARK, WYOMING

PAGE 157
WILLIAM HENRY JACKSON, 1872. COLUMNAR BASALTS ON
THE YELLOWSTONE RIVER (MUSEUM OF NEW MEXICO)

PAGE 158
MARK KLETT AND GORDON BUSHAW FOR THE
REPHOTOGRAPHIC SURVEY PROJECT, 1978. COLUMNAR
BASALTS ON THE YELLOWSTONE RIVER, YELLOWSTONE
NATIONAL PARK, WY

PAGE 159
MARK KLETT AND BYRON WOLFE FOR THIRD VIEW, 2000.
COLUMNAR BASALTS ON THE YELLOWSTONE RIVER AFTER
THE FIRE, YELLOWSTONE NATIONAL PARK, WY

The vantage point is on a ridge overlooking the Yellowstone River north of Tower Junction. The distinctive vertical lines caused by the basalt columns can be seen capping the canyon walls on the river's east side. The rock formed from an ancient lava flow. Between the second and third views the park experienced well-publicized forest fires, and many of the trees near this site were affected. Downed trees now dominate the foreground of this view.

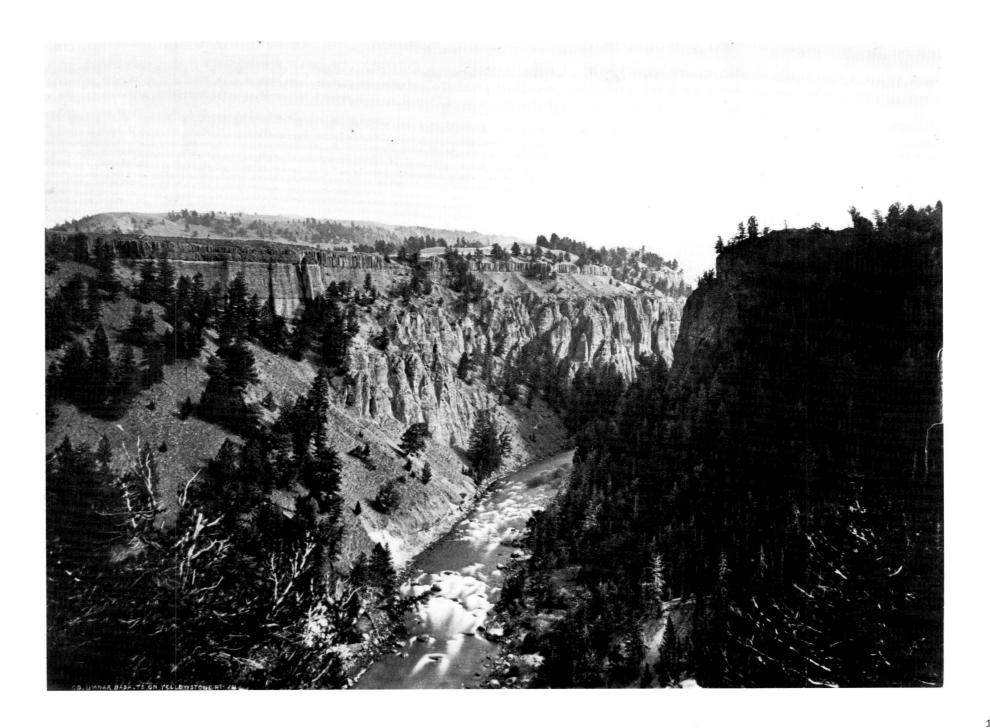

COLUMNAR BASALTS ON YELLOWSTONE RIVER

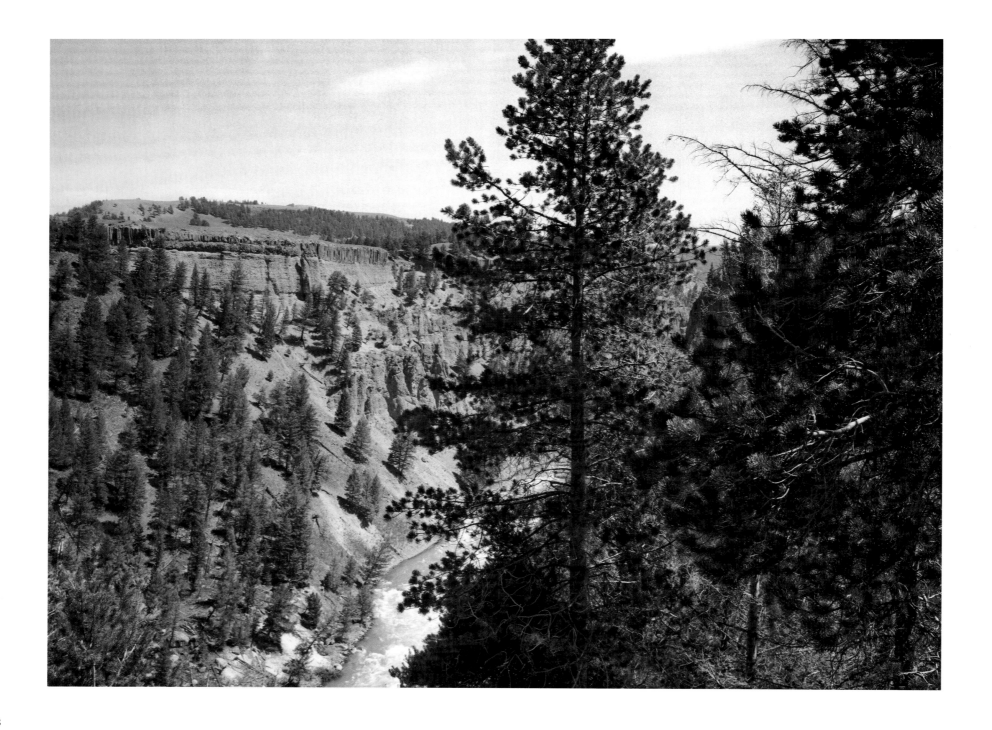

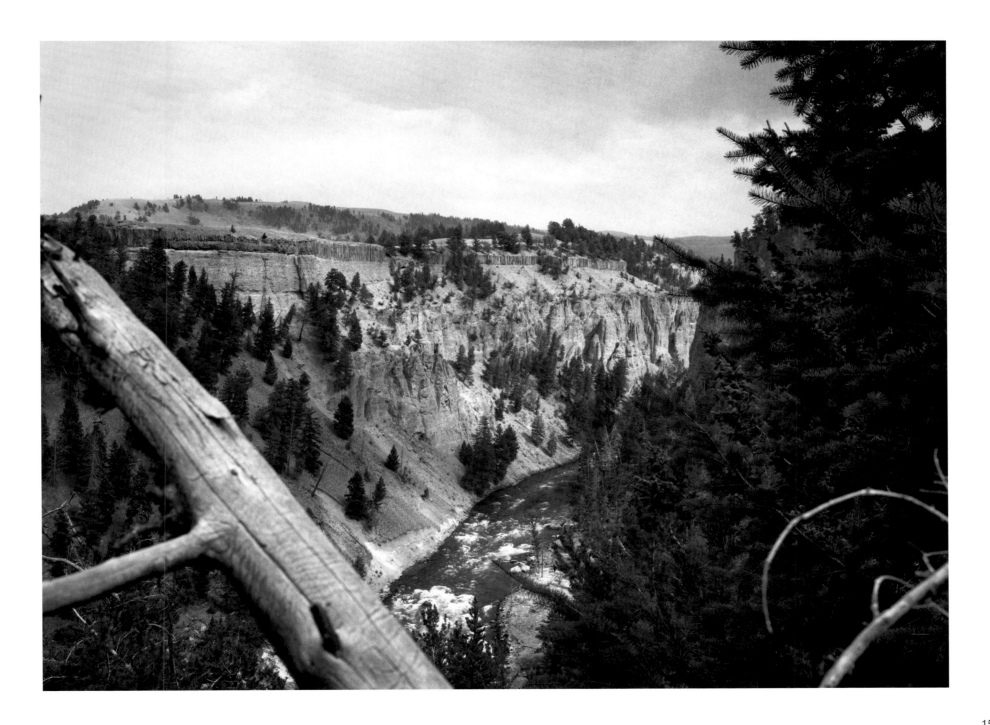

LONE STAR GEYSER, YELLOWSTONE NATIONAL PARK, WYOMING

In Jackson's photograph a figure on top of Lone Star Geyser investigates the vent with what looks like a weighted line. In both the second and third views the geyser is erupting with great force, revealing such an investigation to be hazardous and regaining for the geyser a certain natural autonomy.

This geyser is not on the main geyser basin trail and must be accessed by a walking trail to the site.

In 1978 no other people were at the geyser when it was rephotographed, but in 2000 there were approximately twenty people waiting up to several hours for the geyser to erupt. Before and after the event bathers waded in the nearby Firehole River, and from under a tree children read aloud from the popular book of the season, *Harry Potter and the Sorcerer's Stone.*

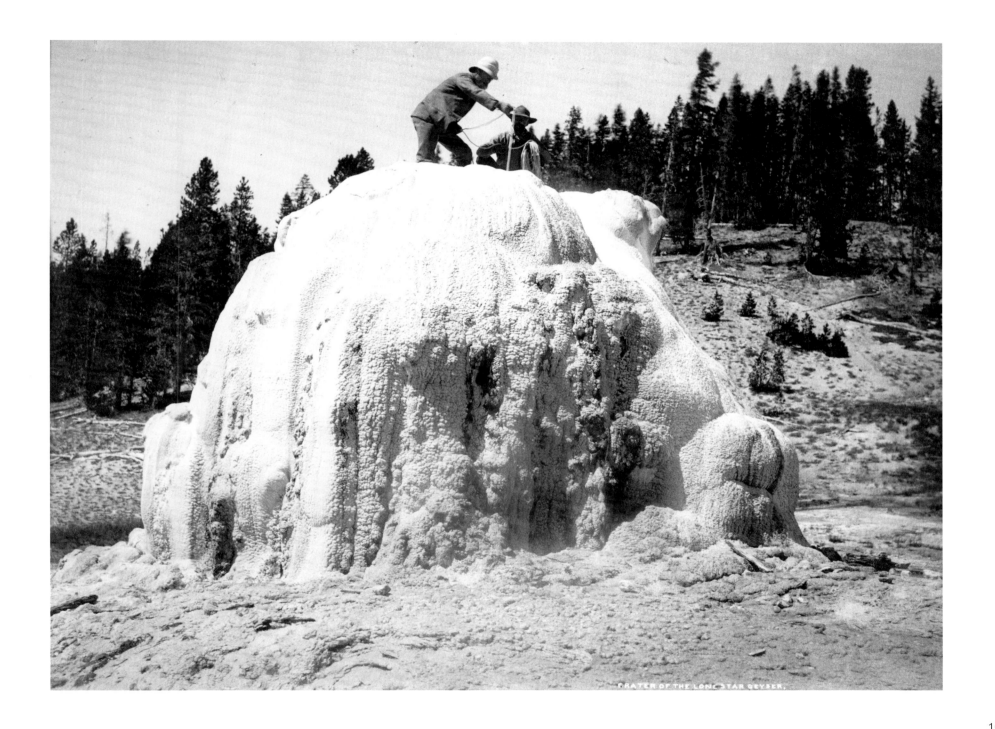

CRATER OF THE LONE STAR GEYSER.

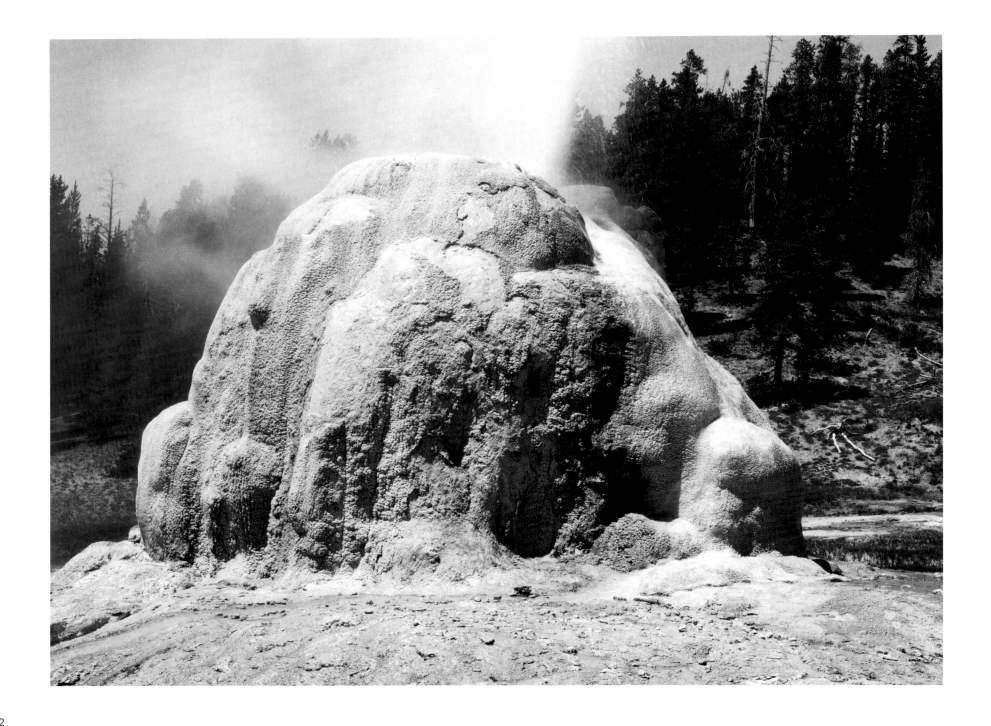

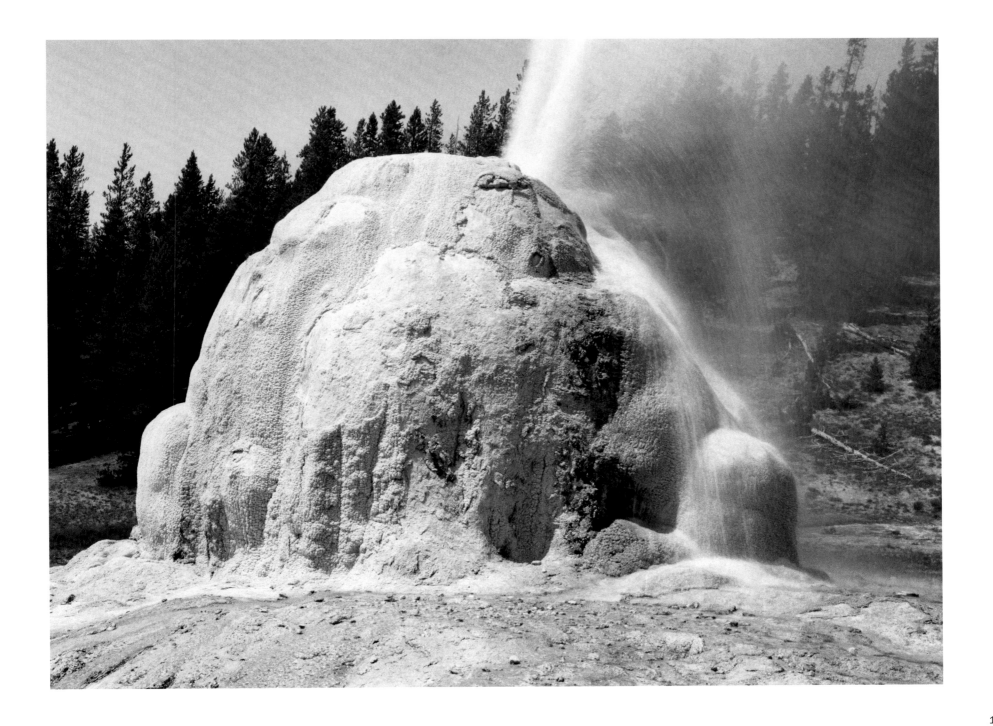

The springs at Mammoth change locations over time, and this terrace was still active when Jackson photographed it in the 1880s. By 1978 the water had moved elsewhere, but it was a surprise to find the dead trees in Jackson's photo still standing. In 2000 the trees remained and little had changed their gray wood. Only the old terrace of travertine had crumbled and decayed significantly.

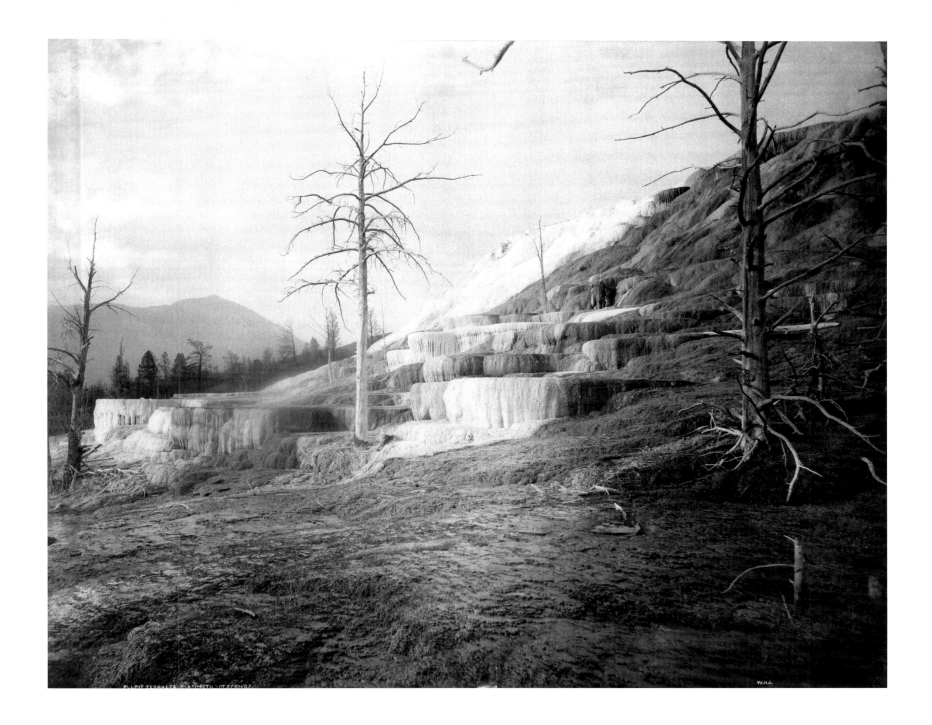

PULPIT TERRACES, MAMMOTH HOT SPRINGS. W.H.J.

165

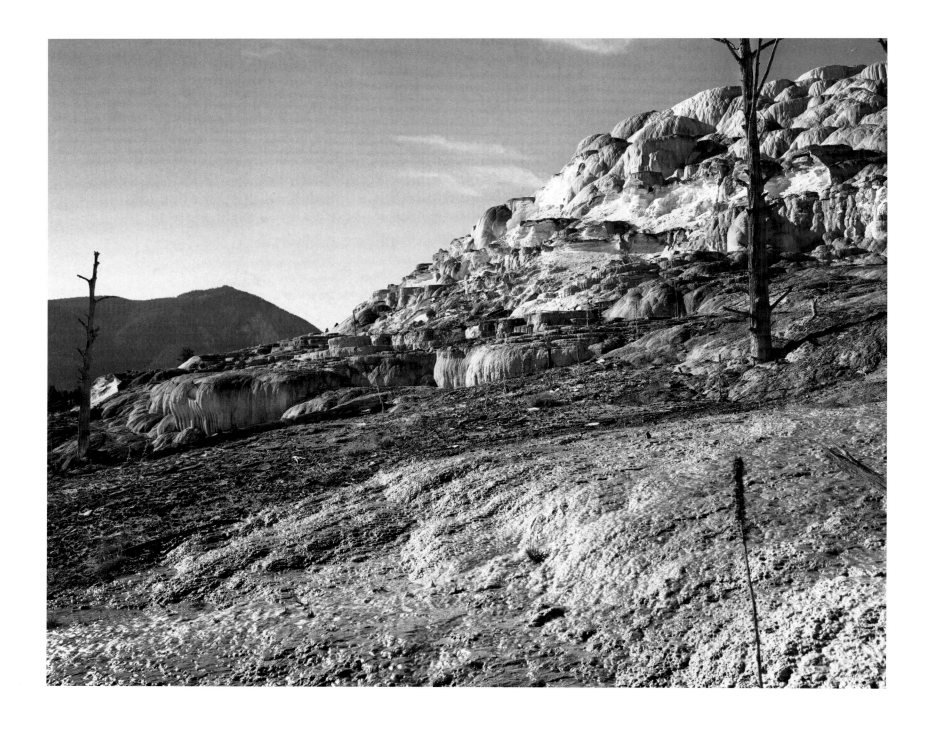

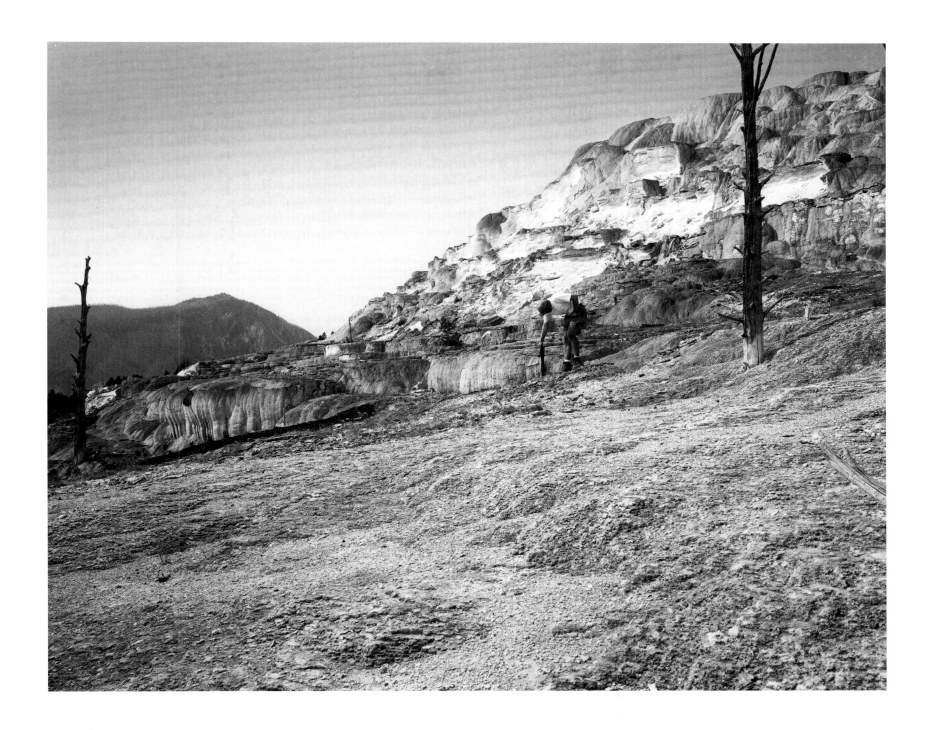

The original photographs show the mouth of Lodore Canyon on the Green River in the extreme northwest corner of Colorado. Using the same vantage point, O'Sullivan made his photographs at two distinct times, mid-morning and late afternoon. The rephotographs duplicate the time of day of these two photographs.

The decision to record the same place at different times was an unusual one for a nineteenth-century photographer. The afternoon photo in particular was many hours past the time of day normally used for wet-plate photography. Photographers of the era preferred the strong, bluer light of midday, and they rarely worked past two in the afternoon. But O'Sullivan made similar exposures high above Lodore Canyon from another vantage point that showed the canyon walls at different times of day. Thus, his was a deliberate choice, and the results show how light defines the shape and changing experience of the canyon walls.

The mouth of Lodore Canyon is the starting point of contemporary river trips that float the Green River. The Park Service built a campground and raft launch about a quarter mile upriver from the vantage point.

GATES OF LODORE CANYON, COLORADO

PAGE 170
TIMOTHY O'SULLIVAN, CA. 1872. CANYON OF LODORE, GREEN RIVER, WYOMING (MORNING) (NATIONAL ARCHIVES)

PAGE 171
MARK KLETT AND BYRON WOLFE FOR THIRD VIEW, 2000. GATES OF LODORE CANYON, GREEN RIVER, CO (MORNING)

PAGE 172
TIMOTHY O'SULLIVAN, CA. 1872. CANYON OF LODORE, GREEN RIVER, WYOMING (AFTERNOON) (NATIONAL ARCHIVES)

PAGE 173
MARK KLETT AND BYRON WOLFE FOR THIRD VIEW, 2000. GATES OF LODORE CANYON, GREEN RIVER, CO (AFTERNOON)

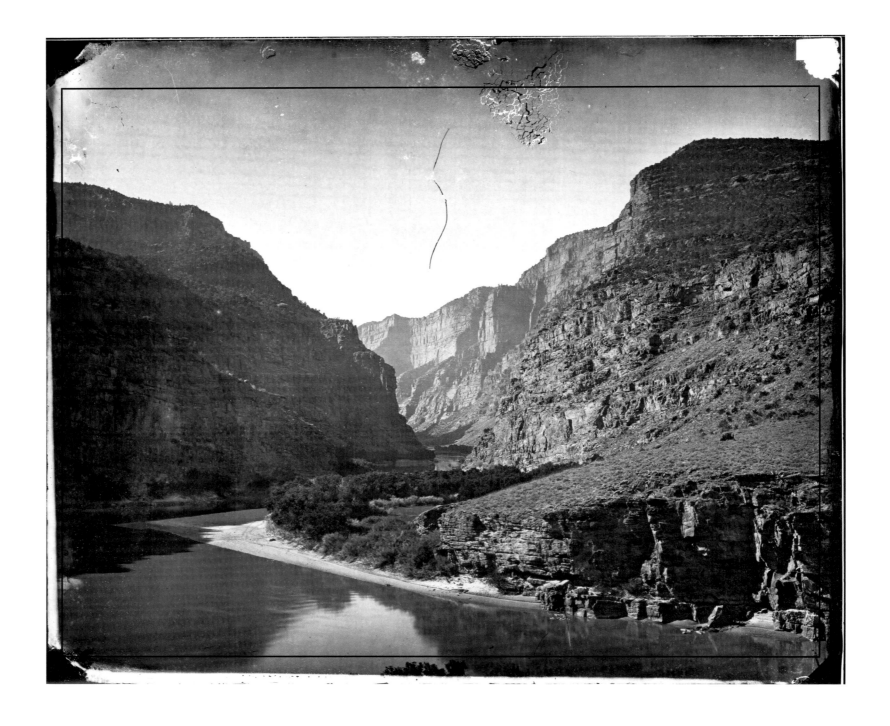

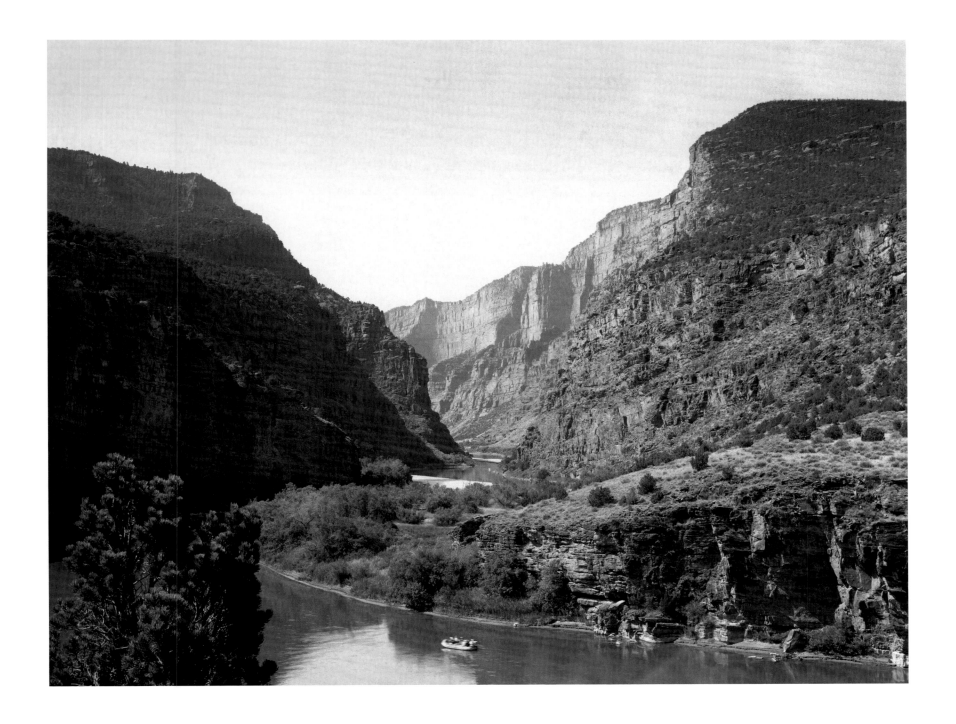

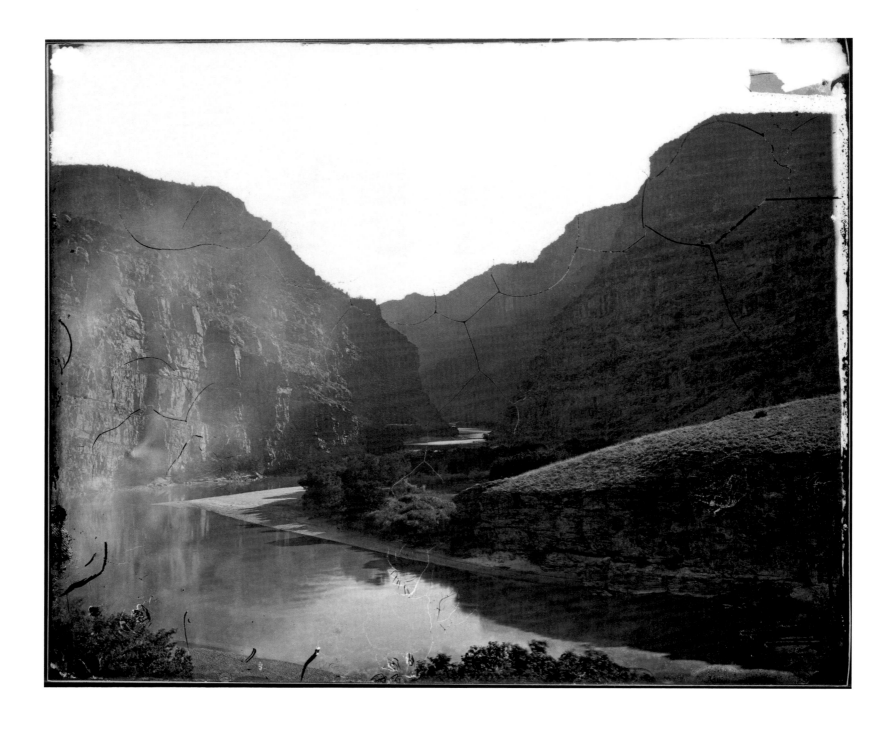

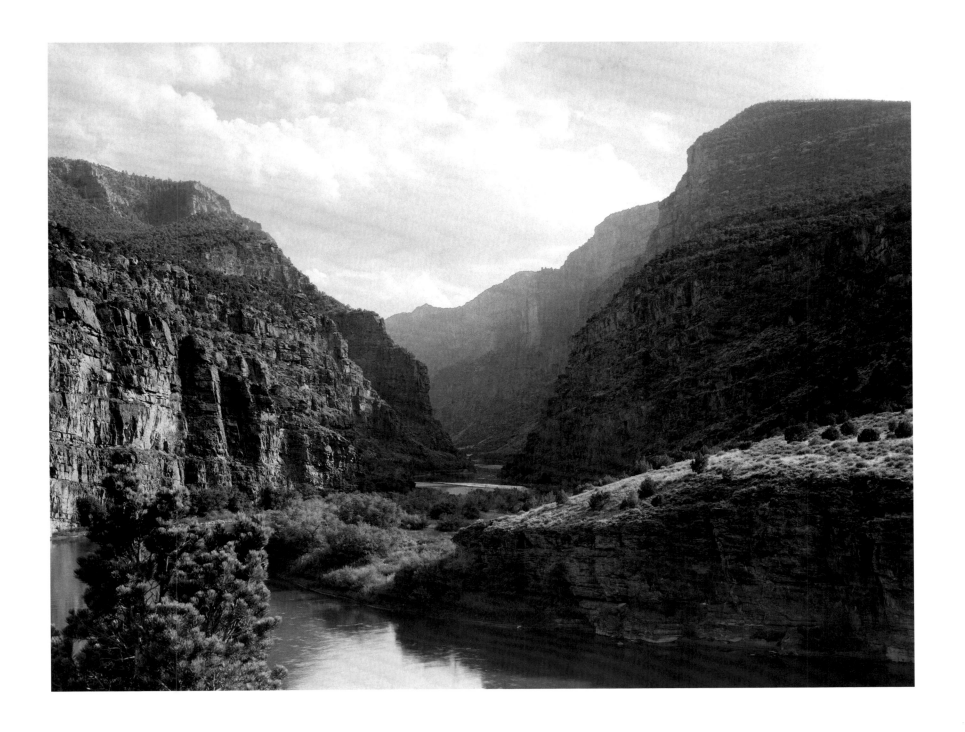

MOUNTAIN OF THE HOLY CROSS, COLORADO

Jackson made this view of the Mountain of the Holy Cross in 1873 while working for the Hayden Survey in central Colorado. It was perhaps his most famous photograph and widely viewed as a symbol of "Manifest Destiny," a sign that God blessed the American continent and national enterprise. Thomas Moran based his famous 1875 painting of the cross on Jackson's photograph.

Jackson's diary recalls the setting. His party had been looking for a mountain that reportedly had a cross of snow. The cross had been elusive, and its existence was the subject of rumors. Like others, Jackson embellished stories about the cross and how difficult it was to find. The day before the photograph was made, he and his companions climbed Notch Mountain to secure a view and spent a stormy night with nothing more than "pocket lunches" for provisions. Across the valley to the west they exchanged calls with members of Hayden's team perched on Holy Cross Mountain. In the morning the storm clouds broke, and with sunshine on white snow the cross was photographed for the first time. Though Jackson returned to photograph the mountain again in later years, he admitted that none of those efforts matched the first photograph.

In 1978 the Rephotographic Survey Project made its second visit to the site. The year before almost no snow was in the cross, and we dubbed it "The Mountain of the Holy Apostrophe." In 2000 there was slightly less snow than in 1978, and it illustrates why the mountain was so hard to find for early white settlers and why its appearance was so variable. Depending on snowfall, in some years the cross simply didn't exist. Some researchers claim Jackson retouched his negative to amplify the snow on the cross. Still, we believe Jackson was just at the right place at the right time (and year). This judgment is based partly on research done by the RSP, by examining original Jackson negatives, and partly on experience at the site and knowledge of its variable snowfall and topography.

The Mountain of the Holy Cross lies less than two miles to the west of the vantage point. Jackson's camera stood above thirteen thousand feet on the north side of the "notch" of Notch Mountain. South of this position, at the top of the trail built to the summit, a small stone cabin was erected in the 1930s. For many years this was the site of Easter services and religious pilgrimages. Myths abound about the cross to the present day, including one that claimed army cannons used the cross for target practice during training at a nearby military camp during World War II.

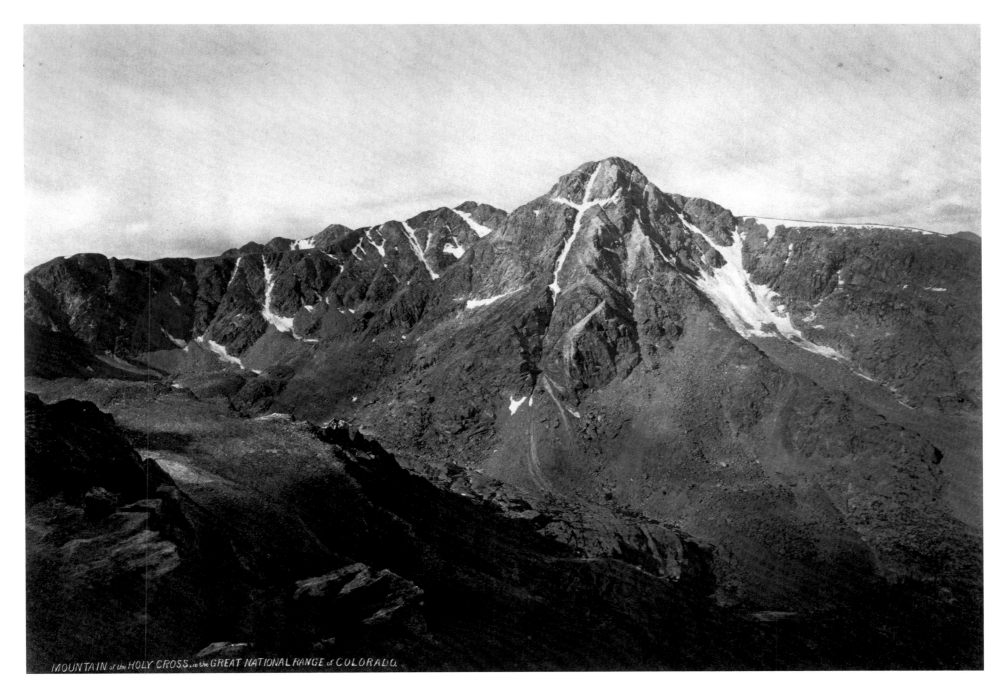

MOUNTAIN of the HOLY CROSS, in the GREAT NATIONAL RANGE of COLORADO.

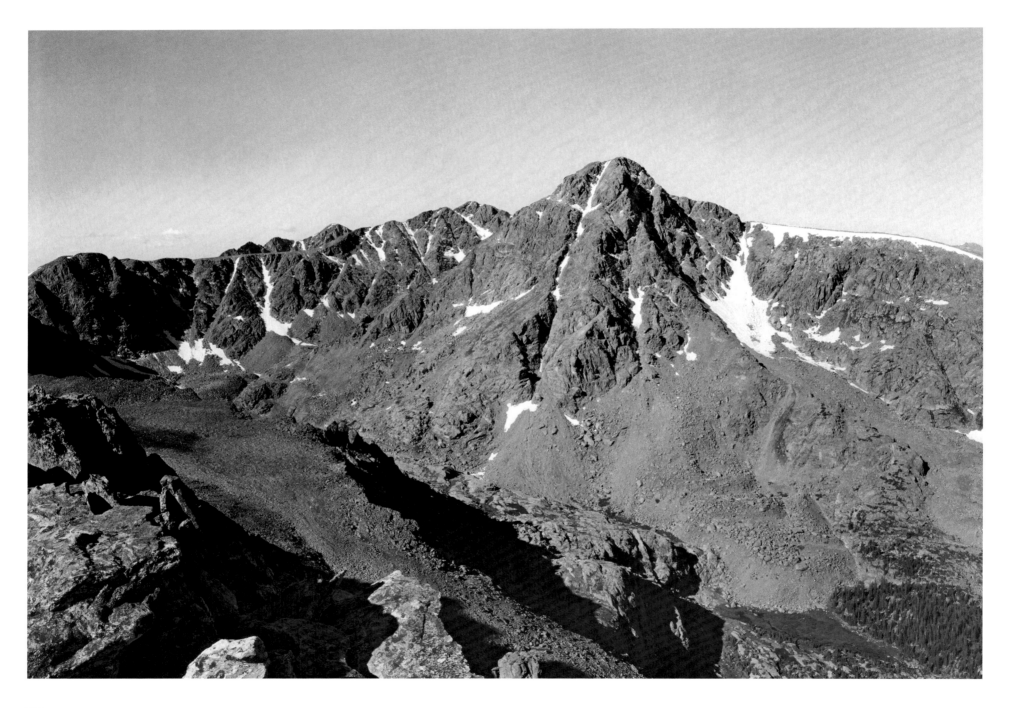

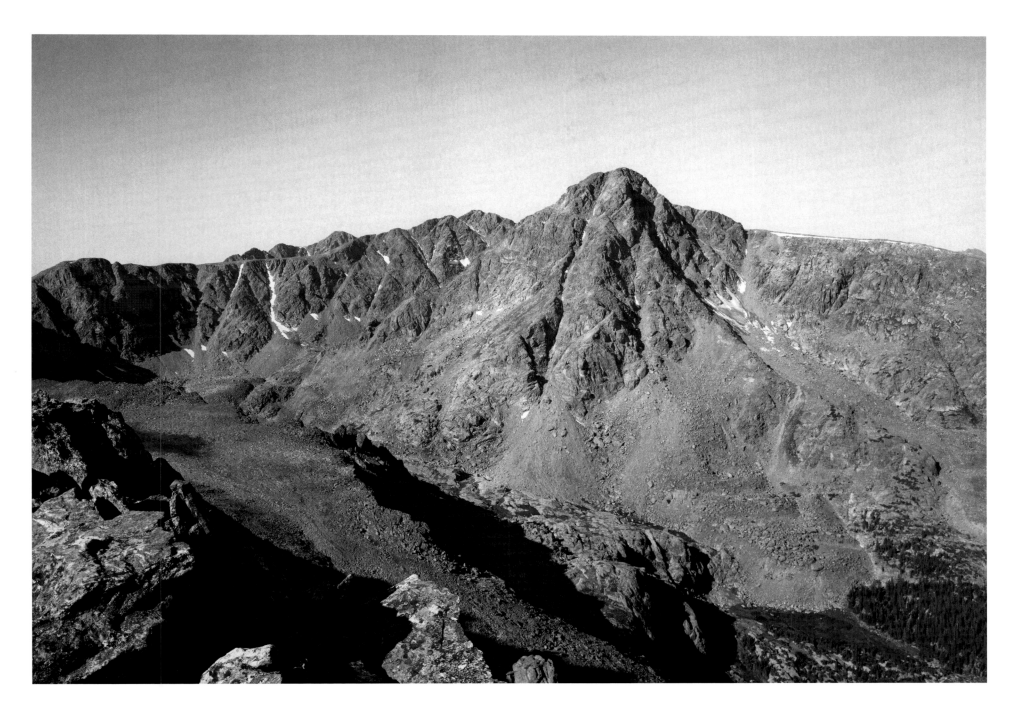

PYRAMID LAKE, NEVADA

Pyramid Lake is thirty-five miles northeast of Reno, Nevada, on the Pyramid Lake Paiute Reservation. The subject of the photograph is also the namesake of the lake, a roughly formed pyramid of "tufa," a hydrothermal rock deposited in the lake waters in ancient times. The lake is fed by water from the Truckee River flowing from Lake Tahoe and the Sierra Nevada Mountains. It has no outlet. In the 1979 rephotograph the lake's water had been lowered about sixty-five feet from the level recorded in O'Sullivan's photograph. The water had been siphoned off before reaching the lake, part of the government's first reclamation project to split water from the Truckee into the nearby Carson River for irrigation. Those changes, dating from dam construction in 1905, were the key to decades of litigation over water rights for the tribe and loss of native fish in the lake. The level of water rising in the Larger and Smaller Soda Lakes near Fallon, Nevada (see the description of the Larger Soda Lake site), are directly related to the diversion of water in the Truckee River and Pyramid Lake. In 2000, as a result of settlements, the lake water had risen but not yet to historic levels.

When O'Sullivan made his photograph, he was standing on a large knob of tufa and had climbed about forty feet from the base up sharp, crumbling rocks. At the top he stood inside the crater of a hollowed-out knob, the backside of which was completely broken away, leaving his position half exposed and open to an unbroken fall backward. Inside the tufa crater, looking out at the Pyramid, there was little room to stand and less than enough room for a tripod. O'Sullivan's solution was simply to set his camera on top of the tufa rim he was looking out from and to capture the other knobs in the foreground of the Pyramid. For both the second and third views, however, we used cameras smaller than O'Sullivan's and had to mount our cameras upside down on tripods and hover the camera body only inches from the surface of the rock where O'Sullivan's camera had been set.

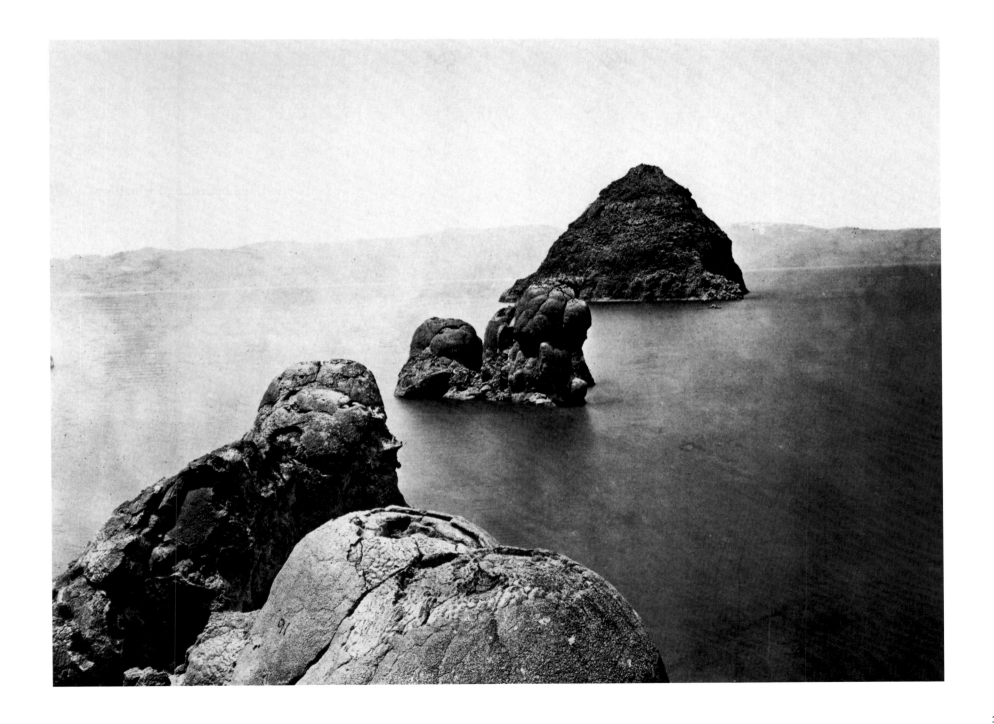

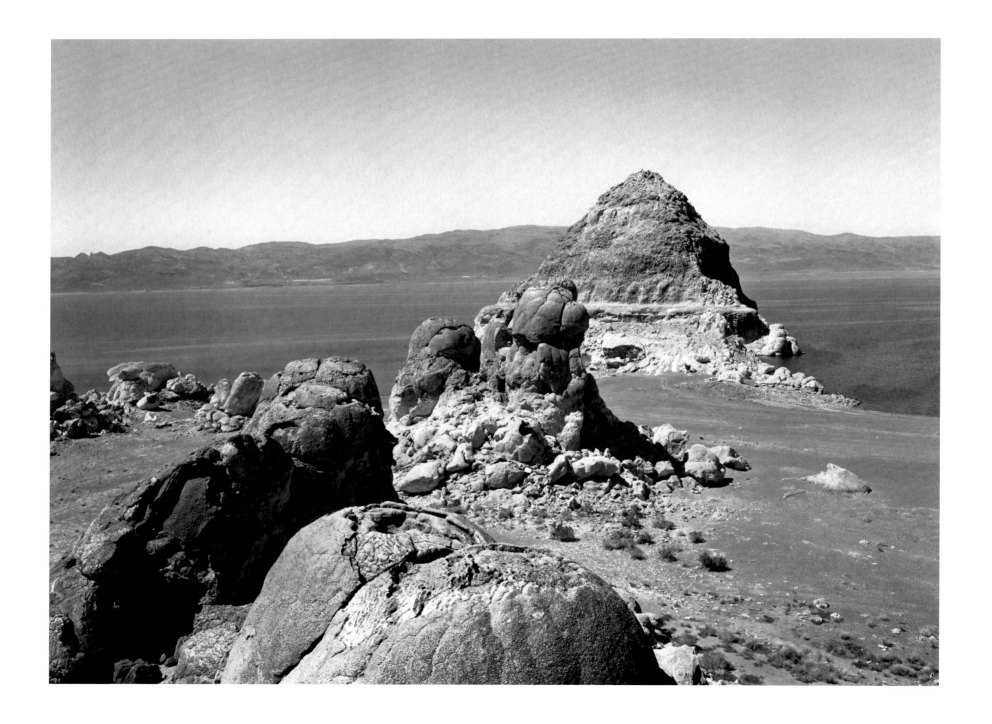

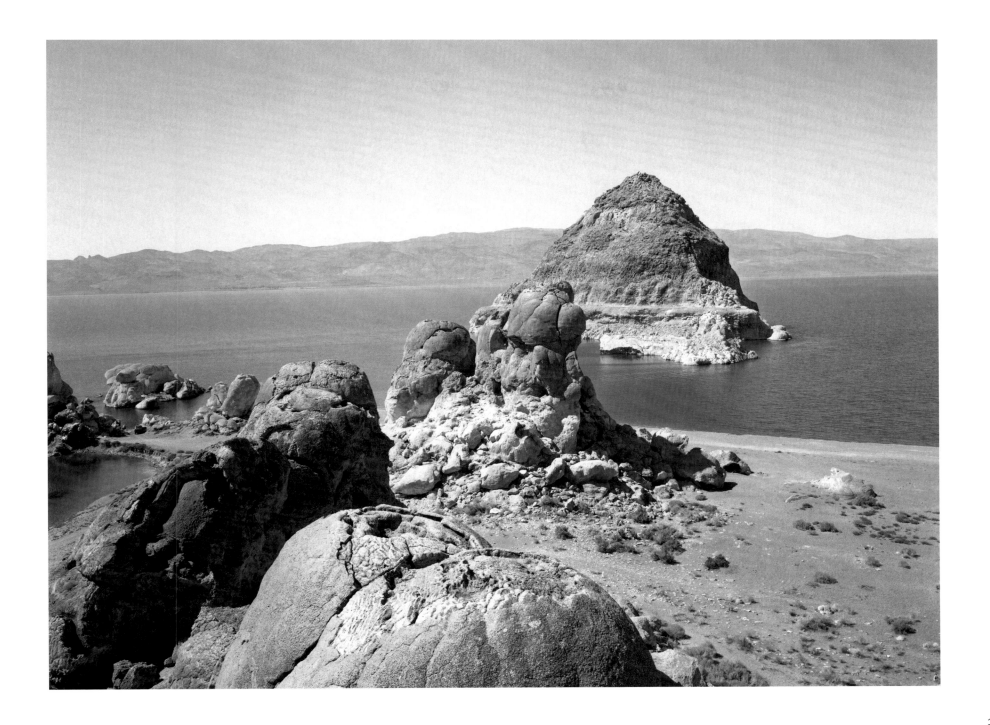

HISTORIC SPANISH RECORD OF THE CONQUEST (INSCRIPTION ROCK), NEW MEXICO

PAGE 183
TIMOTHY O'SULLIVAN, 1873. HISTORIC SPANISH RECORD OF THE CONQUEST, SOUTH SIDE OF INSCRIPTION ROCK, NEW MEXICO (VAN DEREN COKE COLLECTION, SANTA FE)

PAGE 184
MARK KLETT FOR THE REPHOTOGRAPHIC SURVEY PROJECT, 1978. SPANISH INSCRIPTION, INSCRIPTION ROCK, EL MORRO NATIONAL MONUMENT, NM

PAGE 185
MARK KLETT FOR THIRD VIEW, 2000. SPANISH INSCRIPTION, INSCRIPTION ROCK, EL MORRO NATIONAL MONUMENT, NM

Inscription Rock, or El Morro, is a national monument in west-central New Mexico. The rock, actually the end of a long sandstone bluff, was located along routes used by early travelers; thousands of carvings were made in the soft rock. This example photographed by O'Sullivan is one of the earliest made by sixteenth-century Spanish explorers who passed through the area; it has been designated an important site on the Park Service's walking tour around the rock face. The walkway is paved, although access to some areas is restricted.

O'Sullivan modified the scene he photographed in three ways. He used charcoal or pencil to blacken the text of the carving so that it could be seen more easily in his photograph. He cut short the agave plant that was in front of the scene. Finally, he placed a ruler in the scene for scale, propping it against the rock wall. O'Sullivan also carved his name at El Morro only a short distance from where he made this photograph. In current times these practices are illegal.

When the second view was made in 1978, the photograph was shot through the slots of a wooden fence designed to protect the site from visitors. The summer sun had passed the rock wall to the west, and the diffused light matched O'Sullivan's photograph. In 2000 we revisited the site in the fall, and the park closed its gates to visitors earlier than in summer. By closing time the sun had not passed the wall, putting this scene in shadow. Instead, the shadow of a juniper only a few feet from the vantage point created the dappled light on the scene.

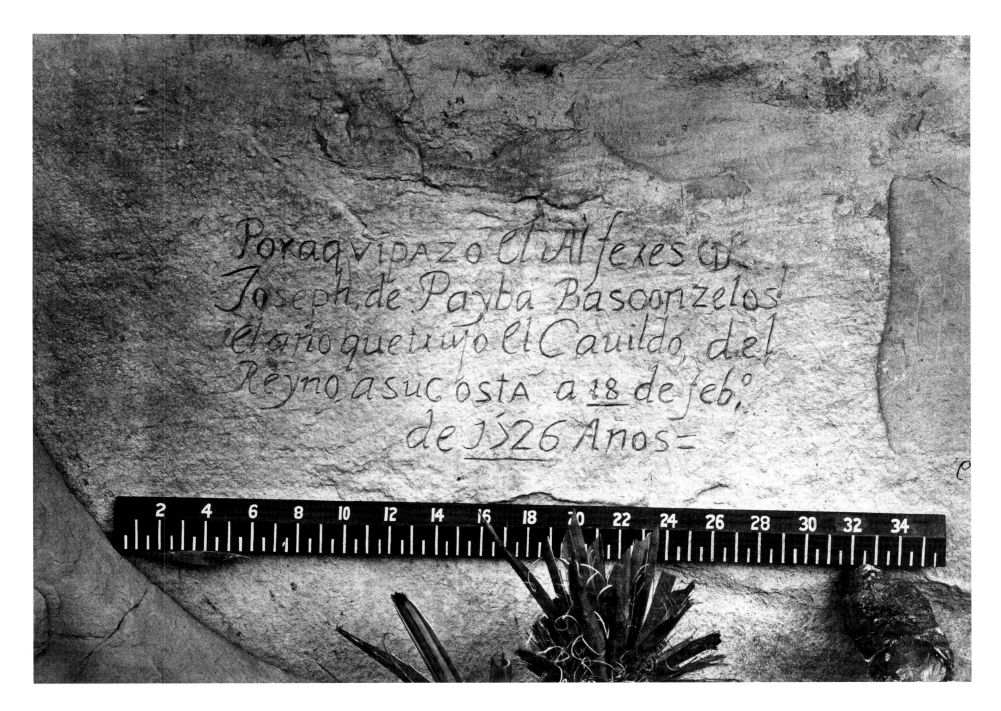

This pair of photographs represents some of the last work by prominent California photographer Carleton Watkins. In 1891 Watkins was commissioned by a British mining company to document the Golden Feather waterways in Butte County, California, near the town of Oroville. His photographs show a portion of the Feather River diverted by means of a nearly two-mile-long rock retaining wall and an enormous wooden flume. Pumps continually eliminated water from the riverbed while gravel was removed and mined for gold. The entire operation was fueled by Chinese laborers and lasted nearly seven years at an expense of more than $12 million. Very little gold was found, and the entire operation was a financial failure. The wooden flume was destroyed when the work ceased. In 1967 the Thermalito Diversion Dam was completed, flooding the Feather River Canyon and submerging the rock diversion wall.

Watkins positioned himself high above a bend in the river so his two views would clearly show the Feather River flowing from the southeast and the sharp turn it takes as it moves west. For this project he made mammoth wet-plate negatives measuring 16" × 22".

The right side of the second view shows a train bridge crossing the canyon. This rail line was built shortly after the turn of the last century by the Western Pacific Railroad and offered an alternative to the often snowy and unreliable route through Donner Pass. Just outside the frame of this view, the line passes through a tunnel that was the site of a train collision in 1967 that killed thirty-four workers building the Oroville Dam.

FEATHER RIVER, CALIFORNIA

PAGE 188
CARLETON WATKINS, 1891. GOLDEN FEATHER MINING CLAIM, NO. 2 (BANCROFT LIBRARY, UNIVERSITY OF CALIFORNIA, BERKELEY) (LEFT HALF)

PAGE 189
CARLETON WATKINS, 1891. GOLDEN FEATHER MINING CLAIM, NO. 3 (BANCROFT LIBRARY, UNIVERSITY OF CALIFORNIA, BERKELEY) (RIGHT HALF)

PAGE 190–191
BYRON WOLFE FOR THIRD VIEW, 2000. FEATHER RIVER, CA (LEFT HALF)

BYRON WOLFE FOR THIRD VIEW, 2000. FEATHER RIVER, CA (RIGHT HALF)

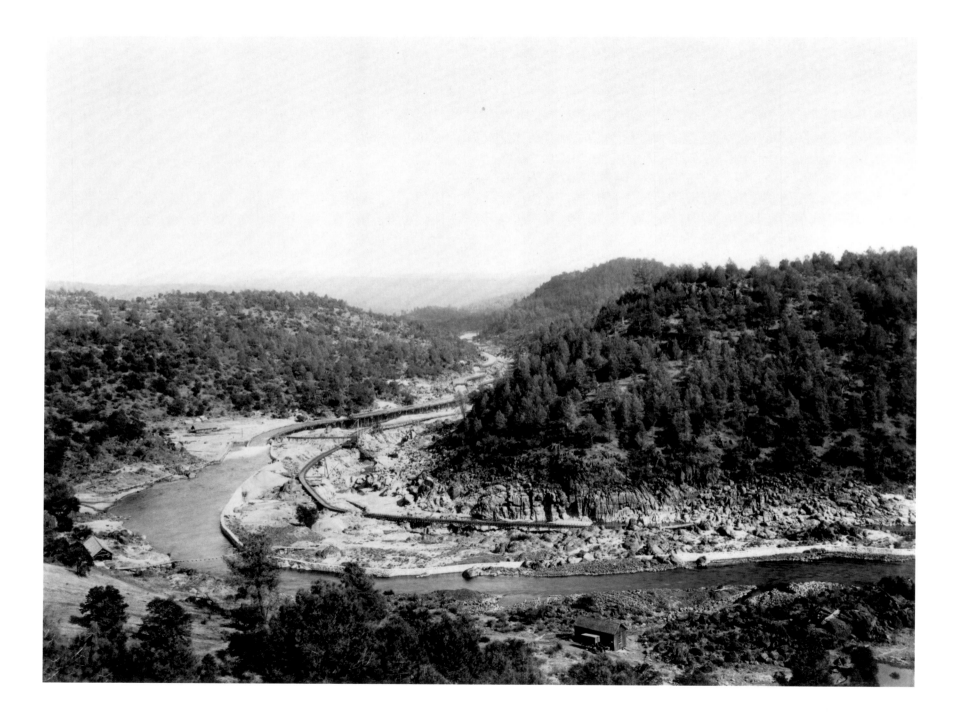

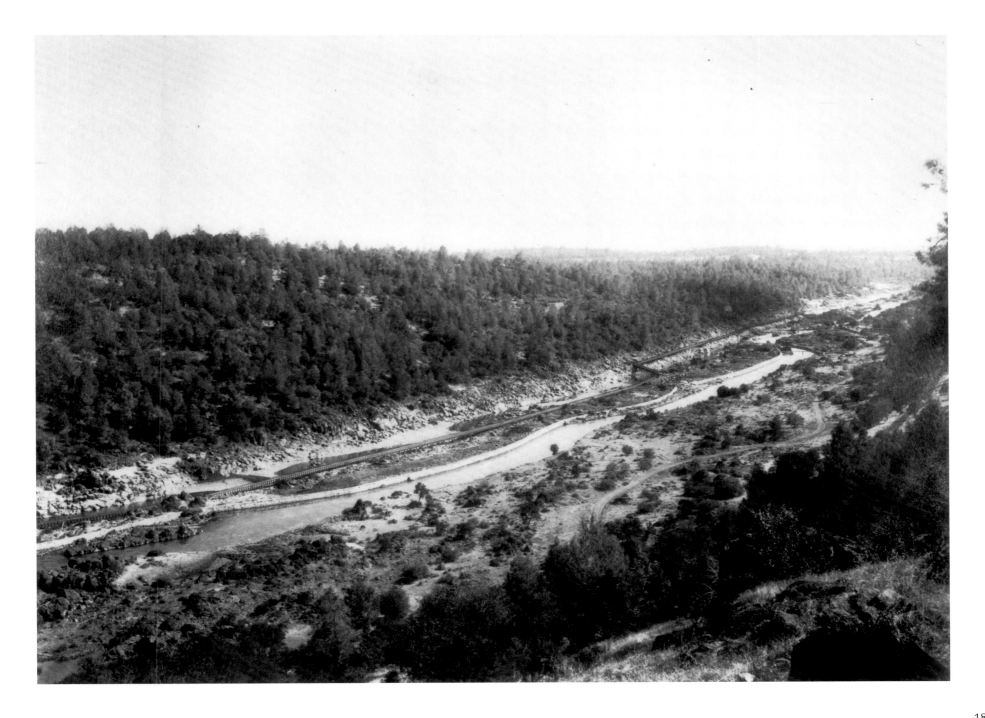

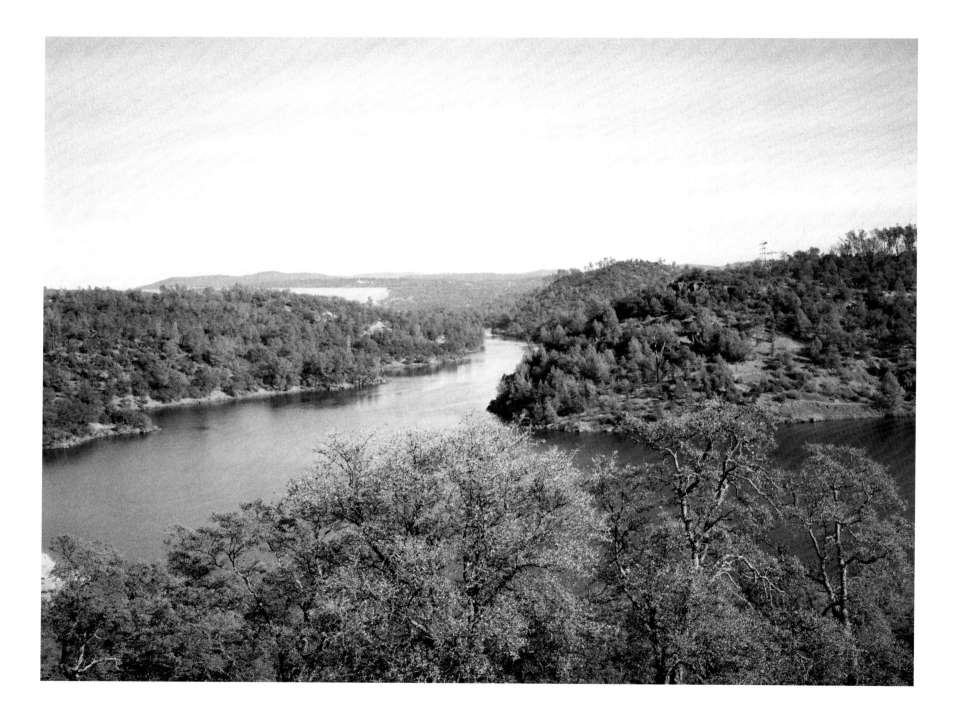

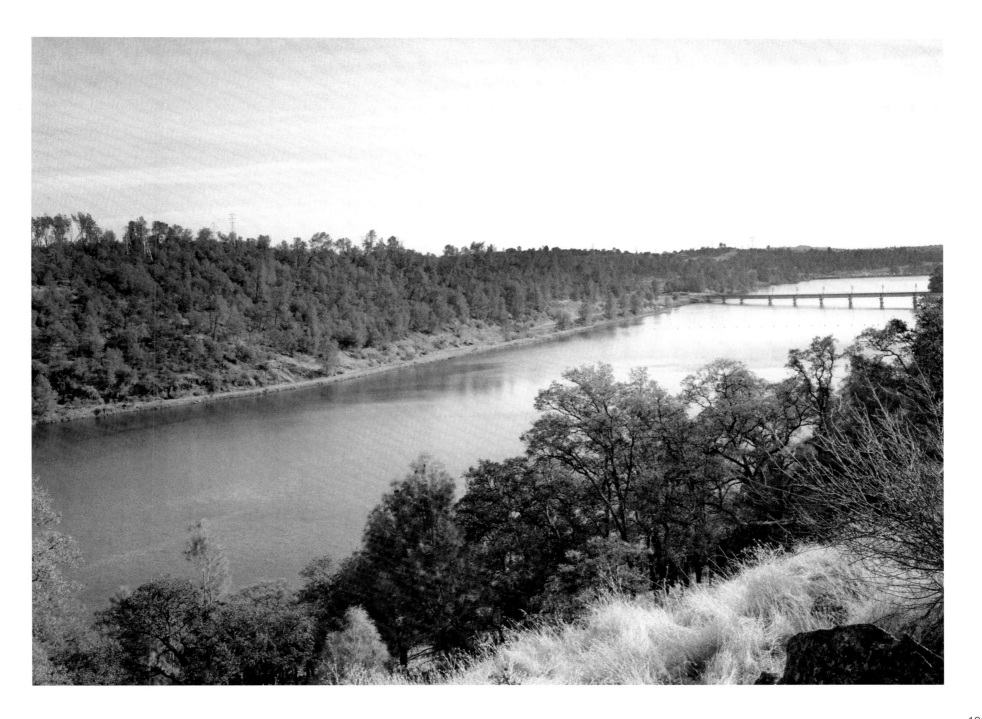

Major John Wesley Powell explored the Grand Canyon for the first time in 1869, but no photographers accompanied that initial, hazardous trip through unknown waters. Later, Powell employed John K. Hillers, the boatman-turned-cameraman who photographed from the river on Powell's second expedition. Another Grand Canyon expedition was led by Lieutenant George Wheeler and ascended the lower part of the canyon from Fort Mojave to Diamond Creek (the present-day put-out location for Grand Canyon float trips). O'Sullivan made photographs for Wheeler's survey from the river in 1871, but in 1872 photographer William Bell was hired to make photographs above the river on the canyon's rim, including this view. Bell used a form of dry-plate process to make his photographs and worked in a vertical format, unlike other cameramen of his day.

Most contemporary visitors to the Grand Canyon see it from the South Rim, but the first photographs of the canyon from above were made from the north side in only two locations. The first from the canyon's eastern end included vantage points near Paria Canyon and south along Marble Canyon to Soap Creek. The second and much farther to the west was at Toroweap Point. In both locations it is possible to look from the rim directly onto the river below.

Bell's photograph was made a few miles east of Toroweap Point and was not repeated by the Rephotographic Survey Project in the 1970s. The scene is illuminated by mid-afternoon light, and the sun was low and far to the south when this exposure was made. Bell made this photograph in either mid-December or early January, close to the winter solstice, when the canyon shadows were at their longest. This was atypical of nineteenth-century survey photographs, which were almost always made during the summer months. The round, ball-shaped rock on the photo's left edge is actually the rounded edge of a sandstone slab, and the dark smudge in the lower left is Bell's shadow or his camera's. When the rephotograph was made, the camera tripod was literally hanging over the sloping corner of a sandstone block at the edge of the canyon twenty-seven hundred feet above the river below. Both camera and photographer were roped in to make the rephotograph, and it was assumed that either Bell was a daredevil or that another rock he stood on to make his photograph had long ago slid over the edge.

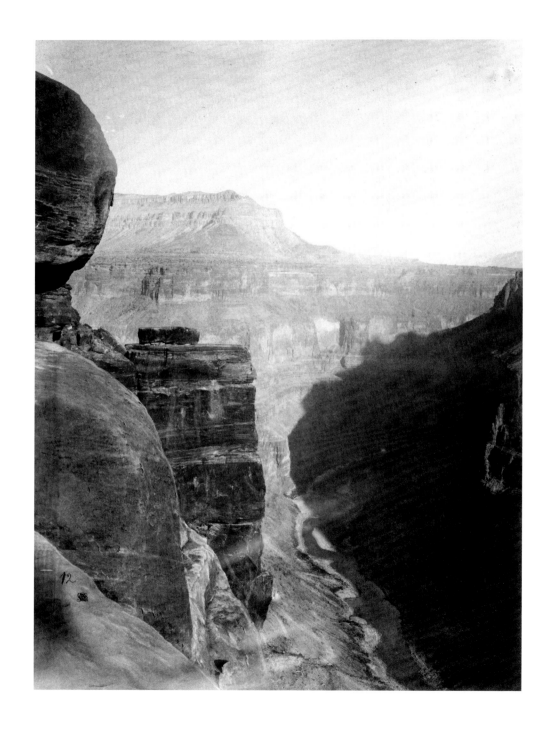

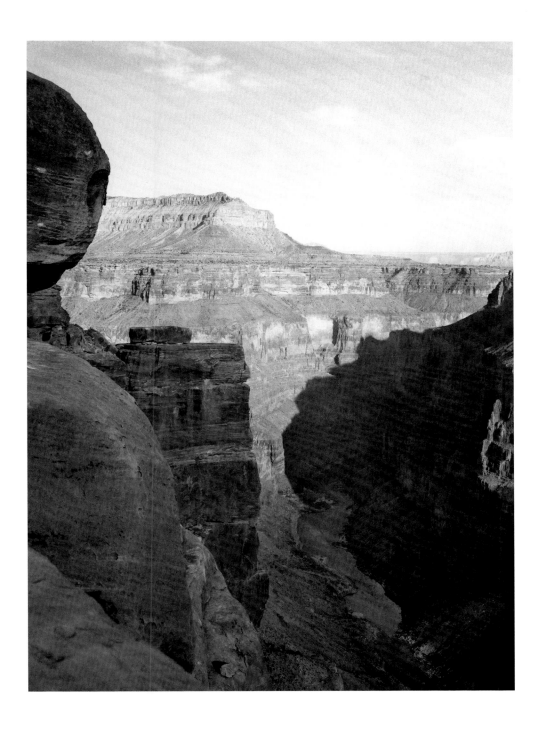

Field Notes

by William L. Fox

THE FOLLOWING ARE EXCERPTS of field notes from eighteen sites and twenty-three days of work (out of a total of 110 sites and 93 days spent in the field between 1997 and 2000). The expeditions undertaken by the Third View team were designed to explore the relationships among art, nature, and culture, and we came to see the rephotography as an armature around which to weave a larger body of work. Likewise, the field notes were first based on the nineteenth-century model of recording where we went and what we did, but they slowly evolved into a conversation among us.

We took raw notes daily with pen and paper on location, reworked them on a laptop, then read them aloud to the team for discussion. [Bill Fox joined the Third View team in July 1998, and there were no written field notes from the 1997 season.] This process helped us to focus not so much on the travel but more on the journey—how to transform a process of literal documentation into a metaphorical inquiry. The daily conversation led us into that territory where history and story and image meet, the place where we hope readers and viewers will be encouraged by the photographs and texts to connect with their own experiences.

SATURDAY, JULY 4, 1998— LOGAN SPRINGS, NEVADA 10:30 A.M.: We wait for light to fall on the cliff as it had for the first photograph more than 125 years ago, in the meantime exploring the nearby stone house. The first view photo shows a settlement of several buildings, and it looks as if this one was expanded with stones from the others.

The original purpose of the town is unclear to us—no mines, logging operations, or corrals are

Mark makes his rephotographic shots in Polaroid black-and-white as well as regular black-and-white and color negative films—seven minutes of shooting after three hours of waiting. O'Sullivan's mid-nineteenth-century technology collapses into the late twentieth century as afterward he begins to document local artifacts with a palm-sized digital camera.

The sense of time periods folding into one another multiplies as Neolithic chert flakes turn up next to shiny brass 30.06 rifle casings. An exquisitely eroded book found inside the house has "Our Nation at Dead Center" at the top of the verso page; "Exercises and Activities" reads the recto. Byron holds up a square, wafer-thin record to the sky, the grooves of the transparent text of religious homilies shot through with sunlight. Layers of sequential habitation are visible here, all connected in a single space yet mysterious as to purpose.

11:00 P.M.: Camped out in a Tonopah motel room, everyone's hunched over the three desktops and two notebooks in the room devoted to producing daily edits. This is new territory for the crew, editing simultaneously still, digital, and video images for the Web. Image degradation drives them nuts—moving pictures from a camera to a computer, compressing the images to go onto the Web, each step tending to bleed out skies, deepen shadows, and delete details. I point out that a stranger coming into the room would think he had stumbled into a sci-fi conspiracy. Mark barks over his shoulder at us: "There are no aliens!" He continues, picking up a cellphone, and deadpans: "Security, we have a situation here."

visible. The house, its ceiling taking a slow, entropic dive onto a floor of decaying shag carpet squares, is full of religious tracts, political advertisements, and women's stockings. Its chaos is lovely despite our suspicion that hanta virus is a possibility in the copious rodent droppings scattered throughout. A bat circles us, then disappears up the chimney like smoke.

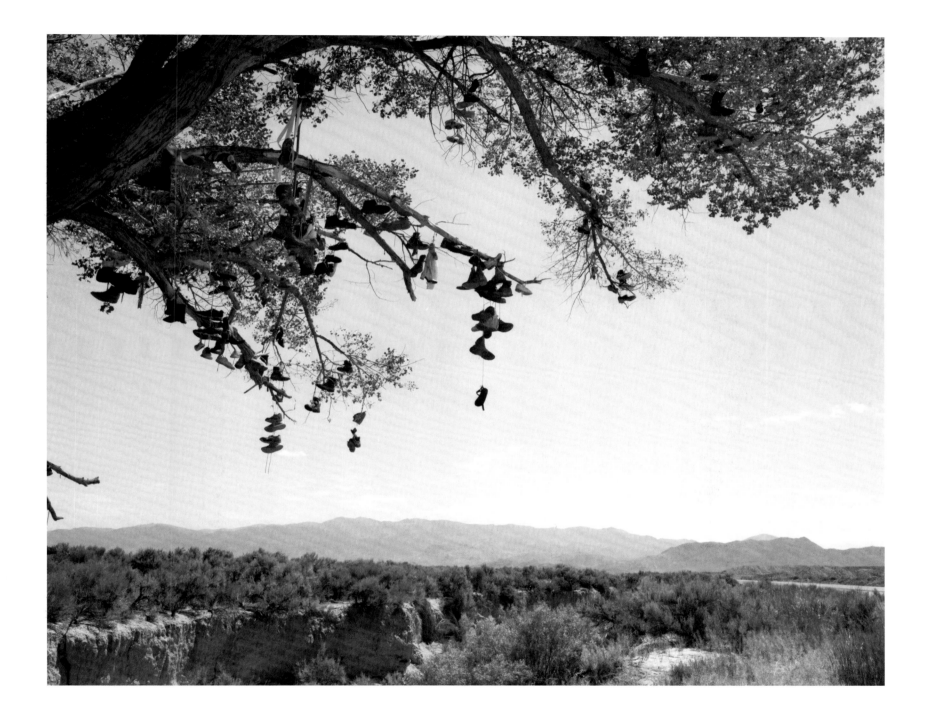

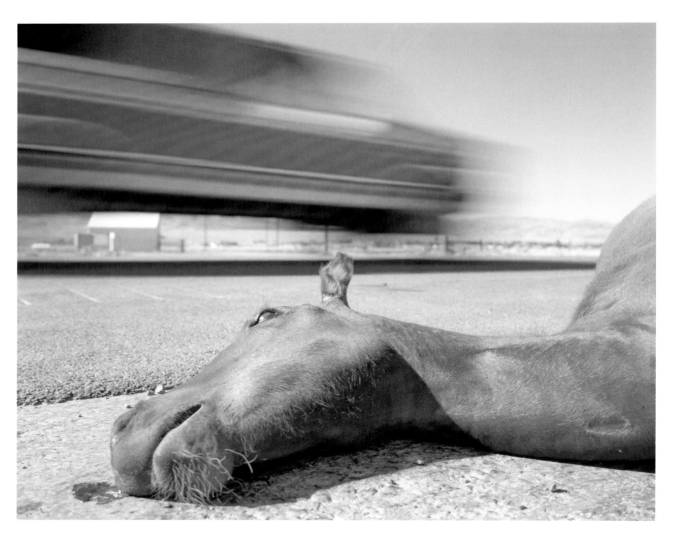

**FRIDAY,
JULY 10, 1998 —
SODA LAKES,
NEVADA**

2:00 P.M.: Mark, Byron, and I stand above Larger Soda Lake, a symmetrical crater large enough to host water-skiers this afternoon. Around what was once the isolated terminus of the feared Forty-Mile Desert crossing are now scattered double-wides and prefab ranch buildings.

Pinpointing the vantage point from which to rephotograph the site involves painstaking comparisons of foliage along the road with shoreline

contours, distant mountains, and the previous photographs. The team is really rephotographing the second view, not the first; although the plant community here has been relatively stable since the first photo in 1867, the individual shrubs and trees have grown, plus there's been some infill. The shoreline's also been altered by water that's higher than in the 1860s, and erosion has reconfigured the foreground.

"To a trained observer," Mark comments with satisfaction, "this will be a nice one, the kind the scientists like." For the next two hours he and Byron try to secure the second of the two rephotos, but by the time they pin down their position, whitecaps are churning across the water and the shadows are so long that further shooting is out of the question. We move a few hundred yards to the south to locate the vantage of Smaller Soda Lake for tomorrow.

A green truck pulls up with a man and woman inside, owners of the property where we're standing. I grab the second view book and go to explain so the guys can keep working.

It's a revealing conversation with Dave and Esther. First, there's the issue of the fence posts—a series of green metal stakes as yet unconnected by wire. They'd planned to close off their quarter of the lake a year ago, an action that would have blocked access to the larger lake for boaters. Dave says they've been too busy to finish the fence, but he allows that the local newspaper reported at length the outrage of the local citizenry over the privatization.

Second, Esther is able to relate how the Bureau of Reclamation's first construction job, the Newlands Irrigation Project—a ditch diverting water from the Truckee to Fallon in the first decade of this century—affected the area. Not only did it not provide enough water to grow the desired alfalfa but it raised the local water table so much that it drowned the soda mine. You can now dive the lakes to visit the old machinery.

The Truckee River, which flows out of Lake Tahoe in the Sierra, rushes down a canyon through Reno and the mountains just to the east, then makes a hard left turn north to where it ends at Pyramid Lake, which is another rephotographic site. All rivers in the Great Basin flow inward, none escaping to the sea. Their waters are held precious by Nevadans, and the Truckee is the most legally contested river in America.

The water level of Tahoe is regulated by an act of Congress; the Indians at Pyramid are guaranteed enough flow to sustain their fisheries; and Reno is a fast-growing urban area. Losing the water battle are the farmers of Fallon, who are allotted irrigation water from the Newlands ditch that sucks water out of the Truckee where it makes its bend toward Pyramid. They can compete with neither the federal mandates nor the vigorous cash economy of the real estate developments in town. The alfalfa fields are disappearing under strip malls, and the original site of Ragtown, Fallon's predecessor, is a manufactured-home sales lot.

COVERED WAGON AND MOBILE HOMES, RAGTOWN, NEAR FALLON, NV. TOSHI UESHINA, 1998.

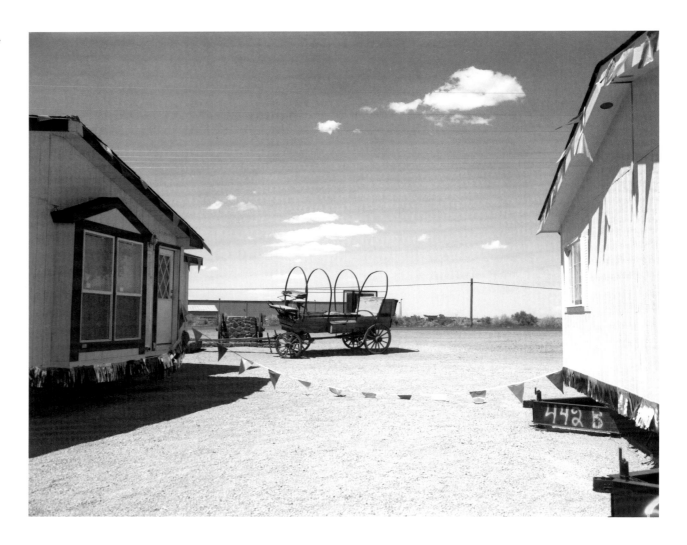

MONDAY, JULY 13, 1998— VIRGINIA CITY, NEVADA

7:00 A.M.: Walking along the hill-sides with Bob Dawson, the floodwaters backed up behind the Lahontan Reservoir far below us are a silver sheet in the morning sun; hundreds of metal roofs and glass windows reflect their light from more than twenty miles away in Silver Springs. Bob, who arrived yesterday with his wife, Ellen Manchester, talks about how peoples' perceptions of the desert are changing, from fear of its harshness to desire for its open spaces as other environments grow more crowded. The urban grid

metastasizing out of Carson City toward Fallon demonstrates how establishing a space of one's own is only a transitory state of affairs.

2:40 P.M.: Mark is at first reluctant to try rephotographing Sugar Loaf, a rocky promontory rising above a bend in the Sixmile Canyon road, the view now almost totally masked by cottonwoods. Once surrounded by the lush weeds, however, which this year tower over his head, he warms to the idea. Across the road is a FOR SALE sign that belongs to a real estate firm touting its status as "National Best Sellers." "Who owns the view?" is a question Ellen has voiced repeatedly.

4:30 P.M.: Bob comes back up the road just as Mark finishes and tells us that just around the bend are some incredible ruins. We find nine separate levels of foundations marching down the hillside, a grand empty staircase outlining the successive refinement of silver ore at what was once a gigantic mill. Huge, rusted bolts stick up, a sign of early reinforced-concrete technology, and swallows nesting in the walls dive-bomb us.

The Comstock is all about ruins and romance, the allure of the abandoned. Underneath the layers of hokey tourism façades, hippified funk, and nineteenth-century wreckage, there exists a deeper, even sublime ruination. Part of it is the scale of hubris. The remnants of machines and their foundations are enormous—flywheels from pumps that transported two million gallons of water daily, for instance. And part of it is the context of desert. Life here was harsh; the effort it took to construct sites this large in a remote place was very nearly superhuman. The site thus evokes admiration for the achievement yet a profound sadness that it has lapsed into decay.

EMIGRANT TRAIL MARKER, FORTY-MILE DESERT, NV. BYRON WOLFE, 1998.

4:15 P.M.: The ride into Salt Lake is depressing. This is where the national grid of "Manifest Destiny" first tested the waters of the western deserts in a serious and methodical fashion, the original result being handsome, rectilinear towns laid out by the Mormons beneath the benign watershed of the Wasatch range. It worked fine until suburbanization hit, and now there's a repressive regularity carved all up and down the front range, which is ruled by roads.

As we enter Big Cottonwood Canyon, signs warn us that the picnic areas close at 10 P.M., that no dogs or horses are allowed, that there's camping in designated spots only. These, too, are the consequences of urban growth overrunning the land. The abrupt conjunction of the city with the wilderness produces severe conflicts over how to preserve access to high-quality experiences. Case in point: The canyon we're now driving up is narrow and holds only a few places wide enough for campgrounds. The Big Cottonwood Creek, furthermore, is part of the water supply for the city. How do you maintain free land usage with millions of people living at the mouth of the place? To preserve the quality of both the visual experience and the drinking water, you regulate its usage with spatial and temporal boundaries (camp here only and leave the party by curfew) and with fees.

8:30 A.M.: We start with the Storm Mountain Amphitheater, a circling of quartzite cliffs down the canyon that Timothy O'Sullivan first photographed. Part of the area is now a reservoir, and the remainder is one of those picnic areas subject to evacuation each evening. Mark had pointed out over breakfast the irony created by contrasting the needs of the nineteenth-century explorers with ours. The former were trying to piece together any security they could manage in the landscape—safe water, forage for pack animals, game for the table, and passable routes through the mountains. We're more concerned with getting away from amenities secured for us by public servants.

Irony is too easy, though, and we keep trying to find a way beyond it. Mark's contention is that people should be able to act responsibly in the land and manage themselves instead of having to be herded together in order to protect the land. This morning as I watched a teenager stripping green vegetation from a live bush in the center of the camping loop, an act of unconscious vandalism for a vanity fire—one not for cooking but just for atmosphere—I had wondered how the public school system could take on that burden.

We enter the Storm Mountain facility to find a still empty parking lot and park in the shade by the reservoir spillway. I can write up field notes in Mark's truck while everyone else goes off to photograph. It stays quiet until a fish hatchery truck arrives and backs up to the water's edge. Two guys hop out. The older man checks the flow of water then gestures for his colleague to scoop some fish

out of the tank on the truck and dump them in the creek. The younger guy tosses the net in the air as if flipping pancakes, and the first of three loads of ten-inch rainbow trout smacks into the water, darting away within seconds. Families from the city will drive up here with the expectation of getting a campsite, catching some fish, and grilling them over a fire. The U.S. Forest Service is not about to disappoint them, but no one should mistake stocking put-and-take trout for a holiday weekend as anything but a manufactured version of nature.

Noon: "We're gonna have to go inside the fence," Mark says, shaking his head. "I sure hope we don't get arrested." He takes off up the road to find a way around the barrier that surrounds the reservoir. People are fishing across the reservoir, and the fence is probably just a precautionary measure; nevertheless, when a sheriff drives by a few minutes later, I get a little nervous. He keeps going up the road, though, more concerned about keeping an eye on the traffic than a gaggle of photographers.

By 1:30 everyone's back at the truck, having gotten three consecutive rephotographs in one long morning. On the drive down the canyon, Mark expresses his particular pleasure in the sequencing of the shots.

"The first one is an overview of where O'Sullivan was camped, and you get a real sense of vista down the canyon. The second shot is truncated by trees, so it's closer in and there's a sense of enclosure. And in the third

one there's that chain-link fence at the reservoir right in front of you, and it's topped with barbed wire. It's not a benign barrier.

"The crux for me is the mediation of experience, the controls the government uses to funnel our experiences. By setting up campgrounds and fire pits, regulating the hours, and putting in fish, they're telling you how you have to interpret the place. In order to have your own experience, you have to override those controls.

"If all you have is an experience designed by someone else, how do you develop an attachment to a place or develop a sense of it? Thank God they haven't fenced Toroweap Point on the North Rim of the Grand Canyon. It's still your choice about how close you get to the edge. It's up to you whether or not you fall. If someone else has kept you away from that edge, you don't have the choice to experience any fear there, hence respect for it.

"I don't mean you have to have fear, but you have to have choice, the freedom to screw up. That's how you develop responsibility. It's like with your kids: You can just order them around or you can help them find out what's going on so they develop their own responsibility."

He pauses for a second, and I jump in: "That's a basic need, that existential choice, but Mark, not every parent knows how to take their kids out camping without hurting the environment. It's like that boy this morning stripping the bushes at his

campsite. He wasn't being bad, he just didn't know any better, and neither did his parents. And given that there's a population that keeps on growing . . ."

"Yeah, but look," Mark continues. "What we need is to teach our kids and students and each other new stories that aren't about domination of the land, that nineteenth-century way of doing things. I don't mean to pick on the National Park Service, but funneling people into one kind of experience is the same old story of control over nature, and we need new stories. That's what Bill Kittredge talks about, and he's right."

4:00 P.M.: After lunch we stop in at a mixed-bag sporting goods store a few doors down. It's one of those places that sells everything from golf balls to rock climbing shoes. The woman behind the counter asks if we're from out of town, and Byron, who's purchasing a pair of sunglasses, answers that we're a photography team.

"Oh," she exclaims, "an advertising shoot? Pretty girls for *Penthouse*?" Byron patiently explains what rephotography is, but the question makes me uneasy. So much landscape photography is exactly that, an advertisement for nature. And some of it is classified by the more militant eco-critics as outright pornography, cameras intruding into the private corners of the land and exposing them for all to see, a kind of scenic exploitation that shows the seductive image of a private wilderness without cultivating any responsibility for it.

SATURDAY, JULY 3, 1999 — SALT LAKE CITY, UTAH

4:00 P.M.: After unloading gear in preparation for washing negatives tonight, we all cram into the Ford and drive up on the hills behind the state capitol building. Salt Lake City is framed to its east and north by a series of steep terraces, prehistoric beaches left behind by the ancient Lake Bonneville, Pleistocene predecessor to the Great Salt Lake. Camped on one of these benches, O'Sullivan took vistas of the valley below, which in the first views show a small settlement — Camp Douglas — surrounded by open sagelands.

The Second View photographs from here struggled to include all of the city within the preexisting frame established by O'Sullivan, but couldn't possibly succeed. The city was too large, with the urban grid marching over any land even remotely flat.

Two years ago a Third View picture was made here just as Dorchester Pointe, a gated community, was being built. We're coming back to see if recent construction is sufficiently advanced to make a noteworthy revision. We end up not making a rephoto, one reason being that smoke from forest fires has erased the required reference points in the Wasatch.

The sales sign at the entrance formerly listed prices for the forty lots starting at $101,000. One of the numerals has been crudely scratched over to revise the prices upward to $140,000 for the cheapest of the remaining thirteen lots. The houses are mostly MacMansions, looking like they'd be more

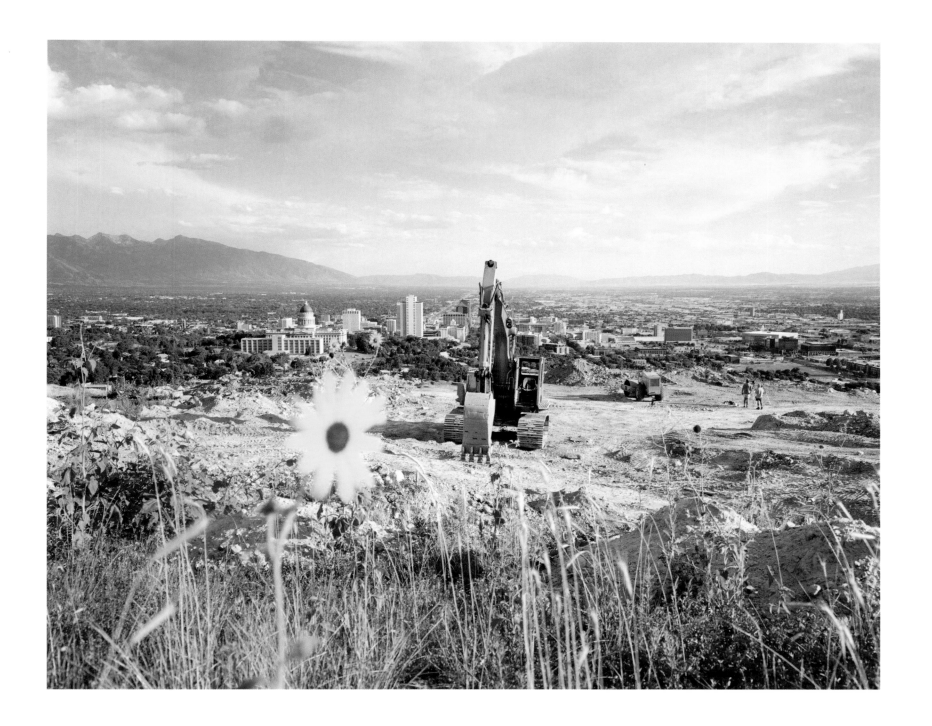

at home in Los Angeles, where such demonstrative architecture is the norm. Perhaps people who live in faux Egyptian temples and Georgian manors prefer campsites of poured concrete to those of pine needles on dirt.

As we're leaving, a story is broadcast on National Public Radio about the proliferation of gated communities. The mediation of outdoor experiences in the Big and Little Cottonwood Canyons is not only a matter of crowd control but also the result of a design aesthetic that no longer has a constituency for structures of appropriate scale and modesty.

SUNDAY, JULY 4, 1999— GOLDEN SPIKE NATIONAL HISTORIC SITE AND MORTON THIOKOL CORPORATION, UTAH 11:25 A.M.: We head north for an experimental site visit. Although not documented as part of the government surveys, the site where the final spike was driven to complete the transcontinental railroad is a historical locus from the same period. As we pull into the parking lot of the Golden Spike National Historical Site, rangers announce that a reenactment of the spike driving will be held in five minutes. In back of the visitor's center two exquisitely re-created steam engines sit head-to-head, puffing gently before an audience of about thirty people.

Eight gentlemen in black frock coats and formal trousers turn out to be volunteer actors and audience members selected to play the part of local dignitaries. For half an hour they give abbreviated versions of the speeches given on May 10, 1869. The master of ceremonies gestures at the Third View crew and proclaims to the audience that "world-famous photographers" have gathered to document the event.

Mark grins and waves, enjoying this unexpected role-playing that doubles back onto us: rephotographing a reenactment of a historical publicity event manufactured by and for early corporate America. We're dealing with a genuine event that was pivotal in the long history of western expansionism, the stitching together of a continent from the Atlantic to the Pacific, but we're also participating in the ongoing maintenance of a cultural myth.

When the spike finally is pounded into place by the resident locomotive engineer, great blasts from the trains' steam whistles throw children into tears, the long mournful hoots too loud in the silence that otherwise reigns on this high plateau. Toshi, as usual, hovers on the edges of the action and videos the scene. I stand on one of the log benches behind Mark and softly hum the theme song from the old television show "The Wild, Wild West." A feature film spun off the series about two Victorian secret agents traveling the West in a train pulled by a locomotive much like the ones in front of us. Byron and I have been arguing strenuously on behalf of seeing it sometime during the trip as an official Third View activity, and this reenactment business is reinforcing the idea.

As we leave, I ask one of the rangers to stamp the official park emblem on a small piece of paper, which usually is requested only by those visitors filling in a national park passport. She obliges, but it's not until

REENACTING HISTORY: THE MEETING OF
THE RAILS AT PROMONTORY POINT, UT,
JULY 4, 1999. MARK KLETT, 1999.

Byron points it out that I see it says "Promotory Point" instead of Promontory, a telling slip.

We caravan out of the park just before four o'clock, stopping at a railroad crossing for one of the locomotives as it realigns itself for the next reenactment. The engineer waves, a railroad enthusiast who runs the engine up and down the same mile and a half of track twice a day for six weeks. The original tracks were pulled up and the final spike removed in 1942, the steel recycled into the "war effort." We're on our way to observe some artifacts from what came next in the development of our

military–industrial complex, another experiment in extending the purview of Third View.

Thiokol is the company that has designed, built, tested, and sold rocket engines for everything from the Minuteman intercontinental ballistic missiles of the Cold War to the Stingers used by the rebels in Afghanistan. It's a name mostly known to the public as the corporation that built the rocket booster that failed on the Challenger space shuttle flight. Some Thiokol engineers had, in fact, argued against the launch that particular day, predicting that a critical O-ring could fail, but launch windows are narrow, time is money, and the countdown proceeded.

Located only a few minutes from the Golden Spike park, Thiokol is spread out judiciously over hundreds of desert hillside acres, the terrain providing natural blast buffers, in addition to the constructed berms. Large corrugated-steel buildings have escape chutes descending from each floor to the ground, which looks as if playground equipment had collided with a chemical plant. The rocket display is a square half-acre of gravel framed with lush lawn. Several dozen white minimalist cylinders, some fat, some slender, some no larger than your arm—and one as tall as a large office building—stand or rest at an incline along the self-guided walking tour.

It all seems innocent, an illusion fostered by the separation of the manufacturing process. You can work at Thiokol and argue that all you do is build rocket engines. You don't make the explosives or the triggers or the guidance systems, all of which are designed and built by other corporations scattered around the country. As a passive audience even further removed from the reality, and walking around on a pleasant summer day, you have to concentrate hard to remember these are actual examples of the most destructive delivery vehicles on the planet.

The largest artifact is a booster rocket from the space shuttle. Raised at an angle, it runs the entire length of one side of the display and dwarfs the ICBM nearby, which is otherwise the heftiest missile here. We stand on tiptoe and wrap our hands around the rim of its immense flared nozzle, an aperture large enough to walk around in. It's a powerful contrast to the weaponry, although the placement of the shuttle booster next to the ICBM reminds us that science, commerce, and the military are linked inseparably throughout historical and contemporary explorations.

TUESDAY, JULY 6, 1999 — TWIN FALLS, IDAHO 1:00 P.M.: This was the only site to which O'Sullivan returned to photograph a second time and where, his biographer speculates, he found an almost mystical connection to nature. Shoshone Falls, billed locally as the "Niagara of the West," drop 212 feet, which is fifty-two feet more than Niagara, though the volume of water is less—at least in the middle of summer when almost three million-acre feet are diverted upstream for potato crops. The sight is impressive enough to warrant forgiving O'Sullivan for pegging yet another location where a future public amenity would be constructed.

ROCKET DISPLAY AT MORTON THIOKOL
CORPORATION 10 MILES FROM
PROMONTORY POINT, UT. MARK KLETT, 1999.

WEDNESDAY, JULY 7, 1999 8:00 A.M.: While Mike scrambles up leftovers with eggs, the crew examines black-and-white Polaroid prints from pictures Mark has been making of our camps. The sequence is assuming a narrative shape for us, each Third View journey having a character of its own.

It's too early to tell precisely what the shape of this one is, but it seems less like the natural history observations of last year and more to do with the "re-history-ing" of the West. It's bound up in the wistful lyrics of a Gene Autry song and the re-creation of the Golden Spike ceremony, with echoes in

the interviews we've conducted and maybe even in the *Wild Wild West* movie.

11:15 A.M.: City Hall directs us to Dennis Bowyer, the superintendent of Twin Falls' Department of Parks and Recreation. Mark describes the access we need down by the river to duplicate O'Sullivan's vantage points and Dennis, whose parents were native-born residents here, is sympathetic. He confirms probable stances from which the First Views might have been taken and photocopies historical records from his files for our own archives.

At the public library, Byron is seated at a computer, having pulled up the photographic files at the National Archives in Washington, D.C., and is printing out copies of O'Sullivan photos that we haven't seen before or didn't bring with us.

"Research sure isn't what it used to be, is it?" muses Mark. This reminds me of what he described yesterday about wading in a trout stream while fishing for hours on end. After watching the water long enough, it seems less like the stream is moving and more like the land is spinning around the water. Less and less is Third View about what we're photographing and more and more is it about the way in which the process of history is the form of our world.

THURSDAY, JULY 8, 1999 10:45 A.M.: Byron is online in the room, hooked up to the National Archives again. The printout from the library doesn't give enough foreground detail to establish the vantage point, so he theory is to download the image into the laptop and drag it into the field, the first time we've tried to do so.

While Mark goes off to make the site from the rim of the canyon, Mike and I go back to Parks & Rec to interview Dennis. He tells us stories of teenage high jinks in the gorge, of industrial dumping into Rock Creek, and of plans to link the parks in town with foot- and bike paths to the gorge. He also pulls out a tattered blueprint drawn up in 1910 by Florence Yoch, a local landscape architect, presumably in response to a proposal to make the falls a national park.

Dennis's obvious pride in the town's growing self-awareness of its scenic tourism is related to the fact that Twin Falls has a city park that easily could be classified as a national geological treasure. Driver education instructors take their students down to the lake behind the dam and teach them how to back up the rear wheels to the water, a necessary skill in a town where boats and waterskiing are primary recreations. What a visitor takes for a scenic climax is regarded by the townspeople as just part of their backyard.

2:45 P.M.: Jamie Rose, a reporter from Phoenix, has arrived and follows us as we move from vantage point to point, some only a few dozen yards apart, as if O'Sullivan had accreted images in a cinematic sense, serial views from multiple viewpoints defining the flow of the falls. Unlike other nineteenth-century photographers such as William Henry Jackson, who tended to pick a singular image from

on high to represent the domination of mankind over the territory, O'Sullivan sometimes worked from many vantage points at different levels, more apparent here than in most other locations.

Mark has Jamie step down into the picture. Working fast with a thin margin of acceptable light, he's taking almost four pictures a minute. Jackson, a phenomenally fast wet-plate photographer, bragged he could do a photo in as little as fifteen minutes. We're wondering how long it will be before we have electronic camera backs able to hold downloaded archival images on the ground glass simultaneously with the view and running on software to direct the photographer to the exact vantage point. Technology someday will have the capability to speed up the process to a point where rephotography could become almost as casual as snapshooting.

4:30 P.M.: Back at our motel, we review interview tapes and Toshi's video and go over field notes, steps critical in the continual assessing and shaping of the trip. Toshi's been taking time-lapse videos from the tripod-mounted camera, four seconds of recording out of every minute. People move in and out of the campsites, meals are built and consumed, the moon leaps across the sky. "It's like watching a surveillance camera," Byron comments. It's another way of presenting time but on a microscale versus the larger leaps taken in the rephotography. In 1997, during the first season of Third View, Toshi's video work had provided the narrative tissue for the project, a task since shifted onto the field notes. Now he

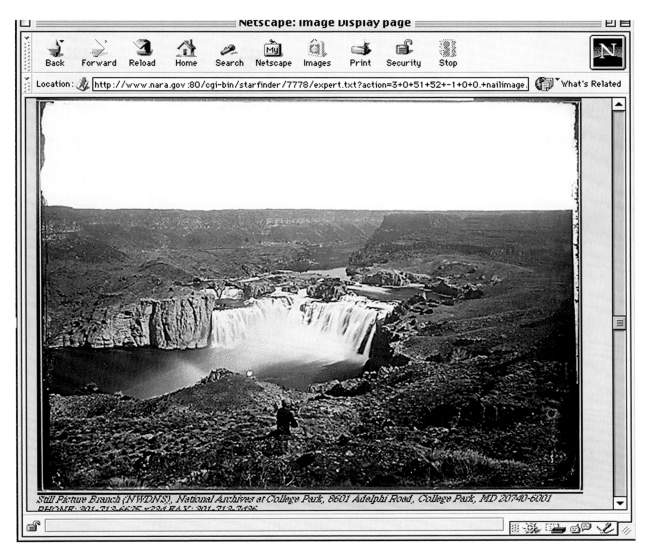

is able to spend more time experimenting with the documentation and doing his own work.

Over dinner Jamie asks what she labels her "journalism questions," one of which is whether we're conscious of "making history."

WHAT BYRON SAW ON HIS LAPTOP ABOVE SHOSHONE FALLS, ID, JULY 1999. NATIONAL ARCHIVES, WASHINGTON, DC, 1999.

TOSHI'S FIRST SHOOTING LESSON NEAR
GREEN RIVER, WY. BYRON WOLFE, 1997.

I caution that this is a loaded phrase and Mark agrees, thinking that to use such a term would be arrogant and presumptive. He describes what we're doing more as participating in a lineage, that we're not separate from history but part of its ongoing process—which I compare to culture likewise being embedded in nature. Mark brings up the idea of "re-story-ing" the West, which I then spin into "re-history-ing."

That leads Mark to compare the more dominating style of Jackson's photographs to O'Sullivan's views, which often are taken from multiple vantage points lower down in the landscape. Jackson was following the pictorial tradition of his time; O'Sullivan, at least from our perspective, seemed to be inventing a new one more appropriate to the land.

FRIDAY, JULY 9, 1999 7:35 P.M.: The *Wild Wild West* movie turns out to be atrocious but relevant, its dramatic crisis occurring at Promontory Point during the driving of the Golden Spike. Although the movie has President Grant attempting to drive the big nail home himself, a fictitious appearance interrupted by the arrival of the villain's eighty-foot-tall, steam-driven metal tarantula, the conflation of place and event with our witnessing the reenactment is striking. The cinematic version looks more like the reenactment than what the photographs show of the actual event, a visual loopiness that's worthy of a French deconstructionist cartoon (or a classic "Roadrunner" episode, which amounts to the same level of literary criticism).

Mike makes the point that *Star Wars* was the westerns gone into space, and it's only fitting that science fiction should come back to the western. That other late-twentieth-century classic, the "Star Trek" television series, and the original "The Wild, Wild West" show were broadcast back-to-back on Friday nights in the late 1960s, which supports his theory.

We try not to relegate these coincidences to irony but connect them in our history, examining the stories and myths that we construct over and over again from events. *Wild Wild West* is, at one level, another retelling of the Golden Spike story, a classic confrontation over who would run the train of Manifest Destiny. It's a fitting symbolism in the movie that the two trains meeting in Utah are blown up during the struggle; after all, progress has been something of a train wreck in the West. Individually and as a team, we revel in that sense of swimming in a deep and live current of time where almost everything we stumble across links to what we're doing.

SATURDAY, JULY 10, 1999 — GREEN RIVER, WYOMING 3:43 P.M.: Byron points out the landmarks as we come into one of the most well-documented landscapes of nineteenth-century western exploration. Castle Rock, Tollgate, Teapot—each freestanding butte evoking a first, second, or third view photo, a painting by Thomas Moran, or a written description by historian William Goetzmann. The Green River, the largest and longest tributary of the 1,700-mile-long

Colorado River, flows to our right. We can see the red steel bridge crossing over to Expedition Island, where Major John Wesley Powell, the intrepid one-armed explorer, launched the first boat voyage down the Colorado in May 1869, just two weeks after the Golden Spike was driven.

Like Promontory, this is a site of pivotal importance in the development of our history, a nexus in the transportation of goods and money, of power and curiosity. In addition to the freeway and the river, dozens of trains crowd the large switching yard here. Power lines and pipelines, bifurcating

highways, communications towers—every grid that crisscrosses America is here in force.

Other kinds of intersections are present, too. Coming off pavement and onto the dirt road that will take us to the base of Castle Rock high above the northern edge of town, we discover the still decomposing remains of four pronghorn, along with dozens of exhausted fireworks launchers. On the local radio stations fundamentalist preachers and talk-show hosts blast vitriol over state and society. Above us by Teapot Rock two pickup trucks sit at the top of steep jeep trails in the shade of a sedimen-

PEDESTRIAN BRIDGE OVER THE RAILROAD YARD AT GREEN RIVER, WY. KYLE BAJAKIAN, 1997.

215

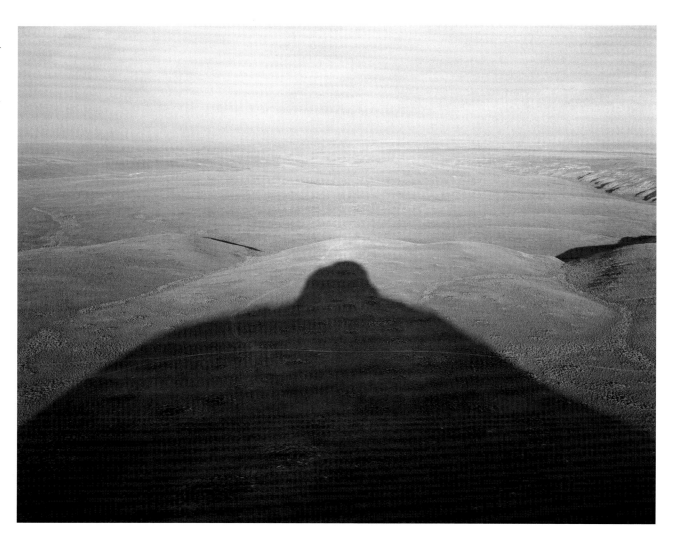

SHADOW OF PILOT BUTTE AT SUNRISE
NORTH OF GREEN RIVER, WY. MICHAEL
MARSHALL, 1999.

tary layer cake. The ground is charged with weird-ness. "Welcome to the real West," intones Mark.

The road leads us up and over the twin tunnels of the interstate to the backside of Castle Rock, where we spend an hour photographing a small rock incised with the words, "Kim I love you forever."

Our shadows are necessary to screen sunlight from the lettering so it's legible, but it gives our presence an unpleasant looming quality over the message, perhaps appropriate to the violence portrayed around us by spent fireworks and munitions, the little sisters of Thiokol.

6:30 A.M.: As we're making coffee at our camp above town, three wild horses trot up out of a draw to the north and circle camp at a brisk canter. We can hear the rhythmic thudding of their hooves, and it's like listening to bagpipes or watching a thunderstorm approach over water: they make the hair on your neck stand up.

Mike sits in a truck and records the local Sunday church talk on the radio. The cadences of organized religion float out into the open brushlands and dis-

sipate. "I love to camp," rhapsodizes the preacher. "Some families like to go out in the middle of nowhere and rough it to get close to God." We recognize the syndrome, if not the denomination.

We pick up our tokens from the stick game last night—our nightly ritual to see who can forecast the position of sunrise on the horizon—which include a pen, a shovel, a .380 ammo round, the vertebra from a medium-sized quadruped, and a 35mm film canister. "When you meet temptation, take a right turn," says the radio, as if to admonish us for

WILD HORSES BEFORE BREAKFAST, PILOT BUTTE CAMP, WY. BYRON WOLFE, 1999.

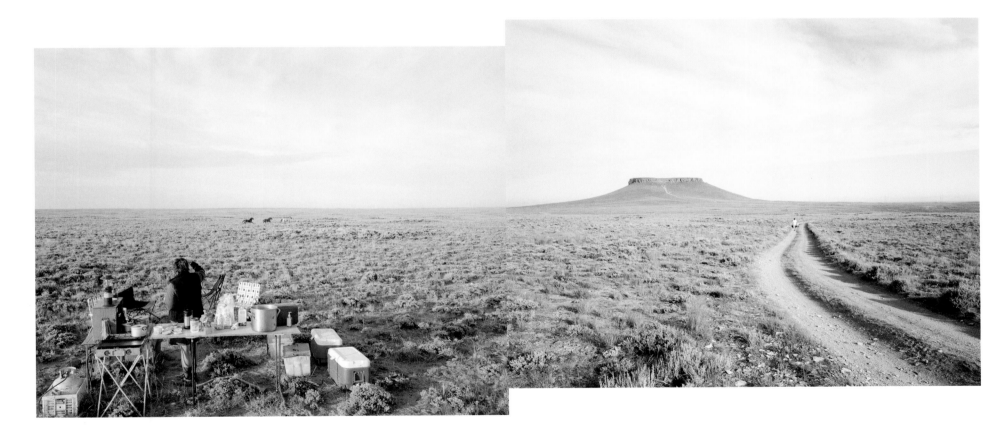

217

SONOGRAM AND BABY PORTRAIT: THE FIRST TWO PAGES OF A DISCARDED PHOTO ALBUM FOUND IN SAGEBRUSH NORTH OF TEAPOT ROCK, WY. MARK KLETT, 1999.

gambling. The church jockey then gives us a weather report, claiming clear skies. We look around at the high clouds covering more than 90 percent of the visible atmosphere and decide he's definitely operating on a wavelength of his own.

Byron pulls up while we're idling in the road during the drive out and hands through our passenger window a photo album he's found sitting about ten feet off to the left in the sagebrush. Its first page is the sonogram of a fetus in utero dated October 1998. The next pages include a baby picture, casual portraits of a young couple, the program from a funeral, a picture of a tombstone, and a half-dozen snapshots of what might be a family reunion in a double-wide. The remaining seven pages are blank.

It's almost too painful to contemplate but we try, independently coming to roughly the same conclu-

sion about something having gone terribly wrong for these people. Too heavy to have been blown off the road, had someone simply dropped it, it seems likely that it was hurled away in an effort to get rid of the pain. Maybe the baby died, maybe the young couple split up. . . . Mark is always urging us to find artifacts that are less generic and more personal; now we've gotten one and wish we hadn't.

MONDAY, JULY 12, 1999 — FLAMING GORGE RESERVOIR, UTAH 5:00 P.M.: We hike up to an overhanging buttress just below the highest point on the rim. One of the sites here didn't have a second view rephoto done and is being set up from a lithograph. The other, which will have to be done tomorrow as the sun is already too low to duplicate the light, is the site where two years ago Kyle found what was almost certainly a shard from one of O'Sullivan's glass plates.

We're surrounded on three sides by some of the 375 miles of reservoir shoreline. This is a relatively small impoundment — at 3.7-million-acre feet about half of what's backed up behind each of the Hoover and Glen Canyon dams, which between them hold about two years of river flow. The imperial water culture of the Northern Hemisphere has dammed up so much water during the last forty-five years that it's slightly unbalanced the planet and slowed its rotation by a fraction of a second each year (Browne, 1996). Not only is our overengineering of the earth radically changing our

notion of space but now we're affecting our sense of time as well.

8:30 P.M.: After dinner we mull over the intensity of our work in Green River. The buttes are prominent in time as well as space, landmarks in the cultural history of the last century as well as handsome geological specimens. You could argue they should be classified as a national historical site, protected from casual, beer-fueled assignations, and interpreted with signs. On the other hand, there's the freedom of discovering for yourself the significance of a neglected site. Wyoming is one of only two or three states remaining with few enough people where that's possible. If you double the population of Green River, whereupon it would begin to approach the size of Twin Falls, the town would probably start to formalize its relationship to the buttes, as it has to Powell's Expedition Island, now a city park.

Then there's the issue of the photo album. Because it's such a recent and singular item from a personal life versus the anonymous emblematic junk we usually collect we have trouble even classifying it as one of our contemporary artifacts. We debate our responsibilities toward its owner, determined to preserve his or her privacy.

The upshot is that we feel the team is maturing into the work. The rephotography is still the core activity, but it is less important than before to what is an evolving process. Rephotography is less the goal of the journey now and more of a starting point from which we take excursions into other issues, whether a site like Promontory Point, a parallel medium like a movie, or, in the future, a photograph by someone other than a nineteenth-century

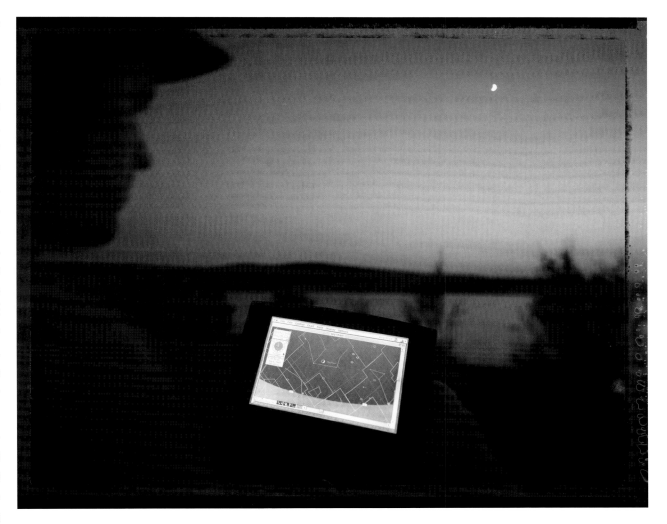

BYRON CHECKING THE POSITION OF THE MOON WITH HIS LAPTOP, 8:56 P.M. AUGUST 8, 1997, FLAMING GORGE, WY. MARK KLETT, 1997.

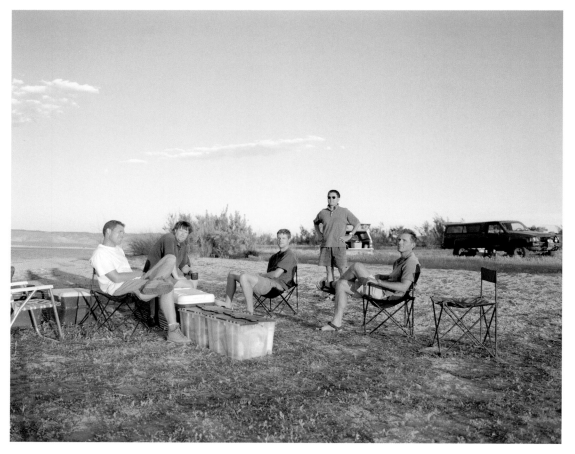

THE FIELD TEAM OF 1999 AT MOSQUITO CAMP (LEFT TO RIGHT): BYRON WOLFE, BILL FOX, MIKE MARSHALL, TOSHI UESHINA, AND MARK KLETT, WITH AN EMPTY CHAIR FOR KYLE BAJAKIAN, FLAMING GORGE RESERVOIR, UT. BYRON WOLFE, 1999.

Because it was the first national park to be established in the world, it's a cluster of sites that brings into question not only how land, wildlife, and people are managed but also aesthetics. Many of the viewpoints, where tourists today are channeled to witness the park's geothermal and scenic climaxes, were vantage points used by Moran and William Henry Jackson, both working on the Hayden Survey of the area in 1871. As in Green River last year, where Moran worked shortly before traveling across Yellowstone, we'll be rephotographing paintings as well as photos.

Last night I slept on a tarp that Mark had in his truck. It was the banner from his show at the Huntington Library in 1999, a photo of Monument Valley as seen upside down on the ground glass of his large-format camera. "Participant Observer" is printed across the top, a good label for a person sleeping on a landscape photograph. The theme of this year's field season seems to be a dialogue between object and process, which will encourage us to look at a variety of art about the landscape as well as the space itself.

survey photographer — a possibility the team has discussed before.

WEDNESDAY, JULY 26, 2000 — PROVO, UTAH 6:30 A.M.: We're up with the coyotes and the sun, making coffee and looking at maps. This year Byron has brought with him a book on the work of Thomas Moran, about a third of which is devoted to paintings and sketches of Yellowstone.

THURSDAY, JULY 27, 2000 — PROVO/ROZEL POINT, UTAH 5:30 A.M.: We're to pick up the writer Rebecca Solnit in Salt Lake City later in the day then take the afternoon to visit sites of interest between there and Yellowstone. We choose *Spiral Jetty*, the iconic earthwork sculpture by Robert Smithson done in 1970. Everyone agrees that the spiral is a visual metaphor for the investiga-

tions we conduct annually, as we trace great circles around the West, always coming back to the same viewpoints yet from farther along the timeline.

3:35 P.M.: Having passed the Golden Spike park headquarters, with its two nineteenth-century locomotives steaming gently on their short line of tourist track, we follow Nancy Holt's directions to *Spiral Jetty,* which she faxed Rebecca this morning. Smithson died in a plane crash three years after completing the work while surveying a site in Texas for another sculpture. Holt, an artist in her own right and his widow, inherited the task of helping colleagues find Smithson's most famous work, which is situated on an obscure section of shoreline. Between the directions and Mark's use of the GPS unit, we find the site although the sculpture is currently underwater, as it has been intermittently for at least fifteen years.

The waters are in the grip of an intense algae bloom that has turned them a pink so vivid the brain has trouble accepting it, and only a light breeze ruffles what is otherwise a stunningly large mirror of the sky. By contrast, the shore is littered with the rusty romanticism of an abandoned oil-drilling operation from the 1950s, one of the reasons Smithson chose the site. The spiral represented to him, among other things, the force of entropy or universal decay, which he had documented earlier in the industrial ruins of New Jersey, his home state. This is not some pristine landscape but an already severely worked place, almost the opposite of the

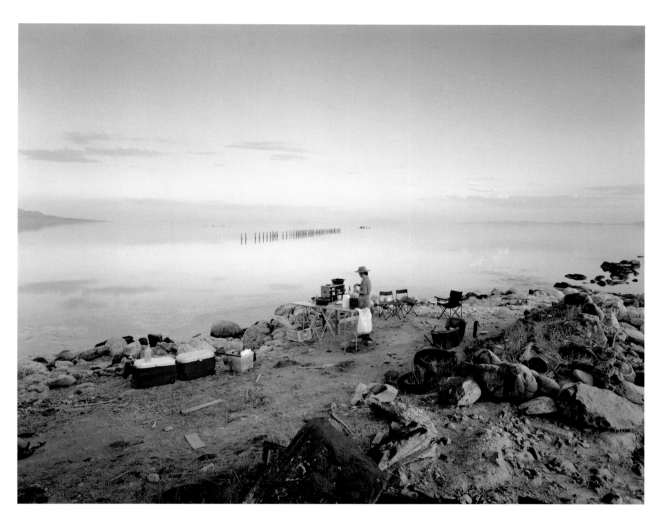

remote valleys chosen by other earthworks artists, such as Michael Heizer and Walter de Maria, in which to place their sculptures.

We camp within the industrial workings, a site that smells of hydrocarbons and dead fish, yet another Third View adventure in toxic living. Oil oozes from a rusting tank canted on the hillside

REBECCA MAKING COQ AU VIN NEAR THE SITE OF ROBERT SMITHSON'S SPIRAL JETTY, THE GREAT SALT LAKE, UT. MARK KLETT, 2000

221

behind us, and a large fish, perhaps a carp, rots beside salt-encrusted tumbleweeds cemented into place by windblown brine. A dead seagull resides to the east of Rebecca's Subaru station wagon. The landscape here is stretched in two dimensions at the same time, being both beautiful and deadly.

That evening the only lights are those of jets flying out of Salt Lake, sixty miles to the southeast, which are reflected in the still waters, as is the Milky Way.

FRIDAY, JULY 28, 2000— ROZEL POINT/ YELLOWSTONE NATIONAL PARK, WYOMING

5:30 A.M.: Mountains and islands across the lake hover like surreal paper cutouts, and a deep purple-gray haze obscures the southern and western horizons. Spatial boundaries are so indeterminate that Rebecca, seeing a pelican a few yards offshore, at first thinks it's a sailboat far out on the lake, a touch of the cognitive dissonance often encountered in the larger deserts of the world.

While coffee brews, Mark decides that if the earthwork is invisible, he'll have to construct his own image. Wrapping a piece of wire into a rough spiral, he tilts it up in front of his camera and photographs it in the direction of the sculpture. In the Polaroid print it looks almost as if someone has drawn a simulacrum of the sculpture on the water. Yesterday, in confirming that we were in the right spot, Mark had lined up a newspaper photograph of *Spiral Jetty* from 1993, when it was above water, and which Holt had faxed us along with the directions. The angle of the relationship to reality is about the same for both photos, which is to say removed by many degrees.

The idea that a sculpture fifteen hundred feet long and fifteen feet wide is forced by nature into an unplanned hide-and-seek position suits Mark just fine, who considers Smithson to have been an object-oriented artist committing an elitist gesture on the land. He much prefers the work of artists such as Andy Goldsworthy and Richard Long, whose works in photographs are transitory phenomena in nature documented in photographs. Rebecca and I also enjoy the disappearance but consider Smithson a conceptual artist whose work was more about process than object. The rising and falling of the lake, and the subsequent status of the art, are part of the dialogue between art and the world.

7:00 P.M.: We enter Yellowstone Park behind an SUV from Missouri, the driver of which is yelling out the window at the rangers in the booth: "What's taking so long?"

"Guy really sounds like he needs a vacation," comments Mark. He reminds himself that, once we're inside, there's no use trying to hurry from site to site; our pace often will be stalled by recreational vehicles. He asks me to start taking down the model names of same, most of which bear nomenclature based on nature. Sure enough, the first one is a "Prowler" with a raccoon face as a logo. The second is a "Sonora Flyer" with a saguaro cactus.

The SUV roars off and we pull up, handing over our permit to work in the park. Designed more to cope with filmmakers than a team of photographers, the permit warns us not to fire off any explosions, including blank rounds of ammunition. Other restrictions include no blocking of traffic, no including rangers as characters, no tipping of park personnel, and so on. In turn, we're handed a lengthy list of regulations regarding bears and food. The gist is that if you have food around you and you're not in the active process of preparing, ingesting, or cleaning it up, you'll be ticketed, if not first eaten.

Once inside the park we're alongside the Madison River, which is readily visible due in part to the enormous fires that consumed 793,000 acres in the park during the summer of 1988. The fire was a major test of whether the government's "let burn" policy would survive. The idea is that fires, either natural ones caused by lightning or controlled burns, would clear out the forest of dense fuels, thus preventing catastrophic events that consume everything versus just the smaller stuff.

It's a logical theory but one caught in an ecological cycle difficult to break. The Yellowstone fire so cleared the land that in some places the regrowth is wall-to-wall lodgepole pine instead of a canopied terrain of the surviving large trees. The subsequent carpet of knee-high saplings is so dense that should there be another fire, the entire forest may once again burn completely to the bare ground. The story is never simple.

Our campsites, once we arrive there at 7:15, having been slowed only by an elk sauntering across the road, turn out to be three adjacent spots in the middle of one of America's largest concentrations of picnic tables. "Campurbia," as Rebecca will call it, is run by a concessionaire and is fully equipped with amenities, including warning labels stapled to the tables about storing food properly. A grizzly bear visited the campground last week, so the warning is appropriate. The topic of object and process comes up again, and Rebecca describes Andy Goldsworthy as "the Martha Stewart of installation work." Apart from her considering his work a poor derivative of that by other sculptors, it irks her that he seems to place pattern as if nature had none of its own. When he stitches together leaves with thorns in color-coordinated spirals, not only is it so pretty as to be suspicious but it appears disingenuous. By contrast, she considers Smithson to have been an innovator making a gesture, with no illusions about the use of heavy machinery to construct it.

Mark talks briefly about Jim Turrell's crater project in Arizona. When he visited it in the early stages, only the rim of the crater had been leveled, enhancing the sensation of "celestial vaulting" that you get when lying on your back on the ground. But as Turrell continued to modify the crater with tunnels and rooms, it seems to have become more about the artist and less about the subject matter, which Mark considers a trait of Smithson's work.

Mark Tansey once painted a large picture of *Spiral Jetty*. Viewed as from the bluff above, his

1982 6'×8' foot oil painting, *Purity Test,* features several incongruous Plains Indians in full regalia mounted on horseback. They gaze out at the sculpture, visitors from the previous century calling into question why a white man would appropriate a native symbol in the first place and, in the second, devote immense amounts of labor to build a useless structure.

7:00 A.M.: We mentally prepare ourselves for interaction with an audience today since we'll be working alongside the boardwalks that guide visitors from geyser to geyser in the Old Faithful region. Mark reminisces about hearing a mother at another park ask a child in all seriousness if he could, for just forty-five minutes, do without a radio or television in order to experience the wilderness. "Wilderness is where you're not in touch with some form of media," Mark quips.

The question of whether it's possible to experience land without cultural baggage is one that's important to Third View. Mark and I agree that it's possible to have a basic emotional response to a geophysical situation without pop culture having shaped it. But we also are convinced that our cognition has been so deeply influenced over generations by specific landscapes that our responses may be genetically encoded to some degree, an idea another of Mark's collaborators, the Arizona scientist and author Gary Nabhan, has promulgated. Rebecca

believes it's impossible to view the landscape without bringing to it your contemporary cultural preconceptions and, therefore, that it's important for people to understand what those are and that they have choices about how they view the land. I'll be tape-recording interviews with people watching the geysers and looking for clues on both sides of the issue.

Our hired ranger, a condition of the permit, is Heather Boughton, who takes us out to Castle Geyser and the Crested Hot Springs. The former is a roughly ten-foot-high cone, an accumulation of silicon dioxide forming a deep crater for a steaming vent. The latter is a clear blue pool of water so hot that it once scalded to death a nine-year-old boy who fell through the crust of its rim and sank in the 180° water. Only nine pounds of material were left by the time they recovered his remains, and the incident is why many of the boardwalks in the park now feature sturdy handrails.

Heather takes Mark and Byron out onto the edge of the Castle, only two of us allowed to track across the delicate and dangerous mineralized surface surrounding the features. Already by 1872, when Jackson made his second photographic foray to the park and took the picture being redone today, roughly three hundred people were visiting the geysers on horseback. Many of them wielded axes and shovels in order to hack off pieces of the cone to take home. Given that the silica, which is splashed out at intervals by the geyser, accumulates at only 1/32th of an inch per year, the earlier damage still is

visible today, a situation that partially accounts for why so much changed between the first and second views, and so little between the second and third, by which time the vandalism had long been halted.

Rebecca and I answer questions from the tourists wandering by. The two most frequent are: "What are they doing out there?" and "How do they know where to walk where it's safe?" One woman quite rightly asks, when told about the nature of the rephotography project, if we are making art or doing science, which I tell her is exactly the issue.

European explorers had been taking painters and writers with them since the early 1700s; they needed visual and literary descriptions of new lands in order to understand and remember them, to enhance the ownership offered by cartography, and to increase their lobbying efforts for more public funding. Hayden took Jackson with him for exactly those purposes.

Thomas Moran, an ambitious young painter, also desired to go because he was aware of Albert Bierstadt's financial success with his pictures of Yosemite the previous decade. But Moran had to raise his own funds—hence, he was not an official part of the survey team and not constrained by any need to represent the landscape in a strictly accurate fashion. As a result, he produced stunning watercolor sketches and later large oils, which followed the artistic principles of his hero, the great English landscape painter J. M. W. Turner. Turner first trained as a topographical artist in the late 1700s, but by the 1810s he was seeking to capture the wild spirit of the places he painted, such as the Alps and the stormy seas of the Atlantic.

Moran felt this was an appropriate model for an artist attempting to represent the American West on canvas; it was a landscape so large and dramatic that presenting it to audiences without some heightening of color and scale would rob them of how it actually felt to be there. Moran was not above moving landscape features around to suit his compositions or emphasizing the mountains' steepness. For more than six weeks in the summer of 1871 the painter and the photographer worked side by side in Yellowstone, and not a little of Turner's aesthetic was transferred by Moran to Jackson. Perhaps that was inevitable, given that Jackson had trained originally as a painter. The two men remain a model in the twenty-first century for teams of artists sent by the government with scientists to places such as the Antarctic.

The question of whether we're doing art or science becomes more one of where the work is shown—its context—than anything else. Show the photographs and collateral materials at the Huntington and it's all about the history of landscape art. Show them in a natural history museum and they become a record of change in ecosystems.

5:55 P.M.: "Do these guys have to be in the picture?" a woman yells at Heather while Mark and Byron walk out toward the cone of Old Faithful. Heather, whose purpose is not only to keep track of the team's whereabouts and safety but also to deal

with such situations, explains to the woman what the team is doing, that they do it only every twenty years, and that visitors should basically enjoy documenting a rare piece of ongoing history.

When Mark first stepped off the boardwalk, he had been accosted by another woman, who expressed her frustration at not being warned that people would be in front of her camera; now, all the other front-row seats were taken, and there was no place she could go to take her picture. While I wander about the audience with microphone and recorder, I pick up a conversation between a burly motorcycle rider with a shaved head and his wife. They figure Mark and Byron are professional photographers, that their presence lends some scale to the scene—and, what the hell, "If they do catch on fire, I've got my zoom lens!"

Another woman nearby frets that the eruption won't be on schedule; she has a dinner reservation at the lodge behind us and doesn't want to be late. Rebecca observes that tourists have specific expectations for the virginal views of nature national parks are to provide and that a "time management weirdness" goes with that attitude—one derived from movies and television where the scenic highlights are shown one after another.

In any case, Mark and Byron document Old Faithful in full eruption, which Jackson wasn't able to do in 1871, having to return the next year to record the event. Old Faithful is not the largest geyser in the park, discharging only 3,700 to 8,400 gallons of water in a jet averaging 130 feet high for something between a minute and a half and five minutes. Giant Geyser, which is a half hour down the boardwalk, can spew out a million gallons in a fount more than 250 feet in the air, an event that literally blows away the signs posted nearby—but it only erupts once or twice a year.

Nor is Old Faithful the most regular geyser. It was *National Geographic* in 1916 that mistakenly perpetuated the myth that it erupts every hour on the hour. Instead, it's subject to what scientists call "exchange of function"; it's linked to other geothermal resources in the park and is interdependent upon them for its hydrostatic power and timing.

Old Faithful is famous because it's accessible, and it has been just large and regular and shapely enough over time to become an iconic emblem for the entire park system. This also helps explain why people have such expectations of it, which they don't want upset by two guys who not only get in the way but are allowed to watch from a lot closer than they are. Afterwards Mark observes: "The physical changes—except for what the 1988 fire did—are pretty subtle. It's the cultural ones that are more important now, what we can get in the sound recordings and on video."

SUNDAY, JULY 30, 2000 — MAMMOTH HOT SPRINGS, YELLOWSTONE Noon: We're in Mammoth Hot Springs where the team has just arrived after working up and down the terraces of the once vivid site. The predominate mineral deposited at this end of the park is travertine, a much softer and more quickly accumulating mineral than the silica in the Upper Geyser Basin.

Travertine is a white rock, basically calcium carbonate, the crumbly stuff in Tums and Rolaids. The colors portrayed here so vividly by Moran—and which helped Congress to declare Yellowstone a national park—are provided by the growth of cyanobacteria that flourish in the hot waters. Now the terraces are rapidly decaying, the erosion clearly visible from the second to third view shots. In many places they are a dry, chalky white, even a dead gray color.

The problem is that the springs keep shifting their flow, and the site is not being replenished with fresh hot water laden with calcium. Furthermore, the nineteenth-century vandals had their way here, too, plus waters were diverted for bathing purposes and, as late as the 1950s, used by the nearby hotel. Local vandalism and poaching were two of the reasons the government sent in the U.S. Cavalry in 1886 to govern the park, a domestic occupation that lasted thirty-two years.

2:20 P.M.: Rebecca has tracked down the park archivist, Lee Whittlesey. The archives are located in the basement of the visitor's center, which was originally constructed as an officers' barracks. It's a handsome building, but the sound of people trundling through the exhibits above us is at times almost deafening. Nevertheless, Mike Marshall manages to record successfully more than two hours of an interview with Lee.

Mark puts in front of him sets of original, second, and third view shots of various geysers and other features. Lee describes what he sees in each one, analyzing the changes. He has worked here for thirty years and has such detailed knowledge of Yellowstone that when he looks at Mark's copy prints of some of the Jackson photos that show more than one geyser erupting at once, he recognizes each distinctive plume and can say with some certainty that Jackson was doctoring the view. He knows which geysers exchange function and how and thus knows Jackson was painting in some secondary background eruptions on the negatives (as well as executing the more well-known and accepted deception of painting in clouds, which were notoriously difficult to photograph in his time).

Lee's knowledge also extends to tourist follies resulting in untimely deaths. In addition to the obvious ones, such as encounters with wildlife that turned out to be less than benign, are the 102 drownings in the park and incidents of people succumbing to noxious fumes and being scalded to death. The two most common hazards are heart attacks and traffic accidents, though at least twenty-five people have simply walked off the edge of the Grand Canyon of the Yellowstone.

"It's a good place to fall off and die. People are notoriously careless trying to get a great picture," he states, shaking his head. "It's like they think they're looking at a painting, so it can't be dangerous." His observation ties together the mediation of nature with the time management issue and with the cognitive dissonance that people suffer when confronted with what Lee calls Big Nature as opposed to City Nature:

"People die in Yellowstone from falling trees, for example. Trees are cleared in city parks before they fall. We're a public facility run by the government, so people think it's the same thing, that it's as safe.

"I think we're satisfied in cities to have less and less of a panoramic view of nature because we're closed in by buildings. We have less and less of a view. But we want it, we need it, yet we're not used to it anymore. People look at the animals here and they don't think they're real. They're too big, so they can't hurt us—just like the landscape. It's so big it has to be a picture, and it can't hurt us.

"We're careful about where we put guardrails on the roads, trying not to interfere with the views, though sometimes we have to put them in, otherwise people would just drive off the road while they were looking. But safety is the responsibility of the traveler. People are always trying to sue the Park Service for the trouble they get into, and they always lose. We take all the reasonable precautions, but beyond that, it's up to you. If you sanitize nature and take away all the danger, it's not nature."

MONDAY, JULY 31, 2000— TOWER FALLS, YELLOWSTONE 5:00 P.M.: Mark thinks the vantage point used by Jackson at Tower Falls has long since been obscured by vegetation; an 1872 chromolithograph by Moran, which he based on a watercolor sketch from the previous year, shows dark pinnacles towering over a waterfall that plunges into the gloomy canyon below. We have no sense of scale, and it looks altogether too gothic to be real. So, in addition to scoping out the vantage point, we're also going to be comparing the reality to Moran's sense of composition.

By the time we're halfway down the trail, we can see that the vantage point is buried in trees and on an abandoned trail. Moran's view of the falls, though, is less an exaggeration than a conflation. He moved Sulfur Mountain, which stands in sunlight across the Yellowstone River, in from the right to provide a contrast between the dark mass of the falls and tilted back the perspective in a way that can't be matched by the camera. But numerous and rugged pinnacles do, indeed, bracket the top of the falls, looking like the towers of an abandoned castle. The falls plummet into dank shadows, disappearing at the bottom into a pool hidden behind huge boulders. The current racing down the small gorge is furious with foam. The falls are a good example of how American scenery can be comparably dramatic to that of the Alps, which were depicted so avidly by Turner and other European artists.

Back at the top, Mark asks Toshi to video examples of animal imagery in the souvenir shop, which play an important part in how visitors' attitudes toward nature are shaped by the park concessionaires. The point is driven home as we travel back to the campsite with the park radio station on, the announcer intoning: "Here you meet nature on its terms, not yours."

We wonder how people view the falls after seeing the Moran painting reproduced on a plaque at the top of the trails or how they regard bears after picking up the warm, cuddly artificial ones in the shop.

9:00 P.M.: After dinner Rebecca asks us about what she thinks are the differences between how people treat Yellowstone and Yosemite. She was surprised to find so few hikers at the former as opposed to Yosemite, where there were many more backpackers, and wonders if Yellowstone was developed more along the European touring model than the California park, which was so strongly influenced by the example of the foot-strong John Muir She finds it annoying that people tend to consider the landscape as a morally redemptive experience without being conscious of the fact that this is just a nineteenth-century romantic construct.

Being more literal-minded, I posit that it's a matter of physiography, that Yellowstone's features are spread out over such a large and relatively flat area (when compared to the compact and severely bounded declivity of Yosemite Valley) and that it lends itself more to car than foot traffic. Then there are the megafaunas, the grizzlies of Wyoming being much more dangerous to humans than the black bears of California. I think that to answer the question, we'd have to compare the demographics of visitors, count the number of backcountry permits issued, and calculate miles traveled on foot in ratio with the amount of square miles in each park. The two viewpoints point up two differing approaches to considering nature, the historical and the physical.

TUESDAY, AUGUST 1, 2000 — LONE STAR GEYSER, YELLOWSTONE

11:00 A.M.: We head out for the two-and-a-half-mile hike into Lone Star Geyser, a feature so named because it sits apart from other geothermal founts, a rarity. We keep trying to push ourselves away from the rephotography and into side excursions and activities, sensing strongly that we need the external inputs to help us see more clearly what we're doing. Fishing and hiking and taking time to experience the landscape, not just looking at it, brings us closer to our nineteenth-century colleagues, isolated as we are behind windshields for much of our work.

The ground immediately around Lone Star is barren from showers of silicon dioxide, but within fifty yards is a small clump of pines under which people sit on logs and in camp chairs that they've packed in. The geyser is a tall cone topped by a bubbling pool of water, which every few minutes boils over to run down the sides of the formation. It erupts at 2:17 P.M., the water crunching at first, then whooshing out of the vent with so much force that it feels as if the cone is going to explode. Byron has positioned himself up a hill to the west and slightly above the geyser, and Mark starts a 360° walk-around, taking a 35mm photograph every four paces. Both he and I get showered, the water by the time it falls on us completely cooled so minute are the droplets.

5:15 P.M.: We stop by Old Faithful so the guys can work the crowd for the late afternoon eruption, the best perhaps done by Mike who interviews a man standing with his back to the geyser during the event. When queried about what he was doing, he pointed to a webcam mounted on the visitor's center and told Mike that his coworkers back home in California were watching the eruption and looking for him.

It's a long-standing habit people all over the world display, standing with their back to a scenic climax so they can be included in the picture, but usually it's a static or continuous view, say a canyon rim or a waterfall, not an event they're unlikely to witness again. The behavior here—a person turning his back to the eruption—strikes us as a declaration of faith in a reproductive medium rather than in human memory.

WEDNESDAY, AUGUST 2, 2000 — GRAND CANYON OF THE YELLOWSTONE

9:00 A.M.: Before leaving, Rebecca asks Mark about Muybridge and the 1990 rephotographing of his San Francisco panorama. Mark talks about how in his version he exaggerated both the circular path of the lens around its pivot point and the time lapse as he followed the sun through the day around the upper floors of what is now the Mark Hopkins Intercontinental Hotel. He thus tied the panoramic tradition to Muybridge's time-lapse studies, which is exactly what Rebecca is writing about; both kinds of photography were studies in time and space and closely related to what we're doing.

At quarter past noon we reach the vantage point for the day, near the Lower Falls of the Yellowstone River. It's located on the edge of a crumbling precipice fifteen feet off the trail and five hundred feet above the river. A constant stream of foot traffic passes us by, and once again we post our permit to keep onlookers from following Mark and Byron out onto dangerous ground.

Mike and I hike down switchbacks to the overlook, a railed platform that projects out over the edge of the three-hundred-foot-high falls. The green water sheets over a lip of rock then instantly turns white, an endless wave over which Mike and I both have visions of falling in slow motion. Teenage kids sidle up to the railing and spit over the edge, participating in the spectacle.

A few feet above us there's a smaller overlook, which puzzles me until we climb up to it. Once there, we see the point—to take pictures of your friends and family in front of the falls, which would otherwise be an impossible shot. It allows you to document your presence exactly as if you were having your picture taken in front of Old Faithful. Like being photographed standing next to someone famous, it validates your own existence by linking you to someone more widely witnessed than you.

4:00 P.M.: We drive over to Artist's Point on the south side of the canyon, reputedly the spot from which Moran made his sketches for his enormous canvas of the view. The site once again has the appropriate Moran painting mounted on a plaque

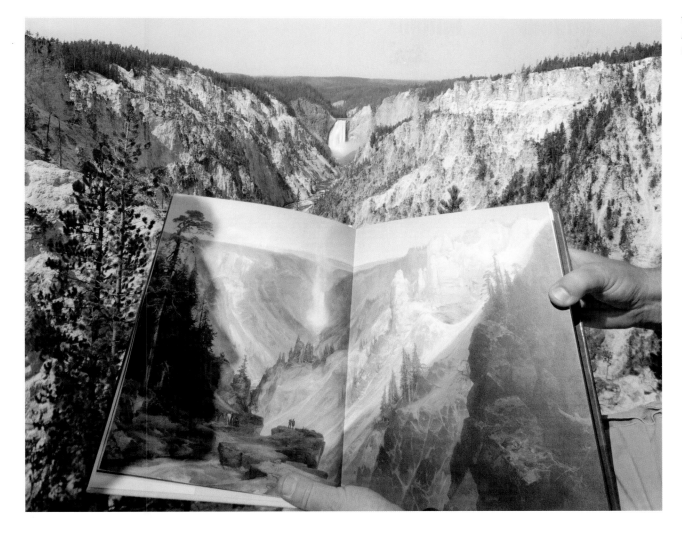

square in front of it so that you're forced into conflating the painting with the reality. Moran brought forward some of the river behind us, as well as some of the canyon walls, yet his painting makes complete sense in terms of how it actually feels to be witnessing the landscape. From here and now, however, instead of his traditional two figures gazing from the foreground into the far distance, we can see at least four other viewpoints up the canyon with people on them, including the Lower Falls platform we were standing on some minutes ago.

Mark can't do much in the way of photography

given the sun's angle in our faces, but he does take several shots of me impulsively holding up Byron's book on Moran. It's open to the painting, elevated above the heads of the tourists at full arm's length, and in front of the view. An older woman standing by Mark when I walk up to him shakes her head. "There's always one in every crowd," she states with disgust then walks off. This is puzzling. Does she mean an art photographer? A painting? Someone not acting reverently enough?

THURSDAY, NOVEMBER 30, 2000 — TOROWEAP POINT, GRAND CANYON, ARIZONA 7:45 A.M.: It's disorienting to have the sun come up so late on a Third View morning. We're used to traveling during the long summer days, and this winter schedule will take some getting used to. Mike, Mark, and I stroll along the canyon rim from the eastern end of a five-part panorama he made in 1986 (extended from a nineteenth-century, two-part panorama made by Hillers). Mark made the panorama not only in sequential space—moving the camera westward along the rim for each shot in the set—but in sequential time, shooting each frame later and later in the day so the shadows and sunlit tones in the canyon change perceptibly.

The scale here is problematic, a cognitive wall people hit when contemplating the canyon. Gazing down at the Lava Falls Rapid, which is more than two miles away to the west and below, we know its drop-off is huge. It's Class Five whitewater down there, as rough as it gets, the standing waves able to flip thirty-foot party rafts upside down like pancakes on a griddle. But from up here, even through ten-power binoculars, it's hard to fathom the depth of the canyon, the width of the river, the virulence of the rapids. Oddly enough, the best clue is when a slight shift in the morning breeze brings us the sound of the river. We can hear the thrashing of the rapids from the rim, and that's an impressive sensory clue from this far away.

I work on field notes while the guys cook up blueberry pancakes—speaking of flipping—for breakfast. Every few minutes sightseeing planes fly overhead, going up the canyon from Las Vegas. High above them are contrails from the intracontinental jetliners ferrying passengers from Los Angeles to points east. The air traffic, compared to our more nineteenth-century camping, is yet another strata of activity in both the time and space of the canyon.

11:00 A.M.: We drive to the turnoff for the Tuckup Trail and proceed down the dirt road, only to find it blocked by boulders with a National Park Service sign announcing that the track is now for foot traffic only. Despite having to schlepp fifty pounds of camera equipment plus water and personal gear an extra half hour until we break south cross-country, it's a pleasant walk. Our route over the slickrock to the rim takes only fifteen minutes until we reach the vantage point, which is located on the very edge of a rounded ledge for Bell's *Grand Cañon of the Colorado River, Mouth of Kanab Wash, Looking East.*

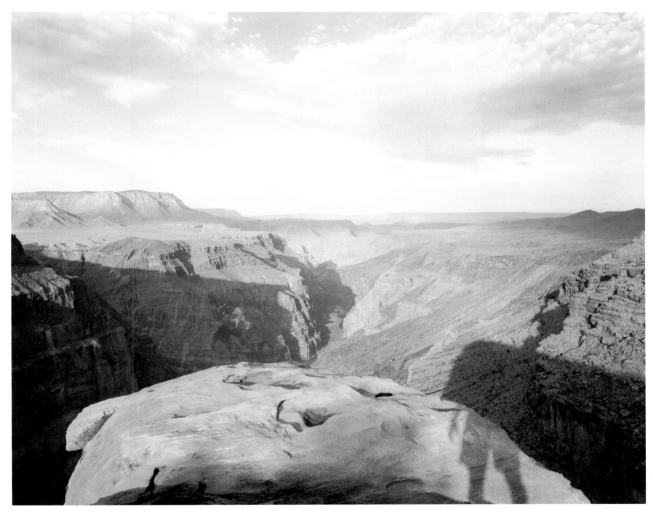

It's not the abrupt precipices that worry us, those sharp edges where you know exactly where not to step, but these sloping surfaces that can tempt you into stepping out too far. Only three fatalities have been recorded in the Toroweap area since 1932, when the ranger station was built, but the most recent was a Swedish woman who apparently just got too close to the rim and lost her footing. So out come the ropes, one for the tripod and camera, which I anchor around a boulder farther back on the ledge, and one for Mark that I use to belay him.

We're all set by 12:05, not knowing the exact time for the shadows to line up and hoping we're here even at the right time of year. Mark has tried

VIEW FROM THE TENT AT PYRAMID LAKE,
NV, 7:45 A.M., SEPTEMBER 17, 2000.
MARK KLETT, 2000.

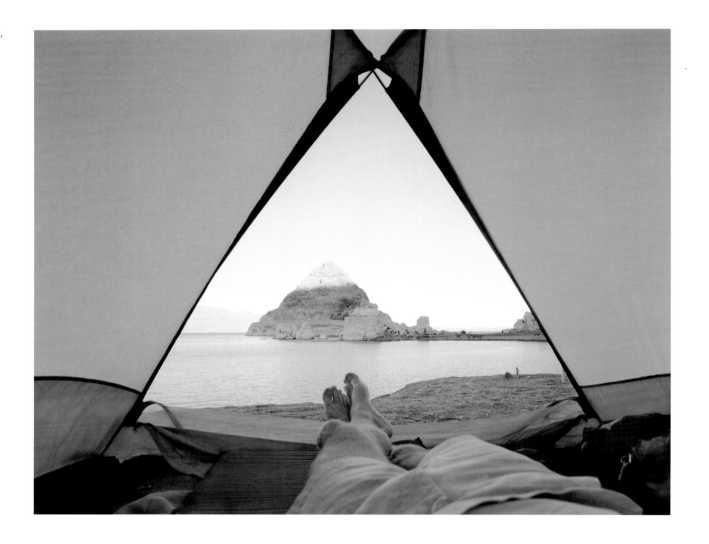

this shot before in every preceding month of the fall throughout the years, and he thinks we've selected the right time of year but can't be sure. We settle in to wait out the light, which upon this vast scale of the canyon seems slow to move anywhere. Mark finds a dead century-plant stalk to carve for the stick game tonight, an appropriate selection given our conversations about time.

9:30 P.M.: It's cold and we huddle closely around the fire where a giant tri-tip steak slowly cooks. Mark whittles on the century plant, thinking about how

to summarize what we're doing. Last night he had said: "One of the things people talk about is how space—the surface of the planet—has now been traversed almost everywhere, but what continues to allow us to make it new is that we come into places at different times. So space is not what's new, but time is, and that's what we traverse in Third View. That's what rephotography is all about."

Tonight he adds: "I've been trying to think what struck me about the time business last night, why it was different from conversations we've had about that before. Maybe it's because I came up with this spooky image of two figures walking through each other, of Bell and myself interpenetrating each other.

"You think you occupy space, but you don't; all you really occupy is time. You sit in a place like today, and you think you own the view, or the land, but all you have claim to is time. We're at this campsite now, but somebody was here before us, and somebody will be here after us."

As I write this down, I also think about how we have been watching the airplanes all day, both those flying low above the canyon for the sightseers and the ones up high, the jetliners, and how altitude is conferred by economic privilege, how the higher we are the greater the scope of the panorama and the more tempting it is to think we own what is below us. Photographs can be taken as a kind of privilege as well, but the ownership of an image isn't a legitimate claim to the land. It's just a moment in time you've borrowed.

Selected Sources

Below is listed a handful of the sources consulted while writing the annual field notes for the Third View project and *View Finder: Mark Klett, Photography, and the Reinvention of Landscape*. Readers interested in pursuing the histories of the American West and its photographers will find much more extensive bibliographies in these titles.

—William L. Fox

WESTERN HISTORY

Browne, Malcolm W. "Dams for Water Supply Are Altering Earth's Orbit, Expert Says." *New York Times*, March 3, 1996, 32.

Fox, William L. *The Void, the Grid, & the Sign*. Salt Lake City: University of Utah Press, 2000.

Goetzmann, William H. *Exploration and Empire: The Explorer and the Scientist in the Winning of the American West*. New York: W. W. Norton & Company, 1966.

Kiney, Joni Louise. *Thomas Moran and the Surveying of the American West*. Washington, D.C.: Smithsonian Institution, 1992.

King, Clarence. *Systematic Geology*. United States Geographical Exploration of the Fortieth Parallel, Vol. 2. Washington, D.C.: Engineering Department, U.S. Army, 1878. Many of Timothy O'Sullivan's photographs are reproduced as lithographs in this and the companion volume, *Descriptive Geology*.

Kittredge, William. *Who Owns the West?* San Francisco: Mercury House, 1996.

Limerick, Patricia Nelson. *The Legacy of Conquest: The Unbroken Past of the American West*. New York: W. W. Norton & Company, 1987.

Stegner, Wallace. *The American West as Living Space*. Ann Arbor: University of Michigan Press, 1987.

Turner, Frederick. *Beyond Geography: The Western Spirit Against the Wilderness*. New York: Viking, 1980.

Worster, Donald. *Rivers of Empire: Water, Aridity & the Growth of the American West*. New York: Pantheon Books, 1985.

LANDSCAPE PHOTOGRAPHY/ PHOTOGRAPHY AND THE WEST

Adams, Robert. *Why People Photograph*. New York: Aperture, 1994.

———. *Beauty in Photography*. New York: Aperture, 1996.

Castleberry, May, et al. *Perpetual Mirage: Photographic Narratives of the Desert West*. New York: Whitney Museum of Art, 1996.

Foresta, Merry A., et al. *Between Home and Heaven: Contemporary American Landscape Photography*. Albuquerque: University of New Mexico Press, 1992.

Fox, William L. *View Finder: Mark Klett, Photography, and the Reinvention of Landscape*. Albuquerque: University of New Mexico Press, 2001.

Jenkins, William. *New Topographics: Photographs of a Man-Altered Landscape*. Rochester: International Museum of Photography at the George Eastman House, 1975.

Klett, Mark. *Revealing Territory*. Essays by Patricia Nelson Limerick and Thomas W. Southall. Albuquerque: University of New Mexico Press, 1992.

———. "Haunted by Rhyolite: Learning from the Landscape of Failure." *American Art* 6 (Fall 1992). A photo essay done in collaboration with Patricia Limerick.

Klett, Mark, Ellen Manchester, and JoAnn Verburg. *Second View: The Rephotographic Survey Project*. Essay by Paul Berger. Albuquerque: University of New Mexico Press, 1984.

Naef, Weston. *Era of Exploration: The Rise of Landscape Exploration in the American West, 1860–1885*. New York: Albright-Knox Gallery/ Metropolitan Museum of Art, 1975.

Phillips, Sandra S., et al. *Crossing the Frontier: Photographs of the Developing West, 1849 to the Present*. San Francisco: Chronicle Books, 1996.

Read, Michael, ed. *Ansel Adams—New Light: Essays on His Legacy and Legend*. San Francisco: Friends of Photography, 1993.

Snyder, Joel. *American Frontiers: The Photographs of Timothy O'Sullivan, 1867-1874*. New York: Aperture, 1981.